JOHN WILLIE

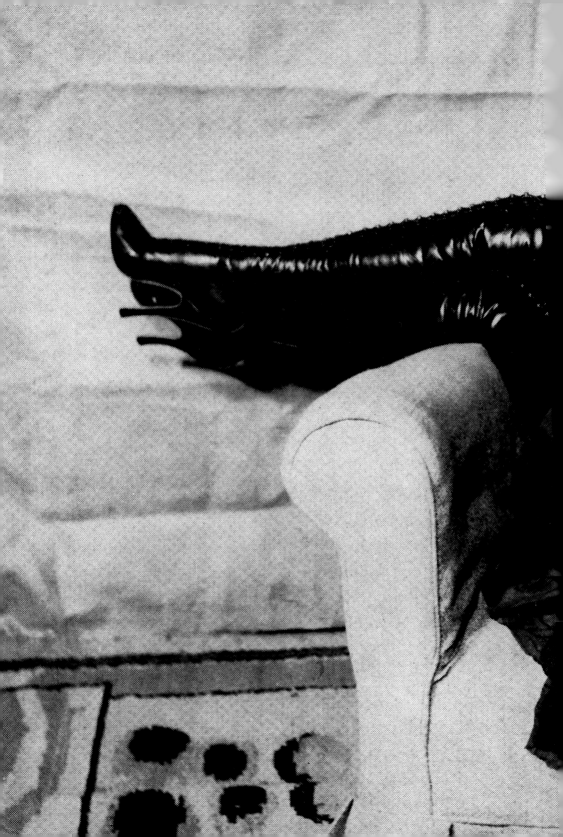

JOHN WILLIE
A BIZARRE LIFE

JANE GARRETT

Other Schiffer Books on Related Subjects:
Eric Stanton & the History of the Bizarre Underground, Richard Pérez Seves, 978-0-7643-5542-4
Retro Glamour Photography of Mark Anthony Lacy, Mark Anthony Lacy, 978-0-7643-5248-5
She's a Wildcat! The Art of Candy, Candy Weil, edited by Jamie Kendall, 978-0-7643-5910-1

Copyright © 2024 by Jane Garrett

Library of Congress Control Number: 2024932187

All rights reserved. No part of this work may be reproduced or used in any form or by any means—graphic, electronic, or mechanical, including photocopying or information storage and retrieval systems—without written permission from the publisher.

The scanning, uploading, and distribution of this book or any part thereof via the Internet or any other means without the permission of the publisher is illegal and punishable by law. Please purchase only authorized editions and do not participate in or encourage the electronic piracy of copyrighted materials.

"Schiffer," "Schiffer Publishing, Ltd.," and the pen and inkwell logo are registered trademarks of Schiffer Publishing, Ltd.

Designed by Lori Malkin Ehrlich
Cover design by Molly Shields
Author photo on jacket by Rik Garrett
Except where indicated, all images are from author's personal collection.
Photograph of John Coutts on page 10 from the collection of the National Archives of Australia: NAA: NAA: B883, NX53936. Used with permission. Photographs by John Coutts copyright Belier Press, Inc.; used with permission: pages 46, 51, 54, 126, 130, 140, 152, and 156.
Type set in Dunbar Low/EB Garamond

ISBN: 978-0-7643-6833-2
978-1-5073-0390-0 (ePub)
Printed in China

Published by Schiffer Publishing, Ltd.
4880 Lower Valley Road
Atglen, PA 19310
Phone: (610) 593-1777; Fax: (610) 593-2002
Email: info@schifferbooks.com
Web: www.schifferbooks.com

For our complete selection of fine books on this and related subjects, please visit our website at www.schifferbooks.com. You may also write for a free catalog.

Schiffer Publishing's titles are available at special discounts for bulk purchases for sales promotions or premiums. Special editions, including personalized covers, corporate imprints, and excerpts, can be created in large quantities for special needs. For more information, contact the publisher.

Contents

Prologue | 7

CHAPTER 1: Beginnings | 15

CHAPTER 2: From London to Sydney | 21

CHAPTER 3: A Chance Encounter | 27

CHAPTER 4: Achilles: For Slaves of Fashion | 39

CHAPTER 5: Holly | 47

CHAPTER 6: Introducing *Bizarre* | 55

CHAPTER 7: Pinups on Parade | 67

CHAPTER 8: Sweet Gwendoline | 77

CHAPTER 9: "Obscene and Immoral": Alfred Kinsey | 87

CHAPTER 10: *Bizarre* Returns | 93

CHAPTER 11: Juvenile Delinquency | 107

CHAPTER 12: The End of *Bizarre* | 117

CHAPTER 13: Los Angeles | 125

CHAPTER 14: The Glamour Girl Killer | 133

CHAPTER 15: New Directions | 139

CHAPTER 16: *Kitan Club*: Bondage in Japan | 147

CHAPTER 17: "Bury Me by Some Sweet Garden-Side" | 155

Epilogue | 162

Notes | 166

Index | 174

About the Author | 176

Prologue

Lorraine Vigil was nervous. The photographer who had picked her up at her Hollywood, California, apartment that evening for a photoshoot seemed a little strange, but Lorraine hadn't minded at first; they were working, after all, not going on a date. He had told her they were headed to a private photography studio near her home. Now they were speeding down the freeway, past every exit in Los Angeles, far into the desert.[1] Something wasn't right.

It was late October 1958, and twenty-eight-year-old Lorraine had signed on with a modeling agency just weeks earlier. The attractive brunette worked as a secretary during the day, but modeling seemed like a fun way to make some extra money. This was her first modeling job.[2]

"Where are we going?" she asked the driver of the speeding car, who had introduced himself as Frank Johnson. She tried to sound calmer than she felt. He didn't answer but kept looking in his rearview mirror.

Johnson pulled off at a deserted-looking exit, mumbling something about a flat tire.[3] Lorraine knew he was lying, but before she could confront him, he pulled a gun on her.

The man Lorraine knew as Frank Johnson wasn't really a professional photographer, and his name wasn't Frank Johnson. He was thirty-year-old television repairman Harvey Murray Glatman, a run-of-the-mill creep who had graduated to serial murder one year prior. By the time he picked up Lorraine under the pretense of a modeling job, he had already raped and murdered three other women: model Judy Ann Dull, mother-of-two Shirley Bridgeford, and dancer and model Ruth Rita Mercado. He was proud of the fact that he used the same special piece of rope to strangle each woman. Now he planned to use the same rope to kill Lorraine.

When Glatman pulled off the freeway, he was prepared to follow his usual routine. Tie her up, to start. He didn't expect any resistance. The gun, he had learned, was a very persuasive tool.

Although Lorraine was inexperienced as a model, she was street smart and a quick thinker. When she saw the gun and the rope in her captor's hands, her first impulse was to fight back.

"'Just do as I tell you and you won't get hurt,'" Lorraine recalled Glatman telling her, noting, "I knew, however, that he would kill me."[4]

Although she was staring down the barrel of the gun, Lorraine had the presence of mind to throw open the car door and roll out of the car onto the shoulder of the road. Glatman dove out of the car after her, and the pair began violently wrestling on the side of the freeway. He fired the gun once during the assault, grazing Lorraine's leg through her skirt as she struggled to escape.

Despite what Lorraine later remembered as "millions" of cars passing, nobody stopped to help her.[5] Glatman pointed the gun directly at her, and, in desperation, she grabbed his arm and bit his wrist. It was a move so gutsy that it frightened even her attacker. He dropped the gun in surprise and leaped away.

"Suddenly I found I had the gun in my hand," Lorraine recalled. "If I knew how to fire it, I believe I could have killed him."[6]

Instead she bluffed wildly, pointing the gun in his direction and screaming at him to stay away. She prayed that somebody, anybody, would stop their car to help.

Lorraine saved herself; fate took care of the rest. A passing highway patrolman just ending his shift noticed the commotion and pulled over, arresting Glatman immediately. It wasn't clear to him what had happened, but they would unravel the details overnight at the police station.

Although Glatman had been killing women every few months for the past year, the police were not even aware that a murderer was at large. His three previous slayings took place in different jurisdictions, and all were classified as routine missing persons cases. In the cases of both Judy Dull and Ruth Mercado, police felt it was likely the young women had simply left town to start new lives. Lorraine Vigil's brave battle on the side of the freeway changed everything.

The police questioned Glatman for days, finally extracting a confession and convincing him to lead them to the bodies of the three women. On Halloween morning, the story broke on front pages nationwide.

"HID BODIES IN DESERT," announced Louisiana's *Shreveport Times*.[7] The *Tribune-Herald* in Casper, Wyoming, filled the center of page 1 with a photo of Glatman's face, eerily lit like a monstrous ghoul.[8] From tiny towns such as Rhinelander, Wisconsin, to big cities such as Chicago, the same story emerged: that of a gawky and "mild-mannered" man who posed as a photographer to convince models to pose for bondage photographs.[9] While they were tied up, he raped, murdered, and photographed them.

The story had all the hallmarks of a classic media circus: beautiful Hollywood models, lurid photography, and a madman hiding in plain sight. The press and the public were captivated. Police fed the frenzy by releasing some of Glatman's photographs of the bound victims to the press, an ethically questionable decision improved only slightly by the promise that all nude and postmortem images had been destroyed. Reporters trailed detectives to Glatman's apartment, where police found more evidence: a box of items belonging to the victims, women's underwear, and a bedroom papered in bondage photographs clipped from magazines. The posed images depicted women who appeared to be bound, gagged, and tortured.

Typical pervert, some of the cops thought. It wasn't the first time that magazine photos like these had been found in the possession of a sex killer, and it wouldn't be the last. The federal government had acknowledged the seriousness of the problem just three years earlier, holding Senate hearings in 1955 to explore possible links among obscene materials, juvenile delinquency, and sex crimes. The average American thought "obscenity" meant nudity or sex, but law enforcement knew that wasn't the half of it. Some guys got off on weird stuff: high heels, stockings, whips, ropes, and chains. Women gagged and bound. Hell, even *men* gagged and bound. What could you do with a guy like that? Police departments nationwide were working to stop the distribution of this kind of material, and some people involved in the trade were under investigation by the FBI. In the minds of many law enforcement officials, it was critically important work—and it needed to happen before someone like Glatman could strike again.

About 4 miles down the road from the Melrose Avenue apartment where Glatman planned his murders, another Los Angeles resident read the news of the killer's arrest. Like everyone else in the city, John Alexander Scott Coutts was horrified by the murders. He was also angry. And he was scared.

It wasn't simply the natural fear of a killer so close to home. At fifty-six years of age, John was still tall and strong from decades of work as a manual laborer; he wasn't worried about a skinny guy with a piece of rope. The fear was something harder to

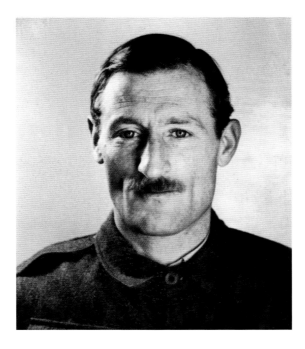

◀ John Coutts in July 1940

dismiss. As an artist and a photographer, John Coutts had dedicated the past twenty years of his life to creating just the sort of images Harvey Glatman collected: those of pretty, seminude women tied up with rope. Would law enforcement be at his door next? Worse yet, had his work influenced a murderer?

"My main pleasure is anything which hampers, hinders, or generally renders more helpless the attractive woman,"[10] John once wrote to a pen pal—a line that could have come directly from Glatman's pen.

But John wasn't a sexual predator. When he tied up a woman, he wanted her to like it. He loved stockings and high-heeled shoes, loved bondage, and most of all loved women who enjoyed receiving discipline as much as he enjoyed administering it. He also had the artistic talent to illustrate his favorite topics in convincing detail.

By the time Harvey Glatman's case hit the national news in 1958, John was already a legend in the underground fetish community. Under the pen name John Willie, he created a fantastical world where men wore corsets, teams of nude women pulled chariots, and everyone was having lots of sexy fun. For some fans, the first introduction to John's work came from the pages of mainstream pinup magazines, where he created saucy spot drawings and bondage comics in the 1940s. Others discovered his photographs and drawings sold through adult mail-order catalogs or under the counter at newsstands. Still others were readers of his pioneering bondage

and fetish magazine, *Bizarre*, which debuted in 1946 and connected a web of sexual outsiders from around the world.

John was not a typical midcentury fetish purveyor. Although he strived to earn a living from his artwork, he was also genuinely concerned with personal liberty and sexual freedom. He created fantasies but lived firmly in reality. He traveled the world, lived in six countries, and, like a magpie, collected inspiration everywhere. Like his favorite author, the eleventh-century mathematician and poet Omar Khayyam, John was both practical and creative. He was as comfortable digging a ditch or remodeling a house as he was wearing women's stockings or creating elaborate fashion illustrations. In an era of strict gender roles, he wasn't afraid to embrace and flaunt his apparent contradictions and encourage others to do the same.

For many fans, John's fantasy world represented a new and better way of life. It was a place where differences were celebrated instead of mocked or treated as pathology. So what if you liked cross-dressing or being trampled under your wife's 8-inch heels? So what if you were a grown woman who liked to be spanked? And just whose business was it if your greatest thrill involved a blindfold, a length of rope, and a quiet evening at home?

"It would perhaps be awfully simple if you could standardize the human being and his behavior as you standardize machinery & nuts & bolts—but it just cannot be done," John wrote to sex researcher Dr. Paul Gebhard, the then director of the Kinsey Institute for Research in Sex, Gender, and Reproduction at Indiana University. "Under the circumstances nothing is 'abnormal'—'unusual,' perhaps, but not 'abnormal.'"[11]

John developed this philosophy from experience; he himself had been called "unusual" and "abnormal" many times for his sexual interests. With *Bizarre* magazine, he hoped to provide others with an escape from mainstream disapproval. He also tried to prove that fantasy did not have to live only on the pages of a magazine or in secret photographs hidden in a shoebox. Even those desires that couldn't be expressed publicly could find a healthy outlet in day-to-day life with a willing partner.

"It became rather like a crusade to me," he admitted. "I kept on trying to ram home—'don't waste time with pictures & stories & stewing in your own juice—Get out, and find someone to have fun with.'"[12]

It sounded straightforward enough, but John was also aware that he was fighting a difficult battle. One by one, the people around him—artists, publishers, distributors, bookstore owners, and customers—fell victim to the law, which painted obscenity with a broad brush.

John's life spanned a period of time that criminalized all manner of so-called deviant sexuality, including homosexuality, cross-dressing, depictions of nudity, and the sale and consumption of pornography. It was not until 1963, the year after John's death, that the United States Supreme Court began lifting some of the sanctions on obscenity

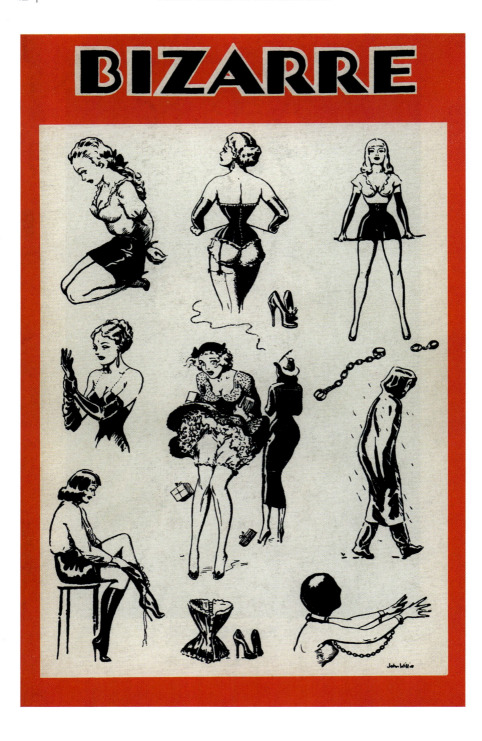

and considering that sexual expression might be a protected right. By the 1970s, John's *Bizarre*—and, indeed, most of his other work—would seem quaint. But in the 1940s and '50s, it was new, frightening, and dangerous.

Although John's fetish material had a large and widespread audience, concepts of consensual and nonconsensual bondage were still beyond the understanding of the average 1950s American. This lack of understanding permitted a panic to spread around high-profile crime cases such as the Glatman murders. Conflating artists like John with the violent crimes of someone like Glatman created an atmosphere of urgent fear. Parents, law enforcement officers, the media, and a bipartisan coalition of political leaders banded together to fight bondage and fetish material, and John and his contemporaries were trapped squarely in the middle.

This national panic meant that John lived his life as if he were a criminal: working clandestinely, releasing his work in great secrecy, and avoiding the attention of law enforcement. He couldn't market his work through most mainstream channels, and the avenues open to him were often populated with shady characters who hurt his business more than they helped. Because of the nature of his work, John had little recourse if a disreputable distributor refused to pay him or a publisher pirated his work.

A large network of fans around the world helped keep his work afloat by subscribing to his magazine; ordering his bondage-themed comic strip, *Sweet Gwendoline*; and purchasing photographs directly from his studio. The fans and customers were also taking enormous risks. To be caught possessing adult material both was embarrassing and, in some cases, could result in a prison sentence.

Over a decade later, in his majority opinion for the obscenity case *Stanley v. Georgia* (1969), Supreme Court justice Thurgood Marshall wrote: "If the First Amendment means anything, it means that a State has no business telling a man, sitting alone in his own house, what books he may read or what films he may watch. Our whole constitutional heritage rebels at the thought of giving government the power to control men's minds."[13]

But 1969 was a long way from the late 1950s, when a perceived need to protect the public from obscenity often trumped individual liberties. John and his colleagues can be credited with helping to usher in the sexual revolution of the 1960s and '70s, though they often suffered terribly for their efforts. Though John himself would not live to see the results of his labor, he helped create a community for a generation of sexual outsiders.

◄ The cover of *Bizarre* issue 11

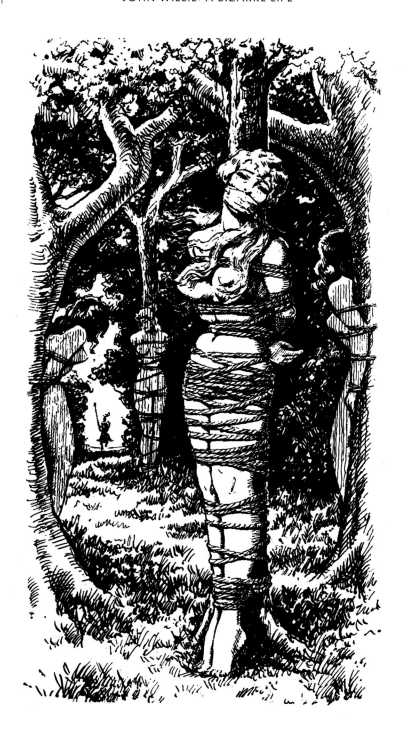

CHAPTER 1
Beginnings

For John Alexander Scott Coutts, it all started with a princess.

At just four years old, he was captivated by a picture of a beautiful woman tied to a tree in his book of fairy tales. The fair-haired, blue-eyed little boy stared at the image often, asking himself questions with answers that felt just out of reach. How did she get there? Was there any hope for escape? John wasn't sure, but she looked to be in real trouble. And it was a daring, exciting sort of trouble that stayed in his mind after the book was closed. The princess needed a prince.

"It was pleasing to me," he later recalled of the image, "in a sexual way. . . . The feeling that I had was that I wanted to rescue her, and somehow or other—I don't know what I wanted her to do, to her, to me, or so on, but somehow there was love entangled up in this. There was this lovely lady, and oh, I was so sorry for her."[14]

John returned to this image again and again, often imagining himself as her hero—and perhaps sometimes, secretly, as the villain who had left her there.

By the time he was four, young John had already seen more of the world than most adults in his small town of St. Albans, 20 miles north of London. Born in Singapore on December 9, 1902, John was the youngest child and only son of Edith Ann Spreckley, a homemaker, and William Scott Coutts Jr., a merchant seaman. The globetrotting family boasted cosmopolitan credentials: William was born in Ambala, India, in 1860; two of the couple's daughters, Mary Katherine and Margaret, were born in Penang, Malaysia; and Edith and her youngest daughter, Janet, were born in England. John's birth completed the family, and they returned to settle in England around 1906.[15]

By 1911, the Coutts family was living in affluence in a twelve-room home with a household staff of four, including a nurse, a cook, and two servants.[16] It was around

◂ John's later interpretation of an early fantasy

this time that John's natural artistic talent blossomed.[17] Although there is no evidence that he received formal training in the arts, drawing would remain a constant in his life through his final days, and he honed his craft with an eye for detail and a rich imagination. Growing up in a region where castles dot the countryside helped encourage his interest in fantasy stories, knights in armor, and damsels in distress; these legends and fantasy stories would later add an air of whimsy to the harsher elements of his sexuality, contributing to his unique style of bondage art.

As he grew into adolescence, John began actively seeking out images of bound women in magazines, books, and other media, noting that these images had "a definite sexual effect" on him.[18] Unaware of the underground worlds of sexual bondage and fetishism, young John had neither the vocabulary to explain his interests nor the social context to understand why the images excited him. He simply knew what he liked.

And, to him, it seemed perfectly natural to like tying up women. He began to look at the girls and women around him, wondering from time to time if they had feelings like his. He also developed a taste for silk stockings and high-heeled shoes, and he suspected that women who wore these garments might also be interested in bondage. To John, a woman on the street in high heels seemed to be communicating in a secret language that only the initiated could understand—asserting to the world that she was "sexually conscious."[19] The fact that most women in St. Albans in the 1910s wore low-heeled, sensible shoes made the rare glimpse of high heels all the more thrilling.

"Of course my family and sisters were very, very staid, the way they are in England," he later recalled. But a woman in high heels was different. "Somehow I felt the woman wearing high heels, that she knows what sex is for."[20]

John had no qualms about his interest in bondage, perhaps because the idea of rescuing a damsel in distress fit neatly into his childhood understanding of masculinity. And his interest in pretty girls clad in stockings and dainty, feminine shoes seemed more or less average for heterosexual boys of his age. But he was less comfortable with a secret desire that first emerged around the age of eleven: a longing to wear the clothing that he so admired on women.

Although he was keenly interested in high-heeled shoes, nobody in his household owned a pair. As an alternative he reached for silk stockings, which he secretly took from his sisters to try on himself. Although he enjoyed the experience, he was left feeling deeply conflicted.

"I'd put them on . . . and there was this sort of feeling in me that I wanted to wear women's clothes," he remembered. "I think it was then that . . . the guilt came into it."[21]

Years later, he allowed himself to enjoy wearing women's stockings and undergarments—even going so far as to wear them publicly at fetish parties—but his tone in discussing the garments suggests that he never fully overcame his discomfort

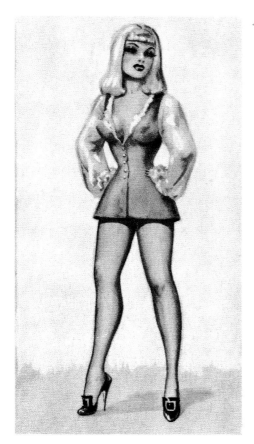

◀ One of John's androgynous designs from 1946

A Page-boy costume suitable for either sex.

about his own cross-dressing. He expressed his personal distaste for wearing dresses, arguing that "women's clothing on a man's figure, particularly a man of my type who had been spending most of his life swinging a pick and shovel, was ludicrous."

At the same time, he was defensive of men's right to wear women's undergarments, shoes, and stockings, stating, "It's only because of the ignorance of the public that they are regarded as 'women's clothes.' . . . Anything that does not look ridiculous on the male figure belongs as much to the male as it does to the female."[22]

Despite mixed feelings about the act of cross-dressing, John remained a staunch supporter of men's freedom of dress for the rest of his life. He frequently drew extravagant costumes for the discerning gentleman, featuring details such as soft blouses and stockings. He also wrote often about knights of old who were both fierce warriors and fashionable dandies, preferring high-heeled shoes, corsets, and lace garments for reasons of both comfort and fashion. In John's mind, a traditional knight was something like John himself: a no-nonsense man's man who happened to like feminine attire.

A boy living at home can explore his sexuality with some sense of privacy, but things change when he goes to school. John began his formal education at a now-defunct preparatory school called Seafield in Bexhill-on-Sea. At the turn of the twentieth century, Bexhill was a fashionable seaside resort town in southeast England and was home to a number of boarding schools catering to children of military and government officials. Seafield was a school for boys aged eight to fourteen, and it was one of the

more exclusive schools in the area, with a tuition of 100 guineas per year in 1911.[23] Seafield's stated purpose was to prepare boys for "entrance into the Public Schools and Royal Navy." The school also boasted "cricket and football grounds,"[24] which may have been the start of John's passion for sports—another interest, like drawing, bondage, stockings, and high-heeled shoes, that would follow him throughout his life.

Through his friends at Seafield, John began to recognize that his sexual interests were "different from the ordinarily accepted schoolboy ideas."[25] Other boys were also interested in girls, but they didn't talk about tying them up. Some even thought high heels were ugly, and they couldn't see the appeal of John's favorite photos and drawings. John was confused. If nobody else cared, why did he crane his neck to look at every pair of lovely legs walking by on high heels? And why did he still daydream about princesses tied to trees?

"I began to think I was screwy," he admitted of his fondness for bondage images, but added that "it didn't make me want to stop looking at them."[26]

During an era when "sexual deviancy" could result in imprisonment or institutionalization, it's notable that John was not ashamed of his sexuality. He learned to keep his interests a secret but continued to find pleasure in his personal fantasies.

John's schoolmates at Seafield left him feeling like a sexual outsider, but the school itself introduced him to a practice that has been a staple of sexual fetishism for centuries: corporal punishment. As the British fetish literature of the nineteenth and early twentieth centuries demonstrates, many fans of sexually charged flagellation first discovered their fetish under the disapproving eye of a school headmaster. John enjoyed the thought of physically punishing women in bondage, but he had no interest in receiving punishment himself. He admitted that as a young troublemaker, he was "beaten by every master in the school," but he flatly denied that these experiences played any part in the development of his sexuality.

"The whole training of British school is that you've got to be able to take a beating without crying about it," he later recalled. Alone in the headmaster's office, "the guy took a whole run and a jump across the whole bloody room he was in and really belted you with that goddamned cane as hard as he damned well could." He added,

> And you came out of that room with your eyes just wet; you were trying not to cry . . . and all the other kids listening outside the door to hear whether you made any outcry. If you'd had, your name was bloody mud. . . . But the whole thing was really the most painful bloody proceeding.

But for a young man interested in sexual power dynamics, was it enjoyable in some way?

No, he insisted. "The only people who enjoyed it were the other kids."[27]

After graduating from Seafield, John attended Trinity College, Glenalmond (now Glenalmond College), an Episcopalian boarding school for boys in Scotland. The school was steeped in its religious identity, and all students were expected to attend chapel daily. Though many of his schoolmates went on to become clergymen, John experienced the opposite effect from the conservative Christian environment; he came to despise what he perceived as the hypocrisy of the Christian faith, and he dismissed the Bible as nothing more than "the legendary history of a nomad tribe."[28] Despite his rebellion against the religious teachings, John excelled in other ways at Glenalmond. He played a number of sports, including rugby and cricket, and was often favorably singled out for his abilities. Following a disastrous cricket match against Perthshire on the North Inch, the *Dundee Courier* reported, "J. A. S. Coutts was the only member of the Glenalmond side who showed any resource, and he played crisply and well."[29]

A new school and a new country did nothing to smother John's burgeoning sexuality. His shoe fetishism could usually be satisfied with a walk down the local high street, and he admitted that by his late teens, "a woman wearing high heels had me in pursuit, full of interest."[30] But the all-male environment of boarding school meant that his sexual interests were usually confined to the realm of fantasy.

John's time at Glenalmond coincided with World War I. By the time the war ended in November 1918, 157 alumni had been killed in action—a number equal to that year's entire student body. The school erected a memorial in the chapel, a solemn daily reminder of the young men who lost their lives not long after graduation.[31]

Though the war had ended by the time John graduated, he could not have ignored the effect it had on his community, or the hero's welcome that greeted returning soldiers. Perhaps inspired by returning servicemen, John applied to Royal Military College (now the Royal Military Academy Sandhurst) and was admitted on September 1, 1921.[32]

Located roughly 40 miles southwest of London, Royal Military College was established in 1802 as a training facility for British army officers and remains one of the most prestigious military academies in the world. John's admission was no small feat; a fellow alumnus, Sir Winston Churchill, applied to the academy three times before finally gaining admission in 1893.[33] Other former cadets went on to international careers as military leaders, government officials, and celebrated cultural figures, including multiple members of Parliament and James Bond creator Ian Fleming.

Though one can speculate that World War I played some part, John's true reasons for choosing a military academy are not clear. Many of his classmates came from military families, and his fellow cadets included the sons of colonels and generals.[34] John excelled despite his family's lack of military background, earning extremely high marks in all subjects, especially tactics.[35] He chose to pursue the infantry rather

than cavalry track, and he was active in school activities, again earning a reputation as a strong rugby player.

"After an indifferent start to the term, he has begun to settle down and make use of his undo[u]bted natural abilities," John's company commander wrote in his first term report in 1922. He went on to praise the young cadet for his athletic skill, then added in a handwritten note, "'Battalion shot' with rifle."

"I hope he will keep this up," the major-general responded in his review of the report.[36]

The following year's term report held even higher praise. "Powers of Leadership: Very good," the major-general noted. "He conceals really high all round ability under a noisy & boyish exterior."[37]

The major-general's praise was not exaggerated: John graduated eighth in his class on July 11, 1923.[38] The following month, he entered military duty as 2nd lieutenant in the Royal Scots, at that time the oldest infantry regiment in the British army.[39] He was young, strong, and accomplished, and he appeared to be on track for a successful career as a military officer. After years of strict religious and military schooling, however, the "noisy and boyish" personality observed by his commanding officer came to the fore. Within two years, his intense individualism, fondness for alcohol, and weakness for beautiful women would collide to set his life on a new trajectory.

CHAPTER 2
From London to Sydney

In 1925, John Coutts could be forgiven for adopting a cocky attitude. At just twenty-two years of age, he had already lived in three countries, attended prestigious private schools, and graduated from the United Kingdom's top military academy. World War I was over, and with it the fear of death or disfigurement on the battlefield. The military gave him purpose—and, not incidentally, a uniform that commanded respect and attention on his 6-foot, 1-inch frame. He was living in London, earning money, and making his own decisions for the first time. After years of rigorous British boarding school rules, it was time to have fun.

Despite suffering severe damage from German bombs during World War I, interwar London was a city on the rise. The city grew in size and population, and building projects that had been halted during the war resumed. Croydon Airport opened in 1920 as London's first international air terminal, further cementing the city's status as a global hub.[40] Like other major international cities, including New York, Berlin, Tokyo, Paris, and Beijing, London experienced a period of rapid social change in the 1920s. Men who had gone abroad to fight in the war mingled with women who had experienced unprecedented independence in the workforce during the war years. The result was a new, more cosmopolitan youth culture—one accustomed to excitement and freedom, with a keen awareness of how easily life can end. To put it another way, as the London *Observer* did in 1925, the "young postwar generation" was "dance-mad, cocktail-swilling, slangy and outspoken, and rather brainless."[41]

More than a few young people might have considered the newspaper's assessment unfair, but John wouldn't have argued. It was true, after all, that his mind was usually on pubs, nightclubs, and every beautiful woman he saw in high heels. Among his friends, John's love of drinking would become legendary.

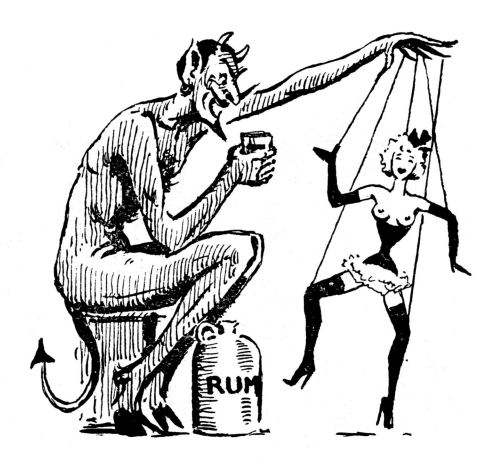

"My favorite tipple is heavy beer[,] which relaxes me," he wrote decades later. "I don't drink until the day's work's done, but if I run into a problem or problems which have me stumped & tearing my hair I quit & drink a couple of pints. The effect is the problems seem no trouble at all—you know exactly what to do, so you quit drinking and go on working—or, if you've done all you had to do then you quit working & lay your ears back with all four feet in the trough."[42]

His drinking would eventually veer into problematic territory, but as a young man he was simply seeking adventure—and, like many young people, the nightlife called to him. On one of his nighttime prowls, John met a young cocktail hostess named Eveline. Glamorous and pretty, Eveline Stella Frances Fisher was different from the girls John had known growing up. To begin with, there was her exciting job in a nightclub, which set her apart immediately from the "very, very staid" women he had known before.[43] She

also had an adventurous streak to match his own. John was smitten, and the pair married at the Holborn registry office in the Camden district of London on August 15, 1925.[44]

Later famed as the center of London's 1970s punk scene, Camden in the 1920s was a typical working-class neighborhood. One guidebook for travelers published in 1923 dismissed it as "a shabby district,"[45] home to the largest of the city's "Rowton Houses, a series of 'Poor Man's Hotels.'"[46] For John's family, who were well off, the elopement in Camden must have come as a surprise. Even more shocking, the marriage led to John's departure from the army, a position he had spent years working toward. His parents had paid handsomely for over a decade of elite private schooling to reach this point, and now he was throwing it all away. Why?

Popular lore states that John was discharged from the military as a result of his marriage to Eveline. It isn't clear whether he was discharged by force or left by choice, but the marriage was undoubtedly a deciding factor. For much of the nineteenth and early twentieth centuries, British army soldiers who wished to marry were expected to seek permission from their commanding officer. The commander would investigate the bride-to-be to ensure that she met his standards of decency and respectability. Soldiers whose brides passed this often-humiliating process were granted permission and said to be married "on the strength," which conferred various privileges upon the couple. Those who disobeyed the wishes of their commanding officers and married in spite of objections were considered "off the strength."

"It is a little galling... to have to satisfy one's commanding officer as to the respectability of the intended wife before marriage," admitted author E. Charles Vivian in his 1914 book *The British Army from Within*, "but it was not so many years ago that there was a good reason for this." He continued:

> Once married ["on the strength"], the soldier is granted free quarters for himself and wife, and the wife is allowed fuel and light up to a certain amount, together with rations, and an additional allowance is made in the event of children being born.... Marriage "off the strength"... is doubly risky, for the wife of the man who marries thus gets no official recognition; her husband has to occupy a place in the barrack-room, for no separate quarters can be allotted to him; he has at the same time to find lodgings somewhere among the civilian inhabitants of the station for his wife—and children, if he has any—and, if he is of a good character, he may be granted a sleeping-out pass, which confers on him the privilege of sleeping out of barracks—and this is a privilege that he must beg, not a right that he can claim.... Men frequently get married "off the strength," though how they manage to exist and at the same time provide for their wives on military pay is a mystery.[47]

It is easy to imagine young and energetic John feeling angry about the military's reaction to his chosen bride. And it would feel insulting to be told that the British army would never officially recognize his wife. He may have been punished for insubordination; he may have stopped caring; he may have simply walked away, fed up with an institution that expected absolute fidelity and obedience, something that John would not and seemingly could not ever fully give.

At first, abandoning the military for love must have seemed romantic. Now free from the rigors of military life, John found the entire world open for his exploration. Growing up as the child of a merchant seaman taught him to think big and look beyond borders, and he had a wife just as willing as he was to try something new. They were ready to leave the urban landscape of London for something a little wilder. The couple ultimately settled on Australia, a country where John's father, William Coutts, had lived and worked as a sheep farmer and gold prospector in the 1880s.[48] Australia may also have held appeal because, as an English-speaking country and a former British colony, it provided the right mix of exoticism and familiarity.

Less than a month after his wedding, on September 3, 1925, John was scheduled to embark alone on a ship to Australia.[49] (The occupation the twenty-two-year-old had listed on the ship's log, "Ret. Officer," was a bit disingenuous; he had been in the military for only two years and "retired" at the lowest officer rank, 2nd lieutenant.) John was not aboard the ship when it sailed, possibly due to a desire to spend more time with his new wife. But the honeymoon would not last long. On February 11, 1926, he sailed for Australia alone, this time listing a new occupation: "Nil."[50]

Eveline followed her husband, but, as John later explained in his classically understated style, "The marriage was not a great success."[51] They married swiftly, before they really knew each other, and soon found they had little in common. John's difficulty in finding and keeping work also tested the relationship. Without the structure of the military around him, he drifted from job to job: seaman, laborer, hired hand. By the time he arrived in Sydney in March 1926, he had been without steady work for months.

From his early years, John considered himself an artist first and foremost and often listed himself as such on official documents. Other jobs were nuisances rather than points of pride, and he took them only to make ends meet and provide financial backing for his true calling. Then as now, working as a full-time artist was a privilege few could afford—and John's wife was not supportive of his dream. Eveline, who had initially been attracted to a man who seemed destined for a high-ranking military future, may have felt cheated by the life she shared with her husband. It was perhaps at her insistence that John applied for a position with the New South Wales police force.

The idea of John Coutts working as a police officer is an incredible one, given that he would one day make a career of carefully avoiding police detection. As a young man in the 1920s, however, it probably seemed reasonable. He was experienced with weapons, leadership, and the conservative nature of military obedience. Why not transfer these skills to law enforcement? He was sworn in as probationary constable no. 2413 on April 27, 1927.[52] Like his other early pursuits, this job was short lived; he was discharged just over a year later, on May 19, 1928, while still in his probationary period.[53]

Just three years after exchanging vows in London, John and Eveline watched their marriage fall apart. The job woes were one major issue; John losing his job on the police force, his steadiest paycheck in years, may have been one disappointment too many. But there was another serious strain on the marriage that grew too big for either to ignore: both partners were sexually dissatisfied.

For John, his earlier positive feelings about his own sexual proclivities and "differences" were replaced by guilt and discomfort during his years with Eveline.

"This worry about being different didn't really bother me at all until I got married," he later said. "When with my wife I wanted her to wear high heels, and also I wanted to tie her up."[54]

After years of fantasizing about high heels, stockings, and bondage, John hoped marriage would mean a constant and willing sex partner. In this he would ultimately be disappointed. Eveline was not interested in bondage, and she abandoned her high heels with delight after leaving her job at the nightclub in London. For John's part, he was not going to force the issue. His feelings for the woman he fell in love with were dead.

"There was very little bondage involved," he said, "mainly because I . . . didn't particularly care."[55]

Eveline had sexual desires too, and they weren't being met by the man she had married. Her own dissatisfaction led to an affair with a man named Nicholas Giunio.

Nicholas was the sort of he-man hero that John, as a boy, had dreamed of being to fair maidens in distress. At first glance, John and Nicholas had much in common: both were immigrants to Australia (John from England, Nicholas from Italy) and both had previously lived internationally (John in Singapore and Scotland, Nicholas in Paris). Nicholas arrived in Australia in 1925, just one year before John. They were even the same age. But there the similarities ended.

As John dealt with marital troubles and struggled to find meaningful work, Nicholas's life read like an adventure story that might have appeared on the pages of Australia's most popular midcentury men's magazine, *Man*. Upon arriving in Australia, the irrepressible Nicholas set out to find his fortune as a crocodile hunter. Breathless newspaper accounts raved about his successes. "The well-known crocodile hunter, Mr.

N. Giunio . . . takes more than a few risks in his dangerous trade," the *Cairns Post* reported after Nicholas had established himself in his career. "The other day he was paddling up the Kennedy [River] . . . when his canoe got between a hungry shark and the stingray it was pursuing. The man-eater at once attacked the canoe, bit a paddle in half, nearly upset the craft, and swept off with a maw full of splintered wood."[56]

Other newspapers regularly reported the size and ferocity of the crocodiles he killed, including one 21 feet long and another that swallowed poison bait and 8 feet of fencing wire before finally being felled by Nicholas's gun.[57] "There can be no more exciting occupation than that of a crocodile hunter," affirmed the *Townsville Daily Bulletin*, adding that the job could also be quite lucrative—"providing the operator is endow[ed] with plenty of pluck, which no doubt, our friend [Nicholas] possesses."[58]

Unhappy as John was in his marriage, learning of Eveline's infidelity must have come as a blow. Why was it happening? And why, of all people, this damned crocodile hunter? As a result of the affair, John filed for divorce in September 1929.[59] Eveline did not contest it, and the divorce was finalized more than a year later, on July 23, 1930.[60] Eveline and Nicholas married later that same year,[61] and she joined her new husband on his crocodile hunting expeditions in the Australian outback. Ever the adventurer, Eveline was an active participant in every aspect of hunting, including skinning the crocodiles and drying their hides in the sun. As news of the female crocodile hunter spread, Eveline received some publicity of her own in the Australian press. "To put in fourteen hours a day hunting and skinning crocodiles is no easy job," she told *Australian Women's Weekly* in 1947, before describing her experiences living on the river with her husband.[62]

She and Nicholas would remain married for the rest of their lives. After retiring from crocodile hunting, Nicholas became a public accountant, and the couple settled in Surfer's Paradise on the northeast coast of Australia.[63]

CHAPTER 3
A Chance Encounter

The end of a relationship can be a tragedy or a gift. At twenty-seven years old, John had very little to show for his five years of marriage: a failed military career, long stretches of unemployment, the early stirrings of a drinking problem, and sexual desires that were still, after all these years, unfulfilled. He was back at work as a laborer. Same old story.

John wasn't the only one struggling in 1930. The United States stock market crash of October 29, 1929 unleashed a global economic depression, and the Australian economy—previously sustained largely by exports of wool and wheat—was especially hard hit. In 1932, Australian unemployment reached a record 30 percent,[64] one of the highest rates in the industrialized world. John, whose professional background consisted chiefly of unskilled labor, found that the number of ditchdiggers, dockworkers, and ship hands far exceeded the jobs available.

Unhoused and unemployed people set up encampments throughout the country. In an effort to discourage such camps, the Australian government devised a scheme by which traveling people could receive free food if they proved they had traveled more than 50 miles in the past week.[65] This encouraged unemployed people to live a transient lifestyle, remaining constantly on the move in order to avoid starving to death. Those who tried to settle in camps were often subject to harsh judgment and even violence.

John wasn't interested in waiting around Sydney to fight for the limited jobs available. Like an estimated 40,000 other men nationwide,[66] he hit the road.

Many traveling workers were attracted to the city of Brisbane, approximately 600 miles north of Sydney. Brisbane's state of Queensland was primarily rural, and it experienced lower unemployment rates than the rest of the country.[67] It was also the first state to develop a government-backed relief program for the unemployed.[68] John made

the move to Queensland in 1930, just as the Depression was ramping up and just as his divorce from Eveline was finally, mercifully deemed official.

His arrival was marked by trouble. On August 7, 1930, just ten days after his divorce was finalized, John landed in court on a petty mischief charge alongside his friend Walter Jaskulsky, a twenty-two-year-old seaman. The charge stemmed from the two men's drunken decision to disrupt a religious meeting led by flamboyant Pentecostal evangelist Frederick Bernardus Van Eyk in the city of Toowoomba.

Originally a boxer from South Africa, Van Eyk arrived in Australia in 1927 and quickly attracted a steady stream of followers. He traveled the country presenting rousing meetings that featured singing, dancing, laying of hands, and speaking in tongues. One Sydney newspaper noted dryly that Van Eyk had invented a special collection plate that locked at the top, making it impossible for attendees to steal money meant for the minister himself.[69]

For John, who had long since abandoned his Christian roots, Van Eyk's brand of religious showmanship represented all that he considered repulsive and hypocritical about organized religion. The Princess Theatre, a large movie house, had been Van Eyk's home base for meetings since arriving in Toowoomba. As John and his friend Walter passed the theater on a Friday night and heard music inside, the desire to have a little fun with the evangelical flock proved too great to ignore.

"It was stated they made a disturbance by interjecting, clapping their hands, and singing out," reported the *Brisbane Courier*.[70]

John denied this in court. "First of all we were asked to sing," he testified. Then, adopting the blasé attitude he often assumed in the face of trouble, he added, "There was no disturbance after that because we were not interested enough."

Codefendant Walter was more forthright. "When it was explained we could not sing, we were told to clap our hands," he told the magistrate. "I suppose in doing so we clapped a little bit too loud."[71]

A guilty verdict could have meant a fine or imprisonment, but one important detail worked in the defendants' favor: mainstream Australia despised Van Eyk. Despite his strong following, especially in rural communities, Van Eyk was frequently the subject of scandal among nonbelievers. Newspapers gleefully reported on his mistreatment of his wife and children, his questionable financial practices, and his affairs with attractive "bobbed-haired believers."[72] The "hot gospeller"[73] with pompadoured hair was even reportedly thrown into a river in MacKay, Queensland, by a crowd seeking to drive him out of town.

Fair or not, public opinion of the flashy evangelical minister likely played a part in the trial of John and Walter. The pair were convicted on the petty mischief charge but were set free at sentencing.

"I do not propose to impose any punishment," the magistrate stated, "but I hope this will act as a warning to others who attend Van Eyk's meetings."

Avoiding fines or jail time was a stroke of good luck, but it was only one small consolation in an otherwise difficult period. In 1930, the Depression was just beginning. John must have anticipated a hard road ahead, but he couldn't have imagined what kind of lifestyle change awaited him. In 1923, he had graduated from the most prestigious military academy in the United Kingdom. Now, less than a decade later, he stood in bread lines for donated food and wandered the streets of the city and its suburbs looking for work. He sometimes participated in relief work, a program under which unemployed people received pay in exchange for labor on state government projects. But this work was limited.

For the next few years, John struggled to survive. He looked for work on a daily basis, only occasionally finding it. He lived in boardinghouses constructed for relief workers and spent his evenings sitting on park benches, waiting until it was time to go to sleep so he could wake up and start over again.[74]

It didn't help that many of those fortunate enough to keep their jobs during the Depression didn't understand relief workers. Some accused the workers of laziness or unwillingness to work. Others felt that supporting the unemployed workers was a waste of taxpayer money.

Speaking on behalf of his fellow relief workers, John begged for understanding from the public.

"We've nearly given up hoping for to-morrow," he wrote in a letter to the Brisbane *Telegraph* in 1933, three years into the Depression. "Once that really does happen and the only anticipation is a repetition of the misery of to-day—you are done."[75]

In his letter, John stated that relief work "seems to have no definite objective"—a common complaint among the relief workers, who were prohibited from doing work that might otherwise be completed by an employed person.[76] John suggested more substantive work for the unemployed: beautifying parks, cleaning the streets, and clearing land outside the cities. He certainly wasn't the only one calling for practical labor, but in 1933, with unemployment at an all-time peak, making such suggestions felt like shouting into an empty cave.

It could have been the end of the road. He could have sunk into oblivion in this port city in an unfamiliar country. Instead, he survived the best way he knew how: head down, ready to work for anyone who would hire him. He was still young, strong, and single, and he had hope for his future in spite of the years of difficulty he had endured.

Long stretches of unstructured time gave John plenty of opportunity to assess his life and consider the future. If nothing else, he knew he didn't want to haul rocks and dig ditches forever. Working a physical job, being tall and strong: these were parts of

his identity that had long given him pride and purpose, but he didn't yet have an outlet for the creative or intuitive sides of his personality. He knew he could draw, but he hadn't yet published any work. As the Depression continued, it seemed increasingly unlikely that anyone would pay him to draw pictures.

And then there was the issue of sex. He had tried to push aside his old feelings while married, but they had never really gone away. He still loved the feeling of silk stockings on his bare legs. He still thought frequently about wearing high heels, though a cursory glance around a women's shoe store always brought him back to reality. High heels were made for dainty women, not for men over 6 feet tall with a pair of feet to match.

Why exactly was that? Was it really so strange for a man to wear high heels? At times he felt indignant, frustrated at the narrow, bland British culture that had followed him halfway around the world. Other times he felt that perhaps *he* was wrong. After all, he had never heard of a man wearing women's clothing. Maybe he was sick.

John regularly traveled between Brisbane and Sydney during the Depression years, eventually moving back to Sydney in the mid-1930s. Living in Sydney was, in some ways, not so different from living in London. Both were the biggest cities in their respective countries. Visitors and new residents poured into the two cities from nearby small towns and rural areas as well as from other countries around the world. Both were magnets for artists, free spirits, dandies, and dilettantes. But Australia had its own atmosphere, a wildness and a hustle that England lacked. Australia was new, having established itself as a country less than 150 years before John's arrival. This newness was distilled to its essence in Sydney. And Kings Cross, the neighborhood where John spent most of his time, was ground zero.

In the early twentieth century, Kings Cross was known as a bohemian paradise. Painters, writers, dancers, sex workers, actors, models, and other men and women who lived by a new code of freedom all called Kings Cross home. Artists gathered in bars, smoked cigarettes over a cup of coffee at the Arabian Coffee Shop, or partied at the annual Artists & Models Ball. One major magazine called Kings Cross "Australia's 'Little Paris,'" noting that women walked the streets in trousers, shorts, or even dressing gowns, and adding with approval, "It is absence of convention that gives 'The Cross' much of its charm."[77]

Though John had devoted his life to the military, marriage, and hard manual labor, he was at his core attracted to the unconventional. Kings Cross was a place to explore the side of his personality that had no outlet in day-to-day life. He enjoyed exploring

the neighborhood, eyeing the beautiful, long-legged women, and thinking about how he might make his own mark.

Wandering through the Cross one day, John passed a shoe store called MacNaught's. He had likely passed it many times before. MacNaught's was one of the largest and most popular shoe stores in Sydney, with three locations selling shoes for men, women, and children. Something in the window caught his eye this time, and he stopped to look.

It was a display of what he later described as "very high-heeled shoes—and one of them obviously large enough for a man to wear."[78]

John was shocked. Could it really be what he thought it was? Was it some kind of mistake?

"This liking for high-heeled shoes on my part always embarrassed me," John would later recall of his desire to wear the shoes. "I thought I was a freak, and the only one of its kind in the world."[79]

The shoes in the window hinted at something John could hardly allow himself to believe: there might be other "freaks" in the world, and some of them could be living in his own neighborhood.

He was, he later admitted, "partly drunk,"[80] which helped him summon the courage to go inside.

The shop buzzed with customers and staff. John approached a salesperson and inquired about the shoes, trying with all his might to appear calm. No need to express too much interest. The unusual shoes were just a novelty, after all, and he was merely curious.

▶ John's fascination with shoes is evident in this illustration from the mid-1950s.

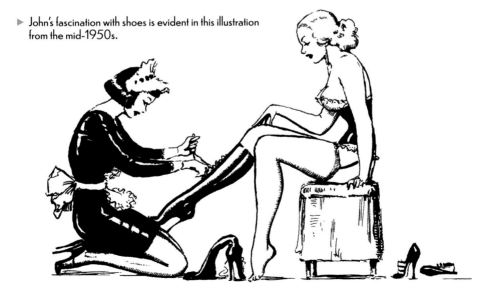

He was immediately directed to a male sales associate who was personally tasked with responding to inquiries about the shoes in the window. John was about to learn something few Sydney residents knew: although it presented itself as a mainstream, family-oriented shop, MacNaught's was also a fetish-friendly establishment catering to men and women who enjoyed wearing and admiring extremely high-heeled shoes.

The sales associate was friendly and open. He tried to put John at ease, even putting the shoes on his own feet and explaining that he had his own pair at home.[81] It was nothing to be shy about. What was wrong with wearing the shoes they wanted to wear?

It was incredible, and almost too much to take in at one time. Just an hour before, John had not known that any other man on Earth was interested in wearing women's shoes. Now he was standing in a family shoe store with another man, discussing the finer points of extreme high heels. He felt himself growing hot with embarrassment.

"I tried to pass the whole thing off as a joke—that I really wasn't interested in getting a pair of shoes which I could wear myself," he later remembered.[82] He needed some time to process all of this. He also needed another drink.

The sales associate understood. If John ever changed his mind, he could always come around the store again. He handed John the business card of a local man who ran a social club for high-heel fetishists. It wasn't just men, either—there were women in the club who loved to wear high-heeled shoes and boots. It was a good way to make friends, and it was a place to relax and be yourself. Then the salesman showed him one more thing that would change the course of his life: a very special magazine called *London Life*.

London Life began publication in 1920, ostensibly as a glamour and movie magazine. The average reader of the 1920s and '30s might enjoy the saucy photographs of film and stage actresses and stories about fashion, but for members of the burgeoning international fetish community, the magazine represented much more. A closer look revealed actresses in unusual or provocative attire, including rubber raincoats, silk stockings, and corsets that harkened back to Victorian times. The back of the magazine featured advertisements for erotic mail-order materials, custom corsetry, and high-heeled boots. Most importantly, the magazine had a correspondence section dedicated to readers sharing their own sexual fetishes and fantasies. Readers wrote in about real or imagined sexual encounters that typically featured an activity (spanking, smothering, dunking in water) or a fetish object (boots, corsets, rubber garments, leather) that fell outside the bounds of mainstream sexuality.

London Life was not the first magazine to feature fetish correspondence, but it was certainly the most popular. By exploring a wide variety of niche sexual topics and devoting extensive space to readers' letters, the magazine developed a strong following among sexual outsiders around the world. Many readers wrote into the magazine

regularly, turning the correspondence pages into a space for entertainment, voyeurism, exhibitionism, and community. As Lisa Z. Sigel has noted in her extensive research of the publication, whether the sexual experiences described in *London Life*'s correspondence pages were real or imaginary is largely immaterial.[83] The fact that *London Life* published the letters at all served to legitimize the erotic longings of its readership and demonstrated the inherent variety in human sexual desire.

For John, a man who frankly admitted he had never met another person who shared his sexual interests, *London Life* was a revelation. Like it did for many sexual outsiders of his era, the magazine became a touchstone that deeply influenced his life. In time, it would also inspire the course of his artwork and career.

John's chance stroll past MacNaught's had transformed into an experience that he found almost impossible to believe. Although he left the store feeling "awfully embarrassed"[84] about the exposure of his secret desires, his shyness ultimately gave way to curiosity about *London Life* and his fellow high-heel fans. He followed up on the card the MacNaught's associate had given him, and he also returned to the shoe store.

"It was such a fantastic relief to me to find out that there were other people in the world, beside myself, who had this urge for high heels," he said later. "It simply—I tell you it was completely changed right away on the spot. Instead of being alone, a freak, there were other people who had the same ideas as I had. So I decided . . . I wasn't mad as I thought I was before."[85]

John joined the club devoted to high-heeled shoes, which he later referred to as the "*London Life* Club." He learned that the group manufactured custom shoes under the name Achilles, which they sold through *London Life* magazine advertisements to customers around the world. (The business name was borrowed from the man who ran the high-heel club, a retired sea captain who took Achilles as his nom de plume when writing to *London Life*.)[86]

John was an enthusiastic member of the club at first, overflowing with excitement at sharing his desires with like-minded people. He began to take his art more seriously. The club members understood him, and—a great boost to his ego—they liked his artwork. It may also have been through the *London Life* club that John met Holly Faram, his second wife and the woman with whom he would share the most important romantic relationship of his life. Holly was a beautiful high-heel fan and professional model who would help set John's artistic life in motion. Things finally seemed to be going right.

John became a regular reader of *London Life*, even sending his own letters into the magazine in an effort to expand his community. Through his friend Achilles, he began an important pen pal relationship with a photographer in Chicago, a fellow *London Life* reader who would later prove instrumental in expanding John's personal and

professional circles. His friends in the high-heel club encouraged him to send his artwork into *London Life*, and when he didn't do it, they did it for him. Like most people who saw his work, the magazine's editors were impressed; John's first known published piece, a painting of a naughty blonde female fetishist surrounded by related sketches, was given a full page of coverage.[87]

To John's frustration, the editors of *London Life* misattributed the artwork to "MacNaught and Co., of Sydney, Australia."[88] They also censored his work by removing whip marks and any references to bondage. "All chains, whips, & straps were removed, & to my mind it practically ruined the whole sketch," John wrote of the incident to his friend in Chicago.[89] Some elements of the drawing no longer made sense with ropes and chains removed. He also noticed that his letters to the magazine, particularly those about bondage, went unpublished. Why the reticence to publish stronger bondage

content, especially in a magazine that branded itself as an inclusive community for sexual outsiders?

London Life likely erred on the side of conservatism to avoid legal trouble. It was one thing to write about high heels, stockings, corsets, rubber, or any number of other fetish objects that could be explained away as nonsexualized interests. It was quite another to publish stories and images that could appear to conflate sex and violence. Publishing such material could destroy the magazine's carefully constructed international distribution channels, a chance they were understandably unwilling to take. None of this mattered to John. As time passed, he began to feel like an outsider among outsiders.

Although John felt frustrated with the editorial limitations of *London Life*, the magazine also served as inspiration for a new idea: a bolder, more overt fetish publication

of his own creation. John claimed that the idea for a fetish magazine came to him shortly after his initial introduction to *London Life*.[90] However, it was not until after 1935, when his edited drawing appeared in the magazine without proper attribution, that he began seeking funding for his new project in earnest.

Even a small magazine is a large financial undertaking, and John quickly discovered that the money he earned as a manual laborer was not sufficient to support a monthly publication. After a year of unsuccessfully seeking funding for the magazine through traditional means, he changed tactics. Why not seek funding directly from fetishists themselves? Surely, he felt, there were other readers who would enjoy reading a stronger version of *London Life*. If he could develop a mailing list of potential subscribers, perhaps their subscription dollars would pay for the printing of the debut issue.

The natural way to build such a mailing list was to advertise in *London Life* itself. The magazine, however, was highly selective in its choice of advertisers, and the editors advised John that they would accept an advertisement from him only if he worked with a larger firm well known to them, such as MacNaught's shoe store. MacNaught's, in turn, told John they would back him only if his venture was shoe-related.[91] John's mind immediately turned to Sydney's *London Life* club and its shoemaking business, Achilles.

In the days before mass-produced fetishwear, it was common for individual craftspeople to create their own garments, shoes, restraints, and jewelry, with varying degrees of success. Mail-order businesses such as Achilles catered to people who were unable to make their own shoes, but it was difficult to know if the shoes that arrived would look anything like the fantasy in the customer's mind. In this regard, John felt that Achilles missed the mark. "I didn't think much of the shoes that they made," he said. "I thought I could damn well do better."[92]

He approached the club members and suggested handing the design work over to him. They liked his artwork, didn't they? Why not make real shoes out of his drawings? The reaction was swift and unequivocal: "They weren't interesting in backing me; they said the idea was absurd," John recalled.[93]

Maybe the idea of a newcomer jumping head first into the complicated world of shoemaking *was* absurd. But John was undeterred. He had definite ideas about the type of high heels he would most like to see and wear, and the output of Achilles—which John bluntly described as "ugly" and "very clumsy"[94]—did not live up to his expectations.

There was clearly some measure of bad blood between John and his friends at Achilles. John claimed that the group eventually allowed him to take over the name Achilles, which he "duly registered"[95] in Sydney in February 1938.[96] He also claimed that he discovered the group's official shoemaker "by accident" and hired the man to realize his own designs.[97]

Whether this is true or not is unclear. It is certainly possible that John employed more underhanded tactics to secure the name and manufacturer of the group's shoes, perhaps frustrated with the dismissive attitude of the group when he declared his intention to make shoes. When he learned that Achilles was not officially registered as a business in Sydney, he did so himself—perhaps without the knowledge of the original Achilles.

Regardless of origin, John acquired a ready-made company when he entered the shoe trade, and his iteration of Achilles Shoes was open for business.

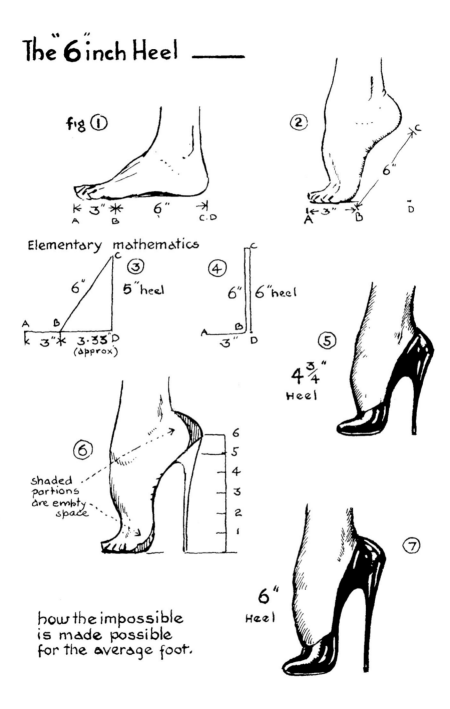

CHAPTER 4
Achilles: For Slaves of Fashion

The seductive beauty of a high-heeled shoe is mathematical. The height of the heel, the forward pitch of the foot, the high curve of the arch, and the perfect fit all come into play when creating a pleasing, artistic line. When John started Achilles Shoes, he knew nothing about shoe construction and nothing about business. But he did know that he could draw a beautiful foot in a beautiful shoe, and that seemed like enough to start.

John set pencil to paper and sketched as he always had, allowing his mind to wander to precisely the type of shoe he would like to see a woman wearing. It needed to have the highest heels possible while still allowing the wearer to stand, walk, and pose. It needed to be black. It might be shiny patent leather, or it might be a matte kidskin soft as human flesh to the touch. John had never been a fan of platforms at the front of shoes, which decrease the curve of the foot and often make the shoe more comfortable for the wearer. In his mind, the point of a beautiful shoe (or a beautiful woman, for that matter) was not comfort.

John placed advertisements for Achilles in *London Life*, deliberately pricing the shoes at extremely high rates to discourage sales. His ultimate goal was not to sell shoes but to build a mailing list for his nascent magazine. "I can then turn around & suggest that each one who replies becomes a subscriber to a new little magazine," John explained hopefully to his friend in Chicago.[98]

In fact, the entire Achilles enterprise was an absolute fantasy; he hadn't yet even consulted with the shoemaker to see if his drawings could become three-dimensional objects. It didn't seem real, and it continued to be unreal until he opened his mailbox and found an order inside.

◀ John demonstrates how to build a shoe with a 6-inch heel.

His first customer! For a brief moment, John felt proud and excited. The other members of the *London Life* club thought he couldn't do it, but here he was: order in hand for his first pair of shoes.

Except there were no shoes.

"Of course, I had no money," John said. "I didn't know how I was going to pay the shoemaker for this first shoe that he made."[99]

The first order of business was to stall the purchaser.

These things take time. . . .

Each shoe is made to order, with care given to the exact dimensions of the wearer's foot. . . .

A disaster has befallen the shop, delaying the fulfillment of all orders. . . .

"I think I even said that the children had measles and [the shoemaker] was in quarantine," John recalled.[100] Anything to buy some time; anything to convince the purchaser that Achilles was a reputable, established shoe company.

In the end, the expert cobbler managed to construct the ultra high heels that John had envisioned in his artwork, and the delighted client received his new shoes.

"I sighed a sigh of relief," John said. "Unfortunately the man I sold them to was so excited by them that he wrote back and ordered another shoe which I'd drawn at complete random and I didn't know whether it was possible to make. . . . But as £20 was involved, I had to do something about it. So I went to my shoemaker, and he said, 'You make the lasts, and I'll make the shoe.' And so the shoe was made. And that was the start of Achilles."[101]

It was John's great fortune to meet a shoemaker talented in the construction of highly unusual shoes and boots. Photographs of Achilles shoes show the work of a cobbler of undeniable skill, able to create shoes as beautiful as any of John's drawings—and unlike

▶ John's partner Holly models a pair of thigh-high boots.

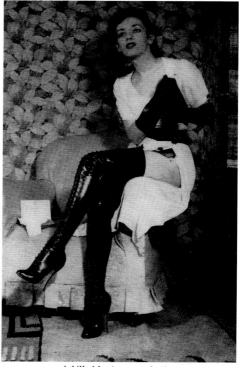

Achilles' boots are perfection

anything else commercially available in Sydney. John's homemade lasts (the foot-shaped forms to which a shoe is fitted and upon which it is constructed) were based on his partner Holly's foot[102] and also added to the special shape and design of the heels. Together, John and his shoemaker brought fantasy after fantasy to life.

There were thigh-high boots that hugged calf, knee, and thigh like second skin. There were shiny black knee-high boots with sharp stiletto heels, ideal for making a man beg. There were tiny lace-up oxfords that could almost be mistaken for similar shoes available in any shoe store of the 1930s, except these had 6-inch heels. And, of course, there were classic pumps, so high and so exquisitely constructed that any woman wearing them commanded a second look. Although John's goal of starting a magazine always took precedence, he took Achilles seriously, creating only the finest shoes for his clients.

What gave the shoes their special appeal?

"To start with[,] high heels are attractive, and the higher the heel, the greater the attraction," John wrote later. "The attraction has a different reason with different people. Some like the shape it gives to the instep, others the precarious balance, the stilted step, the teetering feminine appearance, and so on."[103]

John would later receive many letters from shoe fetishists who shared his fascination with high heels and expressed their own reasons for loving shoes.

"How I would delight in meeting a girl who is as fond of sweet, perfumed, tender footwear as I am," wrote one fan. "I think any girl who had well[-]formed ankles and contrived to wear beautiful expensive shoes, would have me dwelling on her slightest wish. . . . I feel almost like writing a poem about my favorite weakness. What an inspiration are these mirror-black patents rising on a delicately shaped heel."[104]

In the midst of the Great Depression, John had found an essential niche: sexual fulfillment. For his most devoted customers, John provided a service that few others could. In the 1930s, very high-heeled shoes were rarely available to purchase in stores and typically needed to be custom-made.

"To create a heel which while being thin as a pencil still has the needed strength to support the thudding jar of 100 pounds is an art in itself," John wrote several years later. "It is an art which so far machinery has not been able to copy, though with lighter metals coming onto the market the day of the molded metal or plastic heel is not far distant."[105] His prescient comment was just one of many accurate predictions he would make about the future of fashion.

There were many barriers in place for those who wished to own high-quality fetish shoes in the 1930s. Price was, of course, one consideration; leather, wood, and skilled labor all were expensive. Those who had the means to purchase custom shoes might still face several hurdles, chief among them being a lack of appropriate connections. Some shoe fetishists could draw; perhaps a few even knew a good cobbler. But most

wouldn't dare approach anyone in their hometown asking for help. Mail order felt safe and anonymous, and repeat customers knew they could trust Achilles for both quality and discretion. The business grew, and so did the mailing list.

While running Achilles, John developed an interest in photography. It would serve many purposes. For one, photographs represented the shoes more accurately than drawings could; this in turn helped sell the merchandise. John also quickly learned that he could sell the photographs themselves to collectors. Many men wished to see women in very high heels but either couldn't afford a pair of custom shoes or didn't know any women who liked to wear them. Photographs offered a discreet and cost-effective solution. John could also use photographs as references for his drawings, a practice he began in the 1930s and continued for the rest of his career. Many of the drawings and their reference photos would later provide content for John's fetish magazine. And then there was the obvious appeal: taking photos was fun.

▲ A commissioned pair of Achilles shoes with 15-inch heels

John described his earliest images as "purely innocent, casual photographs,"[106] and extant examples confirm this. He photographed many women in Sydney, usually outdoors in what appear to be suburban or rural residential settings. None appear to be professional models; indeed, John's self-described criterion for models during this period was women "who would pose for nothing."[107] The models typically wore modest sweaters, skirts, and even long overcoats with their very high-heeled boots and shoes. With few exceptions, the severely high heels are the only element of the photographs that differentiate them from average snapshots of the 1930s. Like many images in *London Life* and, later, in John's own magazine, the sexual nature of these photographs is obvious only to the audience for whom they are intended—in this case, shoe fetishists.

The simple outdoor photos were a hit, so John decided to try his hand at studio photography. He also began receiving commissions. When one customer requested a shoe with a 15-inch heel, John photographed a woman wearing them before sending them off to their new owner. In the resulting image, a model wearing a hat and fashionable dress is seated on cushions against a white backdrop, the heels of her shoes extending more than a foot beyond the sole.

"I have a shrewd suspicion . . . that the shoe itself, the heel, was nothing more or less than a dildo," John said of the unique footwear.[108]

In addition to the high-heeled-shoe photos, John began exploring bondage photography while living in Sydney. Like the shoe photographs, bondage images were popular among collectors. His early attempts, though unsophisticated, show the roots of his later brilliance. The care John took in his drawing and design work translated readily to bondage, and he would later become well known for his complex and beautiful ropework—a skill no doubt honed at sea, where he learned to tie all manner of knots. As with his other photography, John often took bondage photographs so he could later draw from the images, and he would continue to draw from his 1930s reference photographs for decades.

During this period, John's pen pal in Chicago introduced him to the drawings of French artist Carlo, a mysterious figure who illustrated many books for the fetish-based Parisian publishing house Select Bibliotheque in the 1930s. John was highly influenced by Carlo, a man who also appreciated bondage, sadomasochism, and pony girls (women as ponies were a specific interest of John's, often populating his artwork and stories). John would create a least one human pony sketch that was a direct copy of Carlo's work, and the general impact on his style is undeniable.

"Heavens what an ingenious bird he is," John wrote approvingly of Carlo's drawings.[109]

Although John would continue to work aboard ships and as a laborer, Achilles was successful enough to provide him with a regular income. For the first time, he realized that his talents and interests were financially viable. He was also beginning to earn a small

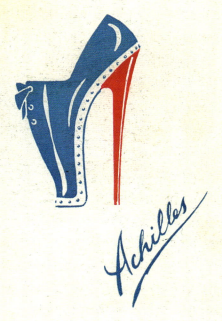

▲ An advertisement for Achilles

international reputation for his shoes, artwork, and photography. His mailing list was growing, and each new name represented a new potential subscriber for his planned magazine. By 1939, he was preparing to launch the magazine he had already been planning for at least three years.

Ironically, John may have been emboldened by a national campaign against pornographic material that gained traction in the late 1930s. In an effort to slow the spread of sex-based media, the Australian federal government announced a ban on the import of risqué magazines in mid-1938.

Sydney-based tabloid *Smith's Weekly* reported that one of the banned magazines (whose name was left unprinted "so that psychopaths may not be tempted to buy [it]") was "a British publication which caters exclusively to the nastiest sort of pervert—he or she who is interested in fetishes. Letters from readers and many sly advertisements are concerned with high-heeled shoes, tight-laced corsets, high-legged boots, torture by whips, and other aberrations which are appalling even to the psychiatrist."[110]

Though *London Life* was not mentioned by name, fans of the magazine would immediately recognize the description. John no doubt recognized that if fetish magazines could no longer be imported to Australia, Australians would need to satisfy their needs domestically. In August 1939, he registered a new business in Sydney: the Bizarre Publishing Company.[111]

Fate wasn't on John's side; 1939 was not a good time to start working on a publishing venture, and it wasn't a good time for glamorous high-heeled shoes, either. War had broken out in Europe and rumbled across the world. It was clear that Australian soldiers would soon be joining their British allies. By 1940, many viewed high heels as unpatriotic due to the leather and wood required to construct the shoes, which could instead go toward the war effort. Australia, England, and the United States introduced clothing rationing during the war; America restricted the manufacture of high-heeled shoes in 1943, limiting heel height to 2 ⅝ inches and reducing the size of platforms.[112]

"The reduction in these platforms alone, it is estimated, will save a foot of leather in each or more than 15,000,000 pairs of shoes," the US government reported in an official statement on shoe rationing.[113]

Achilles had a devoted customer base, but John knew it was time to close up his shoe business for the duration of the war.

As a consequence of the wartime wood shortages, paper also became difficult to acquire, leaving John without the necessary materials to start his magazine. In a whirlwind of just one year, he had watched his business rise and then crumble to nothing before his eyes. It was the first time he faced such a hardship, but it wouldn't be the last.

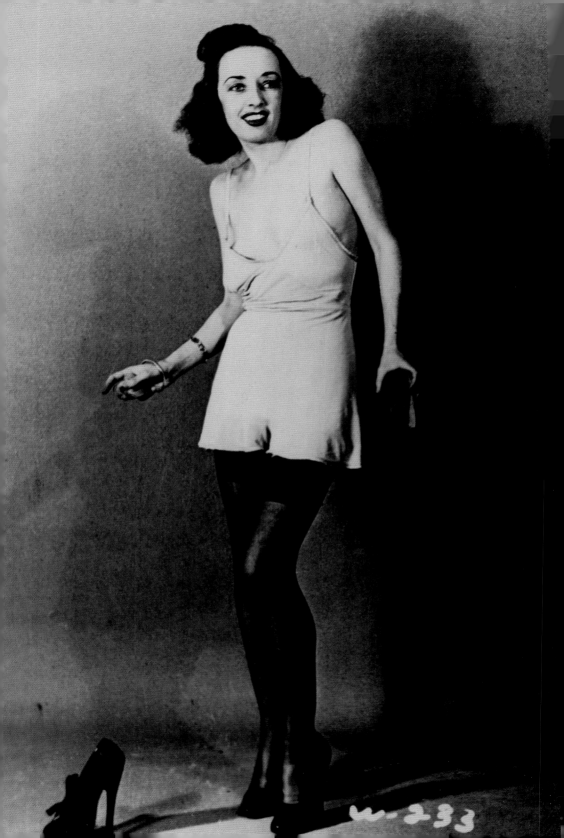

Chapter 5

Holly

❖ ❖ ❖

Holly Faram: a slip of a woman; a ghost; a dream; a fantasy in leather, satin, lace, or nothing at all. Holly was a Kings Cross native, a professional model, and the second wife of John Coutts. Holly, it seemed, was the beginning of something new.

They ran in the same circles. John couldn't have worked his way through a crowded party, grabbed a cup of coffee at the Arabian, or even wandered tipsy through the streets of the Cross for long without catching sight of her: slender, striking, dark haired and blue eyed, with a certain elegant way of holding her trim body. Holly looked beautiful in an evening gown or wool trousers, a tight skirt or a monogrammed sweater. Holly was free as a bird.

When they met in the mid-1930s, the attraction was undeniable. They were poor and talented and lived their lives at the confluence of art and sexuality. In work and in play, they were two sides of the same unconventional coin.

"My wife this time seemed to be definitely interested in being tied up," John later said.[114]

This, as it turns out, was an understatement. The feelings John had felt all his life made sense to Holly; she felt them too. She understood his childhood fantasy of fairy-tale princesses tied to trees. She understood the erotic appeal of stockings and garters and high-heeled shoes.

She modeled for hundreds of his photographs, many of which would later be immortalized in his fetish magazine, *Bizarre*. It was Holly in chains in a white satin dress; Holly in a sheer slip; Holly in a knitted bathing suit with cutouts at the waist; Holly in a black lace veil, rummaging through her purse. It was Holly tied to a chair

◀ Holly Faram, circa late 1930s

or a bed or a tree; Holly nude in thigh-high boots; Holly walking up stairs, climbing over a fence, flashing her stockings and high-heeled boots in a phone booth or out the window of a shiny black car. There was Holly at the pier, Holly by a fountain; Holly in the country and the city and the suburbs; Holly in daylight and Holly at night.

For the rest of his life, John would draw women who looked, if not exactly like Holly, at least like one of her peers: hair and makeup frozen in the style of the 1930s, a lithe body with high breasts and long legs, elegantly clad in expensive-looking lingerie or fantasy costumes, patiently bound and waiting.

Holly Anna Faram was born in Sydney in 1912 to John James and Grace Helena Faram.[115] She spent most of her life in a four-room terrace house on McElhone Street in Woolloomooloo, a working-class neighborhood adjacent to Kings Cross.

Woolloomooloo was, in the early twentieth century, no easy place to be a young woman. Home to a major shipping and immigration port called Finger Wharf, by the mid-nineteenth century the neighborhood was choked with pubs, brothels, "sly grog" shops (speakeasies), and other cheap entertainment intended to appeal to visiting sailors and low-wage dockworkers.[116] Newspaper accounts from Holly's youth detail suicides, murders, muggings, and assaults throughout the small neighborhood. Holly learned to navigate the narrow streets with ease, developing a headstrong independence and a taste for excitement informed by the creative world of 1920s Sydney. Against the wishes of her parents, she began modeling nude at the age of sixteen ("on a bearskin rug, God help me," she later said).[117] She was also an accomplished musician, completing the rigorous examinations of the London College of Music, which were held annually in Sydney. She received an associate degree in piano from the institution in 1929.[118]

After completing school, Holly worked for several years as a dental assistant.[119] Like John, she moved to Brisbane in the early 1930s, where she continued to work in the dental field and began modeling professionally for the first time. Before long, her new career brought her back to Sydney.

"Sydney has a much wider field [for models]," Holly explained in a 1938 magazine interview. "Brisbane is nice, but not very big. I had the field almost to myself, really. And they seem to look upon artists' models as some new species of insect."[120]

She wasn't exaggerating. In 1934, the Brisbane *Telegraph* called Holly "our only artist's model," describing her as "striking, wearing absolutely dead black, with the windblown hair dressing she affects, and brilliant lipstick as the only touch of colour."[121]

In Sydney, models were nothing new. The city had long been the hub of the Australian art scene, and when Holly moved back, she was in demand among the

photographers, painters, and sculptors who lived in and around the free-spirited Kings Cross neighborhood. She worked steadily throughout the 1930s, posing for every major Australian artist of the era, including Norman Lindsay, William Dobell, and Julian Ashton. One article referred to her as "the most famous nude model in Australian art, and the original of many a busty, lusty wench in the heyday of Norman Lindsay's watercolors."[122]

One of the best-known and most beloved artists in Australian history, Norman Lindsay was famous for his fantastic images of nude witches and other debauched themes. His style—in turns sexy and fanciful—may have been a particular influence upon John, and Holly would have been the conduit between the two. A lover of history and a self-described pagan, Norman lived on a palatial estate outside Sydney. He was imagined in one newspaper account as "a roaring satyr, delivering a thwack on the quivering flanks of a nude model"[123]—a description that may well have fit John Coutts as his career progressed. (John, who had long railed against the conservative nature of traditional Christianity, listed his own religion as "Pagan" on his application to the Australian military in 1940.)[124] Norman's sexually charged artwork and controversial lifestyle positioned him as a grandfather of sorts to the artists of Sydney's Kings Cross neighborhood, and Holly was part of his wide circle of friends, describing the unconventional artist as "very charming and considerate."[125]

Norman Lindsay wasn't Holly's only supporter. Sculptor Loma Lautour, a headstrong, free-living artist who was once married to Norman's son Raymond, frequently cited Holly as her favorite model. Loma used Holly as a reference for a number of important public art pieces, including a larger-than-life plaster relief to celebrate Australia's 150th anniversary in 1938. The dynamic nude was completed in classic art deco style and appeared on a float in Sydney's sesquicentennial parade.[126] Loma and Holly undoubtedly bonded over their shared independent natures and strong opinions about the female form.

"Interior decorating would become an important art in Australia if architects were not afraid of nude figures," Loma once declared to a Sydney newspaper reporter.[127] She tried to encourage movement in this direction herself by creating mass-produced, affordable lamps and other interior effects featuring nude models. In her personal scrapbook, she notes that many of her commercial pieces were modeled on Holly, including several lamps, a statue of a Balinese dancer, numerous figurines, and at least one decorative mask.[128]

In 1936, Holly and several other models founded the Guild of Artists' Models, a Sydney-based labor union dedicated to improving conditions for nude models.[129] The guild's circle included some famous faces. A fellow member was Rosaleen Norton,[130] an artist and model whose occult-inspired work earned her the nickname "the Witch

of Kings Cross." Rosaleen lived less than half a mile from Holly's home in Woolloomooloo and also modeled for Norman Lindsay. The guild's lawyer, Edwin Deamer Goldie, was the son of writer and local celebrity Dulcie Deamer, who was known as the "Queen of Bohemia" in 1920s Kings Cross. Dulcie's "bohemian" antics included appearing at a 1923 Artists & Models Ball dressed only in a leopard pelt.

The Guild of Artists' Models emerged during the 1930s global economic depression, which saw an increase in union activity across all working sectors, including manual and creative labor. The models' demands were reasonable and basic: an increased minimum wage, heated studios, and a private area to dress.

"COLD JOB POSING IN THE NUDE," one newspaper headline mocked.[131] Julian Ashton, an artist Holly had posed for, testified against the union's demands, arguing that artists could not pay the rates expected by the models.

"The hours of posing would have to be reduced and the models would get less money than ever," he claimed.[132]

A judge agreed, and the models' demands were dismissed.

It was a blow to all Sydney models, particularly during the Depression, but Holly was used to being ridiculed for her work. When she filed a police report about a prowler outside her apartment in 1939, a gossip columnist in Sydney's *Daily News* called it "ironical" that a nude model "whose picture may be seen in Melbourne and Sydney National Galleries" would be concerned about a man peeking through her windows.[133] The joke underscored a common theme in Holly's public life: a lack of understanding around issues of consent and free agency. It was a theme her future husband, John, understood as well.

In the middle of her busy modeling career, Holly met John. Some accounts suggest that the couple met through the *London Life* club that was centered on MacNaught's shoe store; others state that they met while both were living in Brisbane. In any case, the match at first seemed ideal: though she was ten years his junior, they were both creative risk takers, and their aesthetic tastes and lifestyles were in harmony. For John, who was unquestionably talented but had yet to break into the Sydney art scene, Holly's connections would have been a great help. Before meeting Holly, he had been too busy making a living—"swinging a pick and shovel,"[134] as he put it, or working on ships, or hauling rocks, or trying to be a damned police constable—to think about his artwork in any serious way. But now creativity was all around him. He was in love.

John and Holly were soon inseparable. She helped him with his shoe business, modeling for many of the photographs that John took to publicize Achilles and sell to

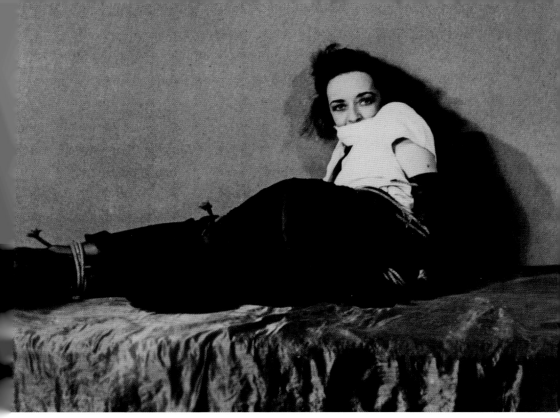

▲ An early bondage photograph of Holly

collectors. Together they haunted the local bars, restaurants, and coffee shops where other artists and models could be found. One of these cafés, Pakie's Club, was a famous destination for Sydney's creative types. Established by Augusta "Pakie" Macdougall in 1929, the club hosted poetry readings, art shows, and monthly "international nights," which highlighted entertainment from around the world. The interior featured brick walls and mismatched furniture brightly painted in a bold rainbow of colors. Pakie's famous guestbook, called the *Book of Words*, includes an autograph from Holly, who signed her name "Holly Coutts (Faram)."

Holly was an active participant in Sydney's art world, and she believed in John's work, giving him a new dose of confidence that helped soothe the pain of his years of poverty and loneliness. John would continue to sell and remix images of Holly—whom he sometimes affectionately referred to in letters as "Fifi"—for decades, and his images of her are among the most enduring of his entire career.

"It is a joy to watch Holly Faram cross a room," wrote one journalist in 1938.[135] It was an assessment that rang true in every photo John took of her.

Neither cared about relationship conventions of the early twentieth century, and they began living together years before they were married. John called Holly his wife as

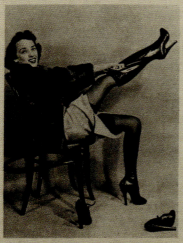

High-Heeled High Boots

EDITOR GAY BOOK:

From the expressions of your readers, there appear to be a large number of high-heel enthusiasts, and I presume they all refer to high-heeled slippers. But for me, give me high-heeled boots that firmly hug the ankle and calf. That is tops in feminine footwear from my point of view.

The accompanying picture illustrates a pair of 18-inch boots with six-inch heels, which were manufactured here in Australia in 1939. Before a fad could develop for them, however, the war broke out and put an end to such lavish use of leather.

I hope to see a return to popularity of this type of footwear after the war.

T. T. S.
Sydney, Australia.

Six-inch heels on 18-inch boots! Made in Australia, they're now a museum-piece. If you want a pair, you'll have to wait till after the war.

◀ Holly models Achilles boots. This letter appeared in *Gay Book* magazine, November 1943.

early as 1940, when, in the face of World War II, he enlisted in the Australian military. (John enlisted at the age of thirty-seven; in a stroke of bad luck, the government increased the enlistment age from thirty-five to forty the year he joined.)[136] He may have listed Holly as his wife to ensure she would receive spousal benefits if he were killed in action, but there is no evidence that he ever saw a battlefield. According to John's Second Australian Imperial Force Personnel Dossier, he was promoted to lieutenant on November 1, 1940, but had his appointment terminated on June 2, 1941, for reason of being "medically unfit."[137] John and Holly married legally in 1942.[138]

For the first time in his life, John felt accepted in a relationship and safe to explore his sexual interests. Both partners enjoyed sadomasochism; he was dominant and she was submissive. Holly delighted in modeling lingerie and high heels for her husband and made her husband feel comfortable wearing them as well.

At times it seemed too simple. When asked later how he broached the topic of his cross-dressing with Holly, John was blunt: "I said, 'Do you mind me dashing around in these high-heeled shoes?' She said no."[139]

For John and Holly, a dominant/submissive sexual dynamic did not translate to day-to-day life. Although John was the family's primary breadwinner, Holly continued to model professionally during their relationship and live life on her own terms.

John also discovered an unexpected downside to a sexually submissive partner. "Later on they start to deliberately create a situation which will annoy you," he said, "so that you will finally lose your temper and belt the backside off of them."[140]

Despite an intense attraction, John and Holly fought often. On one occasion, John lost his temper and hit Holly with his fist, knocking her head into a dresser in their bedroom. It didn't matter if the driving force was alcohol, jealousy, stress, or some combination of the three; John was overcome with shame.

"I tell you, I felt so sorry and miserable," he recalled, the regret still strong in his voice nearly thirty years later. Describing the difference between consensual beatings and physical abuse, he added, "There was a different feeling behind it, when it was a cold bloody wallop. . . . It's completely foreign to me to hit a woman with my fists. It just . . . doesn't exist."[141]

It was clear that John and Holly's relationship, born of love, affection, and creativity, was headed in a dangerous direction. As he had done for much of his life, John found work aboard a ship and left Australia for months at a time. By the mid-1940s, he was clearly preparing to leave Australia permanently. His first stop, in 1945, was Canada. The following year, he was listed as a deck utility on the SS *Sweepstakes*, traveling from Quebec to New York City, where John later indicated he remained until 1948.[142] In January 1948, he was working on board the SS *Onward*, traveling from New York to Sydney by way of New Orleans and Houston.[143] Just four months later, on May 15, John was on a ship to the United States again. This time he was a passenger rather than a crew member, and he had a one-way ticket. His occupation was listed as "Artist"; later this was changed to "Commercial Artist" on the rolls. He also stated that he was married, although his marriage to Holly was effectively over.[144]

The separation was healthier for both of them. Holly continued to model professionally, appearing nude in popular Australian pinup magazines throughout World War II.[145] There is no indication that she wished to join her husband in America, though the pair never legally divorced. Holly remained in Sydney for the rest of her life and, for most of that time, even remained at the same address on McElhone Street. After retiring from modeling, she worked in a cake shop, as an egg inspector, and finally as a waitress at the Arabian Coffee Shop, a popular Kings Cross destination for artists and models. Holly, who said she smoked ninety cigarettes a day,[146] may have been attracted by a "Help Wanted" advertisement for the Arabian from 1947: "WAITRESS, good wages . . . Cigarettes supplied."[147]

In April 1950, Holly appeared on the cover of the third issue of *People* magazine (a popular Australian publication with no relation to the American magazine of the same name). The cover story was an interview, sharing her experiences as a "pioneering nude model" for some of the best-known Australian artists of the previous two decades. Her name was misspelled as "Holly Farram," and advertisements for the forthcoming issue—alongside a glamorous photo of Holly—appeared in newspapers across Australia in the weeks leading up to the magazine's debut.

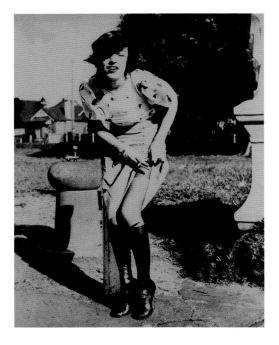

The article emphasized Holly's free spirit, still very much in evidence years after her exit from the modeling profession. "Her 'because I felt like it' is more than sufficient explanation for any act, from getting married to planning a world cruise," *People* reported. For those curious about her marital status, the magazine added:

> There are many mysteries in her life story, most of them secrets. Her Brisbane marriage to artist John Coutts is a half-secret. Holly dismisses it with a flick of her neatly manicured fingers, the long pointed nails of which are painted darkest red. "Of course we are still married, only he is in New York at present," she says.[148]

Following Holly's appearance in the national magazine, little is known of her activities. She gave birth to a son around 1950[149] and is believed to have continued employment at the Arabian Coffee Shop—perhaps as late as 1981, when a locally produced book about Kings Cross stated, "Well known in the Cross as waitress at the Arabian, Holly was also, according to many, the best artist's model."[150] James John Faram, Holly's father, died by suicide on August 19, 1951.[151] Her mother, Helena, died in 1960. Holly herself lived until August 25, 1983; she is buried in Sydney.[152] Although she chose to spend her lifetime in Australia, she became a cult icon the world over for her startling beauty and grace, captured in timeless images by her husband during their happiest days together.

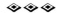

▲ Holly shows off her boots and stockings.

Chapter 6

Introducing *Bizarre*

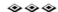

John began his transition away from Sydney in the mid-1940s. It is not clear why he chose to leave when he did, but in all likelihood his time in Australia had simply reached a natural end. Arguments with other members of the *London Life* club hadn't helped his social life, and his relationship with Holly was dissolving. Even *London Life* magazine no longer brought the joy it once had; it was now under new ownership and ceased to offer fetish content in 1941.[153]

John also may have felt that New York offered greater artistic opportunities than Sydney. The social climate of Australia had become increasingly conservative since his arrival nearly twenty years earlier, and sexually charged artwork was not well understood. John had seen obscenity charges leveled against Norman Lindsay in the 1930s, when Norman's novel *Redheap* was banned by Australian authorities.[154] John had also seen a six-month prison sentence handed down to Rob Hillier, the owner of a popular Sydney photo studio who had photographed Holly on numerous occasions for pinup magazines. Rob was caught in a police sting in the 1940s and convicted of possessing obscene photographs "depict[ing] scenes of soldiers with women."[155] It hit close to home. Unfortunately for John, midcentury American artists were plagued with the same problems as their Australian counterparts—though he wouldn't know it until later.

John first arrived in New York City in 1946 via Montreal, Canada, where he lived for a short time while sorting out immigration issues. In New York he frequented the Greenwich Village and Times Square neighborhoods, ultimately settling into an office at 30 Church Street in Manhattan, just steps from the site of what would later become the World Trade Center. Looking around his new city, John must have been struck by the openness of the town. Postwar Times Square was already attracting the burlesque theaters, risqué bookstores, and other adult entertainment that would make its name synonymous with sleaze several decades later. Greenwich Village was home to artists

and freethinkers, which contributed to an atmosphere not unlike Sydney's Kings Cross neighborhood. A world of possibilities presented itself in New York, and John would find that—for a time, at least—his work was understood and appreciated there.

After a decade of planning and dreaming, the fetish magazine that John had wanted to publish since at least 1936 finally came to fruition when he reached North America. He called the digest-sized publication *Bizarre*. He knew what he wanted the magazine to be: a place for sexual outsiders like himself to feel at home. He also hoped *Bizarre* would provide a steady income that would allow him to quit his day job and work exclusively as an artist.

Focusing on his artwork more seriously also inspired John to adopt a new name: John Willie. It may have been a crass sexual joke ("willie" being a British slang term for a penis), or it may have been a nickname acquired in childhood. Regardless of origin, the new name gave him the freedom to create his own brand of sexually charged work from behind a curtain of semianonymity. He would sign his artwork this way (or simply as "JW") for the rest of his life.

It was no accident that *Bizarre* appeared just after World War II. The end of the war meant a newly booming economy and an end to wartime rationing. Paper, a scarce commodity during the war, was again available for printing magazines. Silk stockings could be had again, as well as popular fetishwear materials such as leather and rubber. Men and women who had been separated by the war were reunited, exploring their sexual interests in their own homes.

Bizarre magazine featured photographs, artwork, short stories, editorials, and a correspondence section dedicated to topics such as bondage, female domination, cross-dressing, and human ponies, as well as a variety of fetishistic follies: high heels, corsets, long hair, bloomers, tattoos, piercings, and more. Though heavily inspired by *London Life*, *Bizarre* pushed the envelope still further, ensuring that every article and image had a connection to the unusual or fetishistic. The wide range of topics had one common origin: somebody, somewhere, derived sexual pleasure from the subject. For those who couldn't see the sexual subtext, the magazine might seem very odd indeed.

"We give preference to any subject not covered by other publications," John explained in issue 4. "This fact may help those who are still puzzled about us (if they'll just take the trouble to think)."[156]

This type of carefully coded language was standard for *Bizarre*. To avoid the attention of authorities, John often dismissed the fetishistic content of *Bizarre* as a collection of harmless "fads and fancies," situating the magazine as one that explored

▶ This image was taken in Australia and represents some of John's earliest bondage photography.

unusual fashions rather than sexual pleasures (the phrase "fads and fancies," often used in *Bizarre* and seen in letters from readers, was itself borrowed from the title of a regular column in *London Life*).

"Where does a complete circle begin or end? And doesn't fashion move in a circle?"[157] John wrote in defense of fetishized garments that fell outside the current fashion mode, such as Victorian corsets or high-button boots.

Many issues contained a faux "public service announcement" featuring photographs of scantily clad, bound women with the caption "Don't let this happen to you! Learn jiu-jitsu and the art of self defense"—the caption obviously meant to undermine the sexual intent of the photos. Even *Bizarre*'s title was a coded synonym for the fetishistic, later used and reused by competing publications hoping to capitalize on the success of John's magazine and appeal to readers with uncommon sexual interests. Like *London Life* before it, it was possible to publish *Bizarre* only by hiding the sexual nature of the publication. Readers who were "in the know" easily saw through the thinly veiled material.

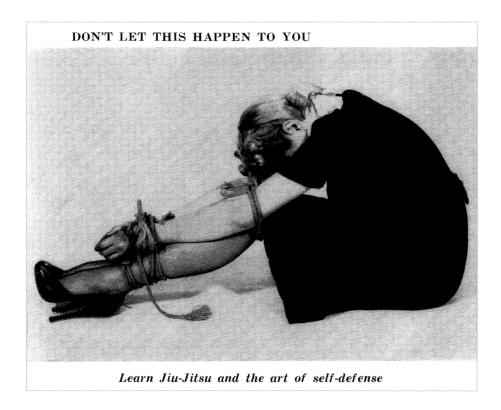

Though small in size, *Bizarre* was an enormous undertaking for its creator. For much of the magazine's run, John was the sole writer, artist, editor, and owner of the publication. In the early years, before he could afford to hire a secretary, he mailed issues to subscribers, answered letters, and handled administrative tasks as well as creative and aesthetic ones.

"I did my own distribution, selling direct to bookstores," John stated. "Stores were most chary about taking the magazine. At the start they didn't think it would sell. But in a very short time they were asking for more, or when the next issue was coming out, and they found it selling extremely well."[158]

Because he was working within a small profit margin, it was necessary at first to proceed as a one-man operation. But John's total artistic control over *Bizarre* also contributed to the magazine's success. His singular vision struck a chord with readers and ensured that the magazine would become a cultural touchstone in the fetish community.

John introduced *Bizarre* magazine to the world with issue 2, printed in December 1945[159] and released in January 1946 while he was living in Canada. Issue 1 did not appear until 1954. John's decision to release issue 1 out of sequence stemmed from his desire for *Bizarre* to have the sort of popular correspondence section so critical to the success of *London Life* and its forerunners. By releasing issue 2 first, he could seed the pot with letters from imaginary readers commenting on a nonexistent premiere issue, thereby encouraging further letters from readers—and perhaps requests for a copy of the "back issue," complete with payment to help fund its publication.[160]

It appears that readers did request copies of issue 1, but John initially resisted. "No copies of No. 1 are available—but a reprint of that issue will be made when paper becomes more plentiful," he promised in issue 4. "Only a few copies of No. 2 and No. 3 are left."[161]

In writing the first letters for *Bizarre*'s correspondence section, John made sure to include references to a variety of interests in order to capture as wide a readership as possible.

"I am glad to see that you include tattooing in your fashions," wrote "Needle,"[162] while a letter from "XYZ" noted approvingly that the first issue "devoted considerable space to fascinating high-heeled shoes. I think the photos were wonderful."[163]

As John put it, "I made #1 sound such a bloody hot number, I hoped that everybody would write in and order it, and with that I would have sufficient money to publish the damned magazine. However, unfortunately, they did not come in as I hoped."[164]

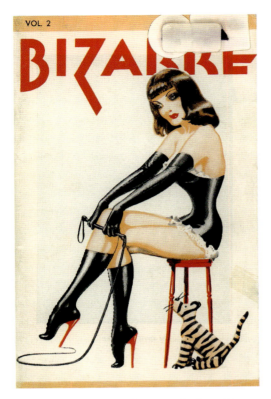

◀ The cover of *Bizarre*'s premiere issue

Although John did write the first letters for the magazine, he vehemently denied writing later letters. "We do not follow the practice of some publications whose 'Letters to the Editor' are actually written by members of the staff," he wrote in issue 6. "That is a dull occupation for dreary people."[165]

There is reason to believe he was telling the truth. *Bizarre* had a wide readership. Many fetishists in mid-twentieth-century America lived in isolation, uncertain how to find similarly minded people in their communities. Magazines such as *Bizarre* offered the best opportunity for sexual outsiders to reach and communicate with one another, and they served a function similar to that of internet communities today.

John's exasperated, repeated admonitions to readers about their letters also suggests that the letters were authentic. "Please don't say[,] 'I'll send photos if you like,'" he wrote in issue 3. "We DO like."[166]

A decade later, John was still singing the same tune. "In the future we are hoping to publish a regular monthly issue, and the more letters and photos you send in for publication[,] the better each issue will be," he wrote in a letter to his mailing list in early 1956. "Don't waste time in asking 'would you like this or that'—just go right ahead and send it in."[167]

In *Bizarre* 17, John went so far as to publish a two-page reproduction of clippings from what appear to be dozens of readers' letters. "After seeing these pages we're damn sure no one will be dumb enough to claim that we own several hundred typewriters and can change our handwriting in so many different ways,"[168] he wrote, attempting to put to rest any further argument about the validity of the correspondence.

In addition to letters, the debut issue of *Bizarre* was filled with photographs—almost all of which were taken by John himself and feature his wife, Holly. He selected his images carefully, primarily choosing photographs that obscured her face, either

for privacy or to disguise the fact that the magazine featured just one model. The images catered to a range of interests: Holly climbing over a fence in a tight skirt, Holly kicking her knee-high-boot-clad legs out of an open car window, Holly bending over in trousers. Perhaps as a triumphant response to the anti-bondage attitude of *London Life*, the very first photograph in the magazine is captioned "The Spirit of Fashion" and features a ghostly image of Holly, almost completely obscured except for her chained wrists and translucent black gown. The articles in this issue primarily referred to the most popular fetishes of the day, corsets and high heels, but a teaser for issue 3 promised two of John's personal interests: more bound women and a "strange tale from the sea of an island where there are no horses, and the young girls are used in their place as human ponies."[169]

Full of fetishistic photographs, drawings, stories, and reader correspondence, *Bizarre* seems at first glance to be in a class of its own in post–World War II America. Though unquestionably one of the most influential fetish publications in history—and the first known to be published in America—*Bizarre* was not an anomaly. There was, of course, the internationally popular *London Life*, which John first viewed at MacNaught's shoe store in Sydney more than a decade before *Bizarre*'s first issue went to press. But even *London Life* was not the first fetish magazine.

For much of the nineteenth century, innocuously titled publications such as *Englishwoman's Domestic Magazine*, *The Family Doctor*, and *The Queen* featured popular correspondence sections where men and women openly discussed sexual fetishes, including corsetry, tightlacing, and flagellation. *Englishwoman's Domestic Magazine*, the earliest of these magazines, was established by husband-and-wife team Samuel and Isabella Beeton in 1852. Isabella Beeton would go on to write *Mrs. Beeton's Book of Household*

▶ The Family Doctor, 1888

Management, a bestselling cookbook and domestic management guide that has been reprinted dozens of times since its introduction over 150 years ago.

Englishwoman's Domestic Magazine catered initially to middle-class women, publishing household hints, fiction, sewing patterns, and fashion advice. In time, the magazine attracted the attention both of men and women thanks to its popular correspondence section, "Conversazione," which published lively letters from across England. As years passed, Conversazione became increasingly dominated by fetish correspondence.

Using nicknames such as "Pretty Boots" and "Tight Shoes," readers were emboldened to write frankly about their sexual desires. "Straight Back," a man who enjoyed corsets and women's boots, wrote that he found "no difficulty having corsets made to my own measure in London," adding, "I prefer, as a rule, to go to a shop where the business is conducted by lady assistants, as I find them much more obliging than male assistants generally are. . . . From my own observation and inquiries I find the practice of corset wearing by young gentlemen is becoming much more usual, but we don't make any display of the fact." As for whether it was "effeminate" to wear women's boots, "Straight Back" was unequivocal: "Effeminacy does not reside in the boots, but in the ideas and thoughts. I do not see that it is any more unmanly for a gentleman to wear boots of the kind usually made for ladies than it is unwomanly for a lady to wear an Ulster coat or a paletot."[170]

Not all readers appreciated the sexual tone of the letters, which could appear at odds with the rest of the magazine's domestic and fashion-based content. When the magazine's editors refused to publish a letter about extreme tightlacing of corsets, reader "Fanny" stated that the decision "has the sympathy of all your right-minded subscribers, and great will be the relief of all but a minority not worth mentioning to hear no more of such tortures."

The "minority not worth mentioning" strongly disagreed. Corset fan "C.H." argued, "From my own observation I know that the circulation of the *Englishwoman's Domestic Magazine* has been largely increased by the introduction of the Corset Correspondence; and on account of it your Magazine has been anxiously expected every month. . . . [I] join with many others in hoping that such an interesting letter may be given in your next number."[172]

Englishwoman's Domestic Magazine folded in 1879, but the tradition of fetish correspondence in popular magazines carried on. By the 1910s, *Photo Bits* magazine (later retitled *Bits of Fun*, a direct precursor to *London Life*) was publishing reader correspondence on a wide range of fetish topics, including high heels, female domination, and the perennially popular corset. It is somewhat ironic that John started *Bizarre* only after moving to North America, since it was his home country of England that

Miss Spaceship

Milkmaid

introduced and sustained this tradition of published fetish correspondence in the English-speaking world.

In terms of global reach, *London Life* was by far the most successful of the pre–World War II fetish correspondence magazines. At the height of its popularity, the correspondence section claimed a large swath of the magazine's pages and gave voice to a wide range of erotic expression. Many readers wrote to the magazine regularly, creating a sense of community among sexual outsiders in countries as far reaching as England, Australia, India, and the United States. Like many fetishists of his era, John was an avid reader of the magazine and considered himself part of the community that developed around it. But just as John knew he could build a better high-heeled shoe than the "clumsy" prototypes developed by his friends in Sydney, he knew he could create a fetish magazine even better than *London Life*. And when *London Life* eliminated its correspondence section in 1941, leaving countless fetishists without the community they had come to know and love, the stage was set for *Bizarre*.

Although fetish correspondence was the primary draw for many readers, the artwork, articles, and serialized stories in *Bizarre* also added to the magazine's appeal. John's unique drawings and paintings illustrated the magazine from the first page to the last. The covers, which were usually printed in color, were visually impactful and helped the magazine stand out on crowded newsstands. Despite John's lack of professional training in the arts, his undeniable talent and clarity of vision made it easy for readers to lose themselves in the fantasy world of *Bizarre*.

At the center of this fantasy world were women: tall, slender, elegant, and frequently perched atop ultra high heels. Some wore corsets; some were bound with rope; some were blindfolded and gagged. Although the proportions of his models are exaggerated, John's careful attention to detail meant that fetishized items such as ropes, gags, shoes, and boots were always drawn

◀ John's fashion designs ranged from traditional to futuristic.

realistically. John's interest in fetishism crystallized in the 1930s, and this is apparent in the clothing, hairstyles, and makeup he drew even in the 1950s. At the same time, his lifelong interest in the future of fashion gives the artwork a uniquely progressive quality that sets it apart from more traditional pinup art of the era.

As a writer, John took on various identities in the early issues of *Bizarre* to present the appearance of a full staff: Achilles, who wrote about shoe production; Falstaff, who wrote historical stories of "Merrie England"; John Willie, the staff artist; and, of course, the exhausted "Editor," who responded to letters and kept the whole publication running. John opened each issue with a different quote from his favorite book of poetry, the *Rubaiyat of Omar Khayyam*, an unusual decision for a fetish magazine and one that underscores John's idiosyncratic approach to his work. He also used his new publication as a means of publishing his own fetish comic strip, *Sir D'Arcy D'Arcy*.

The first episode of *Sir D'Arcy D'Arcy* appeared in *Bizarre* number 3.[173] The main character of the comic strip is the blonde, innocent, and curvaceous Sweet Gwendoline, who wishes to save her father's home from the clutches of the devilish landowner Sir D'Arcy, who has threatened to foreclose upon the property unless Gwendoline will marry him. Sir D'Arcy and his cruel sidekick, the mysterious Countess, kidnap Gwendoline and tie her up in a dungeon to prevent her from earning the money to pay her father's mortgage.

Thin plot thus established, *Sir D'Arcy D'Arcy* subsequently appeared in issues 4 and 5 of *Bizarre*, after which it would develop a life of its own in various forms. The beautiful Gwendoline is subject to creative methods of torture and interesting bondage ties and is assisted in her escape attempts by a sexy stranger, Secret Agent U-69.

Sir D'Arcy D'Arcy was an important element of the early issues of *Bizarre* and helped establish John's reputation as an excellent illustrator of bondage and beautiful women. John later admitted that the character of D'Arcy, a scoundrel with a pointed mustache, was based on himself.[174] The dark haired, pale-eyed Countess also bears more than a passing resemblance to Holly, and some panels were clearly based on photographs John had taken of her.

Although the comic developed a dedicated cult following, reader response to *Sir D'Arcy D'Arcy* was initially mixed, lending further credence to the argument that the letters in *Bizarre* were authentic.

"I have a hunch I'm going to have a new favorite comic strip, and also a new favorite comic strip character—the latter being the exotic-looking Countess," wrote "S.W."[175]

"Personally, I would rather see the space devoted to D'Arcy used for more correspondence, or other illustrations of readers' fads and fashions," opined another reader.[176]

"More letters and less Sir D'Arcy would please me greatly," added "Gauron."[177]

Despite the tepid early response, John loved the comic strip—often more than he enjoyed working on *Bizarre* itself.

"You know I love that cartoon," he wrote near the end of his life. "It was the only thing that made life worthwhile."[178]

Indeed, *Sir D'Arcy D'Arcy* and the character of Sweet Gwendoline would follow John to the end of his life, serving as a constant source of inspiration and delight for its creator and its fans. Many bondage fans would later recall with great affection discovering Sweet Gwendoline for the first time, a far cry from the early opinions of readers. The lovely but naive Gwendoline would go on to become one of the most beloved characters in the history of bondage art.

Adding *Sir D'Arcy D'Arcy* to the pages of *Bizarre* meant an even heavier workload for John, who both drew and inked his own comics. Although he had ambitiously advertised that *Bizarre* would be released monthly, he quickly realized that a monthly publication for which he was the sole writer, artist, editor, and publisher was a difficult and expensive proposition.

"New readers will notice that we no longer guarantee a regular monthly publication," John wrote in issue 3, only the second issue of the magazine. "We are of course trying to do so[,] but that's all we can say. If you take out an 'annual subscription' you take this chance: You will certainly get your 12 consecutive volumes but When (with a capital W) . . . is in the lap of the Gods."[179]

The year 1946 saw a total of four issues of *Bizarre*. The final issue of the year, 5, was a "Correspondence Digest" devoted entirely to letters from readers and interspersed with the usual fetish photographs and artwork (both by John and, in the style of *London Life*, movie star and "straight" model photos suggestive of fetishistic themes). This issue also featured two full episodes of *Sir D'Arcy D'Arcy*. Although it is again possible that some of the letters were invented by the editor, it is likely that the majority were not—a testament to the great popularity of the very young publication.

Unfortunately, popularity did not guarantee early success for *Bizarre*. John was undeniably an artist, not a businessman. In a theme that would repeat itself throughout his life, his insistence upon high-quality work and his unfamiliarity with the business side of the fetish world left him in a prime position to be cheated by those with less talent and more financial prowess. His letters from the editor at the beginning of each issue frequently center on such troubles as postwar paper shortages and dishonest distributors who refused to pay him as promised.

"Maybe it would have been better to wait until paper supplies, etc. became normal," John reflected in issue 3. "Maybe we should have done this and that, but we didn't."[180]

John held on as long as he could, but the road ahead was uncertain. At the end of 1946, following issue 5, the magazine went dormant until 1951.

INTRODUCING BIZARRE | 65

ATTENTION !

Paper is still scarce – and so the supply of copies is limited.

Become an ANNUAL SUBSCRIBER and thus be sure of your copy of "BIZARRE" each month.

The Subscription for 12 monthly issues is $3.00 in Canada. Everywhere else the equivalent of $3.00 U.S.A. POST FREE.

To ORDER. Cut Out and Mail the COUPON below.

"BIZARRE"
P.O. Box 162, Montreal, Canada

I enclose $3.00 as subscription for 12 issues whenever they may be published.

Name...

Address...

...

NOTE: We do our best but owing to the uncertainty of the supply of paper etc., we do not guarantee to publish regularly each month. Subscriptions are for 12 consecutive issues.

Copyrighted 1946 by Bizarre Pub. Co.

▲ Post–World War II paper shortages affected the printing of *Bizarre*, as evidenced by this advertisement from issue 4.

Chapter 7
Pinups on Parade

In 1947, with finances exhausted, John again took a job on a ship to make money. In a personal letter to an acquaintance in June of that year, he stated that he had also gone to sea between the release of *Bizarre* issues 2, 3, and 4 to fund the publication of each issue. "It's all very annoying and makes the publishing business rather awkward," he wrote. "The only difference between me & Randolph Hearst is that he goes away on a yacht with his typist & I go & sweat my guts out as an AB [able seaman] on a dirty old cargo ship. Such is life."[181]

Although *Bizarre* lay fallow, John remained busy in New York. For a man who loved beer almost as much as he loved women, the discovery of a laid-back local bar—Chumley's, in Greenwich Village—was a delight. It became his favorite haunt in New York. Chumley's, which closed in 2020, had been a popular hangout for generations of artists and writers, including e.e. cummings, John Dos Passos, and Edna St. Vincent Millay. According to one account, John was once kicked out of the bar for "playing the ukulele too loud."[182]

It was likely at Chumley's that John met Richard Bagley, a writer and cinematographer who shared John's taste for alcohol. Richard would eventually cast John in a short film called *Within a Story* (1955). In the film, John flexes his acting skills by playing a maniacally religious building superintendent[183] (no small challenge for a man who, both in his private and professional lives, passionately opposed Christianity at every opportunity).

The following year, Richard Bagley was involved in the filming of the award-winning docudrama *On the Bowery* (1956), about down-and-out alcoholic men living in the Bowery district of New York City. John noted that while *On the Bowery* was an international success, *Within a Story* passed through the art theater circuit without fanfare—"otherwise I might be making fat money."[184]

John also became an ardent Brooklyn Dodgers fan while living in New York, even making a successful suggestion to Dodgers general manager Branch Rickey in the summer of 1950.[185] As an alternative to a pitching machine, John encouraged the Dodgers to try using a "cricket cradle" at practice. A cricket cradle is a device built with wooden slats and shaped like a boat or a hammock and is traditionally used when practicing the British game of cricket.

"The idea is to have players throw baseballs into the cradle and retrieve them as they bounce crazily off the wooden slats," explained one newspaper account of the Dodgers' new practice tool.[186]

The cradle was unfamiliar to Americans, but Branch Rickey was known for his innovative ideas and willingness to try new things. In 1945, he helped to break Major League Baseball's "color barrier" when he signed Jackie Robinson, a Black man, to the Dodgers' previously all-white roster. Although some major league teams remained segregated until 1959, the Dodgers' decision to racially integrate inspired many other teams to follow suit. Branch was also known for more modest ideas, such as encouraging the use of (then uncommon) batting helmets. The cricket cradle seemed simple enough of an idea to try, and he ultimately purchased several for the Dodgers to use during practice sessions. Although the cradle never caught on among baseball players, the *Brooklyn Eagle* interviewed John about the innovation over a few pints of beer. John claimed he first saw American baseball when he was working as a seaman in New Guinea during World War II.

"What attracted you to the Dodgers?" the interviewer asked.

"I can't say," John replied. "It might be, you know, that shocking nickname some people have pinned on 'em—the Bums. Something in common and all that sort of bally rot."[187]

New York City wasn't all beer and baseball. John also began to make professional contacts with colleagues in his fields of art and publishing, aided by introductions from his longtime pen pal in Chicago, who was himself a photographer with close ties to the New York fetish community. It was through his Chicago contact that John met and befriended Charles Guyette, a pioneering fetish purveyor and stylist for whom John had long expressed his admiration. The two men had much in common: they were the same age, both had experience as seamen, and in the 1930s, Charles sold unique European-influenced bondage and fetish photographs through mail order and also ran a shoe business similar to Achilles.[188] John had, in fact, been a fan of Charles since his days is Australia, learning of him first through the pages of *London Life*. Charles frequently purchased advertising space in the magazine to promote his mail-order business.

"Before the war his photos . . . were known all over the world," John wrote, adding that Charles was "the only source, as far as I know, of ultra high heels in the USA."[189]

Charles, who had served a federal prison term for obscenity in 1935, no longer distributed photographic materials and artwork but continued to be a major force in the mid-twentieth-century fetish community. He opened a business selling burlesque costumes, eventually acquiring the moniker "the G-String King." During the 1940s, Charles also worked as a consultant for pinup magazine mogul Robert Harrison, sourcing fetish boots and costumes for photoshoots.[190] It was in this capacity that Charles would have the most direct professional impact on John.

Unlike John, Robert Harrison was a businessman who understood how to make money in the magazine world. Brash and forceful, he built an empire on lurid gossip and boldly illustrated stories of sex and crime. Perhaps best known for his controversial magazine *Confidential*, which published extremely personal stories about Hollywood's top actors and actresses, Robert was also the brains behind the most popular wartime pinup magazines in America.

In the early 1940s, Robert was fired from his job at Quigley Publishing Company for using work contacts to secure pinup model photos, which he planned to use in a magazine of his own creation. After his dismissal from Quigley, Robert's two sisters and his niece raised money to fund his first venture, *Beauty Parade*. The magazine, which featured jokes, lightweight articles, and photographs of beautiful women in skimpy clothing, was an immediate hit. Three more magazines—*Eyeful*, *Titter*, and *Wink*—soon followed, all using the same winning formula. In 1946 he launched *Whisper*, which added true crime stories into the mix.[191]

All of Robert's magazines were popular, but they truly began to take shape when he hired Edythe Farrell to join his team as a lead editor. Edythe was a shrewd businesswoman with an eye for lucrative content in the magazine world. And she had strong,

▶ *Flirt* magazine, a Robert Harrison publication

◀ A 1942 issue of *National Police Gazette*, published during Edythe Farrell's tenure as editor

relevant experience: in 1938, at just twenty-five years old, she was hired as editor of *National Police Gazette*, a tabloid-style men's magazine looking for a fresh direction.

Established in 1847, *National Police Gazette* was beginning to show its age when Edythe took the helm. The publication peaked in popularity at the turn of the twentieth century under the direction of its most famous editor, the eccentric Richard K. Fox. He filled the magazine with content designed to appeal to white, working-class bachelors: lurid crime stories, illustrations of buxom women, and coverage of every sport from the expected (baseball) to the bizarre (wrestling on horseback). The back of the magazine featured advertisements that sold the good life to freewheeling men, offering gambling paraphernalia, grooming products, mail-order treatments for hair loss, and more. "Manhood restored," promised one early ad, and "PARTS ENLARGED."[192]

The audacious approach worked, and it set the mold for all tabloid journalism to follow. Were other newspapers publishing salacious stories? *Police Gazette* would make them naughtier—and publish them on pink paper, just for good measure. Did a competitor write about a popular boxer? *Police Gazette* would publish an illustration of the reigning champ stripped to the waist, then offer a cash prize to anyone who could beat him. Throughout the late nineteenth and early twentieth centuries, the magazine's pink pages could be seen in the hands of men in every barber shop in America. It was such an important cultural touchstone of the Victorian era that by 1932, when Mae West played bawdy nineteenth-century dance hall girl Diamond Lil in *She Done Him Wrong*, the troublemaking Lil lounges in bed with a copy of *National Police Gazette*.

In the late 1930s, after nearly a century in print, *Police Gazette* limped along with a circulation of 40,000 (down from a peak of over half a million in the 1890s).[193] The

magazine still featured risqué content, and Edythe knew better than to disrupt a formula. But she also knew that what passed for sexy in 1900 looked very different in 1938. She needed something new and daring to capture the attention of a younger generation who thought *Police Gazette* was something their grandfather read.

One perennial element of the magazine had been introduced by Richard K. Fox himself: female wrestlers. Edythe kept this theme going. Wrestling women, with their unkempt hair and contorted bodies, were always popular with men. Female wrestlers also happened to be of particular interest to Charles Guyette. According to biographer Richard Pérez Seves, the fetish purveyor regularly submitted his own photographs to *Police Gazette*, eventually developing a working relationship with Edythe. Legend has it that when a photo Charles submitted of a woman in tall boots caught Edythe's eye, she published it on the cover of the magazine—a decision that proved enormously popular.[194] Fetish material thereafter became a regular feature in the magazine.

"My theory is that sex and crime are ageless and styleless," Edythe explained. "Men like 'em both straight."[195]

National Police Gazette would never regain the popularity of its heyday, but under Edythe's sure-handed leadership it grew at a pace that shocked both detractors and supporters. From its nadir of 40,000, the magazine's circulation soared to 200,000.[196] Soon Edythe herself appeared in newspapers and magazines nationwide, interviewed by other journalists who praised the young editor's writing, business acumen, and "well-molded figure."[197]

The 5-foot, 3-inch Edythe was "very small, very feminine, and very competent," according to one article from 1941.[198]

"She could talk like a certified intellectual and swear like a fish-wife," another journalist wrote approvingly.[199]

Even Hollywood took note. One of the top-grossing films of 1943, Betty Grable's *Sweet Rosie O'Grady*, featured *Police Gazette* and its iconic pink cover as a central plot theme.

Edythe's work with *Police Gazette* also caught the eye of pinup magazine publisher Robert Harrison. The magazine was undoubtedly an influence on Robert's own work, and he was impressed by Edythe's proven ability to increase readership. He brought her on board with Harrison Publications in 1944 to work her magic on his own stable of magazines, and she brought her secret weapon, Charles Guyette, with her.

Robert was plainly disinterested in bondage, high heels, and sadomasochism, but he agreed to include these themes in his magazines because of their undeniable popularity. Edythe also denied a personal interest in fetish material, stating that she simply published the photographs because they had "appeal" for a section of the population.[200]

Edythe had studied psychology as a student at Hunter College and understood fetish culture better than many of her contemporaries.[201] She was also aware of the editorial benefit of fetish materials: while it was illegal to publish images of graphic nudity or sex in magazines, there were no laws against high heels, corsets, bound women, or whips and chains. It was a simple way to provide a sexual thrill for a magazine's target audience while maintaining a thin veneer of innocence. And it worked: like *National Police Gazette* before, Robert's magazines rose steadily in popularity under Edythe's editorial eye.

Charles Guyette was happy to have steady work that he enjoyed at Harrison Publications, but with multiple monthly magazines to fill with sexually charged content, he couldn't possibly keep pace alone. He brought friends on board to help, one of whom was John Coutts.

John was also grateful for the work. Working for the pinup magazines gave him an insider's perspective on larger-scale magazine operations. It also provided a steady paycheck for something other than manual labor. By the time John joined Robert's team in 1947, the pinup magazines were becoming suspiciously similar to *Bizarre* itself, with photographs of women in dominant or submissive poses, corsets, and high boots in regular rotation.

Robert Harrison's initial interest in John's work stemmed from *Sir D'Arcy D'Arcy*, *Bizarre*'s in-house comic strip. Robert had read the comic, recognized John's talent, and suspected that the buxom lead character of Sweet Gwendoline would be a hit with readers. The strip was renamed *Sweet Gwendoline*, and Gwendoline's overtly sexual friend, Secret Agent U-69, was renamed U-89. The comic began appearing as a bimonthly feature in *Wink* magazine in June 1947. At the same time, Robert's *Flirt* magazine published another of John's comics, *Diary of a French Maid*.

John became a fixture around Robert's office, even providing his services as a model for several feature stories. (Robert admitted that he often used his office workers—and himself!—as amateur models in the magazines "so I could save the $10-an-hour model's fee.")[202] In one article about spanking published in the June 1949 issue of *Flirt*, the dominant John went distinctly against type.

"Many gal entertainers insist that women should spank their men when they need it," read the caption of a photo of John bent over the knee of a stern glamour girl in a satin halter top. "Do YOU agree with them?"[203]

In addition to his comics and modeling, John contributed drawings to the pages of Robert's magazine, providing suggestive illustrations to short letters that purported to be from readers. With letters about long hair, spanking, corsets, and high heels, much of the content would not have been out of place in John's own *Bizarre* magazine—and indeed, some of the illustrations he drew for Harrison publications later served as inspiration for images that appeared in *Bizarre*.

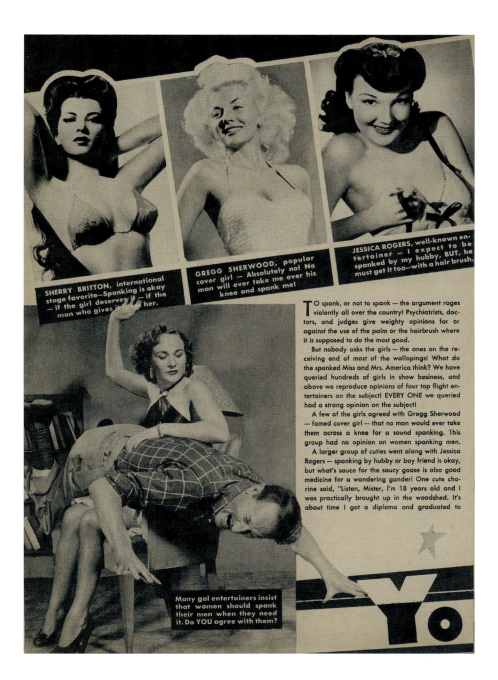

John models for *Flirt* magazine.

Working for Robert Harrison brought in much-needed money for John during the interim period of 1947 to 1951, when *Bizarre* was not in print. It also allowed him to continue working on and being paid for a project he found extremely personally fulfilling, the comic *Sweet Gwendoline*. But John was a man accustomed to doing things his own way, and working for Robert wasn't always easy. Robert could be slow to pay his artists, something John complained about to his friends. Additionally, like many other fetish purveyors of the day, Robert simply didn't care about the material he was producing; he only cared that it sold magazines. Unlike Robert and Edythe, Charles and John both privately enjoyed the same themes they explored publicly.

This is not to say that John was disinterested in money. He once said, "They want pictures of a woman wearing knee boots with buttons—all right, if I can provide that picture of knee boots and buttons, I'll make a few bucks. That is all that concerns me—not the reason for the fetish, but that it exists at all."[204]

So why should it matter if the producer of fetish artwork is personally a fetishist? The enduring power of images by John Willie and Charles Guyette lies in their personal investment in the subject matter. The careful posing, deliberate staging, and attention to detail all combine to create work of a higher caliber than most of their contemporaries. John often spoke disdainfully of bondage photographs and films where models were tied so ineffectively that they could easily step out of their bonds and escape ("Illustrations you saw in books . . . they were all so bad," he said).[205] The compelling part of John's fantasy work lies in its very realism: they were scenes that *could* be re-created with the right materials and the right participants. By contrast, many of his contemporaries drew scenes that could exist only in fantasy—a woman suspended at an improbable angle over a dungeon of spikes, perhaps, or limbs bent at impossible angles.

The differences aren't obvious just to the modern-day viewer. John himself was keenly aware of his own abilities.

"The only difference between [my work] and anything else around the place was that the bondage was well drawn," he said. "I suppose I'm a perfectionist."[206]

John's fans drew a distinction between his work and that of Robert Harrison too. As one bondage fan wrote in 1977, "Some of my first recollections of pinups are from the early girly magazines, *Titter* [and] *Wink* . . . and, although they had attractive girls and 6[-]inch heels, black stockings and other desirable apparel, they invariably showed a model whose stockings sagged and wrinkled, while she leaned back to avoid standing in shoes much too large for her." By contrast, in John's work, "models were never allowed to appear in wrinkled or torn stockings, clothing which ill-fitted them, or shoes or boots which were obviously too large."[207]

For Robert Harrison, a lack of interest in the fetish subcultures he featured in his magazines also meant that he was unwilling to dive beneath the surface when it came

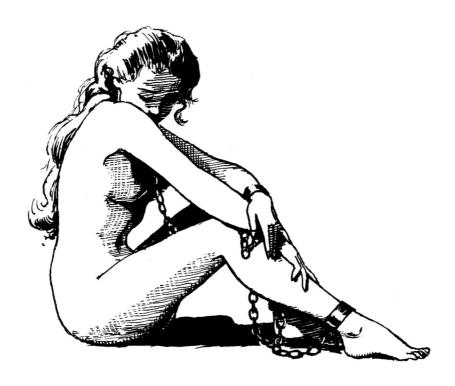

to explorations of sexuality or power dynamics. John's genuine interest lent an air of authenticity to *Bizarre* that was (and remains) absent from most monetized depictions of sexuality. While *Bizarre* included more "extreme" fetishes such as pony play or amputees, *Wink*, *Titter*, and the other magazines in the Harrison stable stuck strictly to the top players: bondage, high heels, corsets, and light domination and submission. While the pinup magazines included sections for readers' letters, many of these letters appear to have been written by the magazine's staff, and correspondence was not encouraged as it was in *Bizarre* or its predecessors. *Bizarre* sometimes published entire correspondence issues filled with long, passionately written letters submitted by readers. By contrast, the letters to Harrison publications were short, allowing for little more than a declaration of love for spanking, long hair, or boots before moving on.

Much to John's displeasure, Robert's lack of nuance spilled over into his editing of artwork. *Sweet Gwendoline* was presented in short, serialized segments, and Robert required each strip's artwork to prominently feature the title character in bondage.

"Drawing for Harrison, I had to have Gwendoline in a tough spot in every single issue," John explained in an interview shortly before his death.

I had no time for any other picture . . . that hadn't got Sweet Gwendoline in it. The various humorous incidents in it about Sir D'Arcy . . . the thing was[,] I couldn't do that stuff for Harrison because it wasn't Gwendoline, but to me that was the most delightful part of the whole bloody cartoon that I'd ever done. . . . Anybody can go along and see these pictures of damsels in distress and so on, but there's no humor to it and there's nothing in it.[208]

In 1950, John's relationship with the Harrison enterprise ended. The last issue featuring *Sweet Gwendoline* appeared in February of that year, cutting the serial off midstory. Early that same year, mail-order fetish purveyor Irving Klaw wrote that the United States Postal Service had forced Robert Harrison to drop *Sweet Gwendoline* from *Wink* due to the bondage content, "under threat of revoking their second-class [mailing] permit."[209]

A second-class mailing permit allows commercial publications such as magazines and newspapers to be mailed at a cheaper rate. According to the Classification Act of 1879, a periodical needed to meet certain stipulations to qualify for a second-class permit; among other requirements, the publication "must be originated and published for the dissemination of information of a public character, or devoted to literature, the sciences, arts or some special industry."[210] Paired with other long-standing laws against sending obscene materials through the mail, this statute placed the postal service in a powerful position. Revocation of second-class mailing permits was a common tactic employed by postal authorities to destroy businesses accused of mailing risqué or otherwise controversial periodicals, including some socialist and anarchist publications.[211] Sending magazines first class was so expensive as to be financially unsustainable, and most business owners would do anything in their power to keep their second-class status. The status could be revoked even before a business was able to defend itself against obscenity charges in court.

Many popular titles faced revocation of their mailing permits as a form of censorship and control in the 1940s. *Esquire* magazine temporarily lost its permit in 1944 thanks to the revealing pinup paintings of artist Alberto Vargas.[212] *National Police Gazette* had lost its second-class mailing permit in 1942 "on ground that it was given over to 'leg art' and lewd language";[213] under Edythe Farrell's editorial leadership, the magazine survived and had its permit reinstated one year later.

The largest magazines could afford to fight the post office, but for most periodicals, the loss of a second-class mailing permit was a death sentence. If *Sweet Gwendoline* would require *Wink* to be mailed first class, then *Sweet Gwendoline* had to go. For all the reasons outlined above, John may have felt a sense of relief. Finally, he could return to drawing Gwendoline the way he wanted to, not in a manner that best fit a mainstream men's magazine.

CHAPTER 8
Sweet Gwendoline

John often spoke of *Sweet Gwendoline* with great fondness. The comic strip permitted him to draw, which he preferred to photography, and also allowed him to explore classic narrative storytelling ("The old-fashioned melodrama has always amused me immensely and delighted me," he explained in an interview).[214] Although *Bizarre* magazine can only be described as a labor of love, it was heavy on labor: writing, editing, taking photographs, drawing, creating a layout, handling distribution, and responding to direct mail orders. By contrast, *Sweet Gwendoline* must have felt like an opportunity to return to his artistic roots.

Regarding the origins of *Sweet Gwendoline*, John said:

> Now, to me, the sight of a woman tied up is always sexually intriguing. My own particular urge was to rescue her. I don't know why it made me sexually excited. I didn't want to go and rape her. I wanted to rescue her. And I knew that a lot of people . . . liked pictures of bondage as a result of reading *London Life*. And so the simplest way I felt I could produce these pictures, in keeping with the laws of the land in regards to obscenity and so forth, was producing an old-fashioned cartoon, and that was that. That was the way *Sweet Gwendoline* started.[215]

John was exceedingly protective of the comic strip, often referring to it as "clean sexy fun," "nonsense," and even "pure 'corn.'" To its creator, *Sweet Gwendoline* was not meant to be pornographic; instead, it represented sexy yet silly fun. It is true that Gwendoline never found herself in real danger in the early comics, but John did revel in drawing realistic bondage scenarios for his lead character. The plotlines harkened back to the days of the Victorian melodrama, but the bondage and sexuality present in the strip restricted its sale and readership to an adult audience.

The idea of comics for adults extends back to the beginning of the medium. In the early twentieth century, many adults read popular newspaper strips such as *The Yellow Kid* and *Krazy Kat*. The 1930s saw the advent of "Tijuana bibles" or "eight pagers," which were sexually explicit comics that often featured movie stars, sports heroes, or popular mainstream comic strip characters engaging in all manner of sex acts. Blondie and Dagwood, Dick Tracy, Betty Boop, Mae West, James Cagney, Lou Gehrig, even Mohandas Gandhi(!)—whether real or fictional, no celebrity of the decade was safe from the enterprising pencil of the (always anonymous) Tijuana bible artist. Often poorly drawn and frequently riddled with misspellings, the little books were nonetheless incredibly popular. Produced for pennies, they sold for anywhere from ten cents to several dollars.

Like all graphic sexual depictions, Tijuana bibles were not legal to sell on newsstands during their heyday but had a voracious audience on the black market. They became a central focus of anti-obscenity efforts, with emphasis placed on the fact that the comic format was especially appealing to children.

Courtney Ryley Cooper, a former circus performer turned crime writer and personal friend of FBI head J. Edgar Hoover, summed up Tijuana bibles in his 1939 book *Designs in Scarlet*:

> The pattern usually runs the same, merely with different characters. The cover carries a drawing which can easily be recognized as that of a well-known person in athletics or entertainment. To insure [sic] recognition, the name is printed in large letters, together with a filthy caption.... These "cartoons" [depict] widely known persons, running about naked together, and indulging in every form of perversion known to Krafft-Ebing.[216]

◀ A Tijuana bible featuring a caricature of popular 1930s film star Joan Blondell

As the Great Depression came to a close, Tijuana bibles waned in popularity. Some continued to be printed throughout the 1940s and into the 1950s, but the availability of much higher-quality erotic materials eventually contributed to the medium's demise. They are now viewed as collectors' items and prized as works of folk art, a turn few of their creators might have envisioned.

The pornographic comics also left an interesting legacy. "Though nobody has been eager to bring it up before, the Tijuana Bibles were the very first real comic books in America to do more than merely reprint old newspaper strips, predating by five or ten years the format we've now come to think of as comics," artist Art Spiegelman wrote in an analysis of the books.[217]

They also opened the door for other comics with a sexual slant, including *Sweet Gwendoline*. The quality of the artwork in *Sweet Gwendoline* far surpasses anything created in the Tijuana bibles, and the story arc has far more in common with damsel-in-distress tales such as the 1920s comic strip *Hairbreadth Harry* or the early film serial *The Perils of Pauline*. But with its heavy bondage content and figure-conscious drawing style, *Sweet Gwendoline* might still be called a cousin of the early Tijuana bibles.

Though he published *Bizarre* sporadically, John worked on *Sweet Gwendoline* consistently. He had been required to continue drawing the strip while working for Robert Harrison, but he was also happy for the excuse to continue working on something he cared about. With *Bizarre* on hiatus and his relationship with the Harrison magazine empire at an end, John hoped he had found an additional stream of income when he licensed the comic strip to distributor Irving Klaw.

In mid-twentieth-century America, Irving Klaw was the reigning king of the mail-order fetish world. Born in Brooklyn in 1910, Irving and his younger sister, Paula, opened a used book store in Manhattan in 1938. When they acquired a box of movie star photographs, they quickly discovered that photos were more lucrative than used books. The name of the store was eventually changed to Irving Klaw Pin-Up Photos (and later, Movie Star News), and it dealt primarily in film stills, portraits of actors and actresses, and cheesecake photographs of popular models. The Klaws began selling their merchandise through mail-order catalogs, first titled *Movie Star News* and, later, *Cartoon and Model Parade*.

Like their contemporaries Robert Harrison and Edythe Farrell, the Klaws became aware of a growing public interest in bondage and fetish photography following World War II. Their greatest influence in this area was a wealthy fetishist named "Little John," who would introduce them to the world of erotic bondage in 1947.

Little John was a friend of John Coutts; the pair met through John's bondage and fetish social circle in New York, which included Charles Guyette, and Little John would introduce John to Irving Klaw later in 1947. Little John was a longtime customer of

the Klaws, frequently purchasing film stills from popular adventure movies featuring actresses bound and gagged.[218] Emboldened by the fact that Irving sold these soft-bondage images, Little John requested a commissioned bondage photo shoot from the Klaws. Irving agreed, and Little John showed Irving and Paula the finer points of his preferred type of bondage—how to tie knots, what sort of garments the models should wear, and what type of facial expressions were most effective in a bondage scene. Irving tested out the sale of these images in his *Movie Star News* catalog alongside fetish photos focused on high heels, corsets, long hair, and "dominant female poses." Once the Klaws began offering bondage and fetish photo sets, business would never be the same.

"We thought of it as one big joke," Paula told an interviewer in 1980. "Then it really took off."[219]

Although they continued to sell straight movie star photos, the bulk of the Klaws' business was soon devoted to mail-order bondage photos. In addition to Little John, Irving and Paula invited other bondage fans from the local community to join their photo shoots; after paying a fee to the Klaws, the men would supply costumes and tie the models in their own preferred style, resulting in a wide range of creative bondage images.[220] Many of the photos were taken by Paula, who also helped bind and pose the models and even occasionally modeled herself when a scheduled girl failed to show. "I'd put on a little mask," Paula explained.[221]

John found serious fault with Irving's practice of allowing customers to participate in his photo shoots. John, who valued privacy and control in his own work, described the concept of Irving's open studio as "bloody awful." Irving had invited John to attend one of these crowded photo shoots to assist with posing a model, but John refused. In a later interview, he explained his reasons:

> A friend of mine that was down at one of these sessions, he said, well, God almighty . . . a lot of these blokes down there sitting with their hands in their

pockets, feeling their balls, getting an awful kick, and they'd tie this bloody girl up in some way, they hadn't tied a girl up before in their lives and didn't know what to do . . . they would stand up there in the corner and more or less jerk themselves off in their excitement while [the photo shoot] was going on, and well, candidly, to me it was absolutely disgusting.[222]

This interpretation of the bondage shoots, which John admitted he heard second-hand, might be slightly exaggerated. However, Paula Klaw herself confessed that in these early photoshoots, "the photographers would sometimes get suggestive with the girls" (she was quick to add, "Irving always stopped that fast").[223] The concept of allowing "fans" to enter the photo studio at all stood in stark contrast to John's own working style and contributed to his later distrust and dislike of Irving. The practice would last only a few short years; after Little John's death in the mid-1950s, Irving and Paula no longer allowed customers to attend their photo shoots.

The Klaws' most popular pinup and bondage model was Bettie Page, who was *Playboy* magazine's Playmate of the Month in January 1955 and is said to have appeared on more magazine covers than any other woman of the 1950s. With her sweet smile, trademark bangs, and emotive style, Bettie was and remains America's most beloved fetish model. She even appeared on the cover of *Bizarre* 14 in 1954, although the photo was sourced elsewhere rather than taken by John (Bettie and John both denied ever meeting each other).

Irving Klaw was well known for offering high-quality products. He was notoriously meticulous about models' attire and often featured complex ropework in his bondage images rather than the ineffective bonds seen elsewhere. But like many of the most financially successful fetish purveyors, Irving and Paula Klaw were not personally interested in fetish material. Irving was a businessman first and was quick to recognize what people wanted and how best to monetize their desires. He was constantly on watch for new models, photographers, and artists to expand his stock, and when Little John introduced him to John Willie in 1947, it didn't take long for him to recognize the financial possibilities of the latter's work.

Advertisements for *Sweet Gwendoline* first appear in Irving's *Movie Star News* issue 29, released in 1949. "Attention John Willie Fans," the ad begins, indicating John's name recognition by this point in his career. Irving offered thirteen episodes of *Sweet Gwendoline*, reproduced on glossy photographic paper.[224] The following year, advertisements for the comic appeared in Irving's mail-order newsletter, the *Irving Klaw Bulletin*. The newsletter functioned as a sort of "best of" collection of material from the catalog, and in early 1950 Irving devoted half a page of advertising space to John's artwork—no small amount of real estate in a newsletter that ran only

four pages.[225] By June 1950, the newsletter had grown to six pages, and Irving offered twenty-two episodes of *Sweet Gwendoline*.[226] Another issue of the *Bulletin* dedicated an entire page to John's comic strip.[227] One thing is clear: *Sweet Gwendoline* was earning money for the Klaws.

The success of *Sweet Gwendoline* inspired Irving to license additional work from John. Irving's *Cartoon and Model Parade* catalog advertised sets of photographs taken by John (though not always credited as such). One collection, not attributed to John but advertised as "taken in Australia," features some of his earliest known photographic work.

As with many of his other professional relationships, John quickly became disenchanted with Irving ("I just didn't like the man and I didn't want to be associated with him in any way," John stated).[228] One issue, as mentioned previously, was John's distaste for Irving's habit of allowing fans to tie up models. But financial matters were an even greater problem. Irving notoriously discouraged communication between artists who worked for him, likely to prevent them from discussing their paychecks or sharing leads on other avenues of work. Artists worked as independent contractors, and Irving could not forbid them from picking up work with rival mail-order houses. He did, however, do all in his power to keep them from learning about other opportunities in the first place.[229]

Many of Irving's artists were young men, recent art school graduates who were excited to be paid any amount of money for their work.[230] John was in his forties and was actively working toward his own independent business as an artist and publisher. He wasn't interested in using his talent solely to contribute to Irving's bottom line.

Irving viewed John as unreliable, and he didn't appreciate rebellion. He pushed for additional episodes of *Sweet Gwendoline* but received nothing beyond issue 22.

"John Willie has left town and is supposedly at sea and has not turned in any work for over three months now," Irving wrote coldly to sex researcher Dr. Alfred Kinsey in early 1950. "[He has] not writte[n] or gotten in touch with me about future work."[231]

Finances were an obvious bone of contention, but for John, the greatest insult may have been Irving's censorship of his work. Irving believed he knew how far he could push the line of decency when sending sexy material through the mail, and some of the photographs he licensed from John went too far. In one photograph of Holly, her cardigan sweater has slipped from her shoulder, revealing one bare breast. Before the photograph could be sold, a net bra was drawn over the offending body part; for

◀ Irving Klaw's top model, Bettie Page, on the cover of *Bizarre* issue 14

◀ A censored panel from *The New Adventures of Sweet Gwendoline*

good measure, a gag was also drawn over her mouth. Changes like these were understood to be necessary and sometimes had their own charm. Some were even made by John himself, who always tried to make his hand-drawn additions as delicate and inconspicuous as possible (many of John's efforts in this area are so carefully rendered as to be almost undetectable). Then came tragedy: Irving insisted on censoring one of John's most beautiful comic series, *Gwendoline and the Missing Princess*.

Gwendoline and the Missing Princess is different from any of John's other known work. Although it features his beloved Gwendoline character, *The Missing Princess* has none of Sir D'Arcy's dastardly deeds and none of the silly jokes between Gwendoline and U-69. Instead the reader finds full nudity, lash marks from whips, and scene after scene of extreme bondage. Though far more sexually explicit than John's other published work, it is also some of his most carefully crafted work, rendered beautifully in gouache.

When John first published *The Missing Princess* in 1951, he sold it through his mailing list in serialized form. When he felt he had made all the money out of it that he could, he sold the entire series outright to Irving.

Irving knew immediately that he could never sell *The Missing Princess* in its original form. John himself had taken an enormous risk sending copies through the mail, but this risk was mitigated by the fact that he sold to a very select group of customers who had already purchased material in the past. For a distributor of Irving's scale to send such

sexually explicit material through the mail would certainly have ended in arrest. John had not advertised beyond a letter to his subscribers, and he didn't dare include images. Irving's audience expected images in his advertising, so in his eyes there was only one thing to do.

Irving put one of his best artists, Eric Stanton, on the job. Eric would go on to become a legend of the 1960s fetish art world, specializing in female domination. He respected John deeply and admitted that his own earliest fetish work had been an attempt at imitating John's style.[232] Eric had seen John in Irving's studio but, as usual, had not been permitted to speak to him. Now he had before him John's carefully crafted original work, along with one directive: change it.

Irving demanded that Eric paint clothing on the characters in *The Missing Princess*, remove whip marks, and otherwise make the work suitable for sending through the mail. What's more, Irving insisted that the only way to do it was to paint directly on the original artwork. Eric was horrified.

Wasn't there another way? A simple sheet of clear acetate, such as that used by animators, could be used to trace and edit the work without permanently changing the originals, and Eric offered this solution to Irving. Irving rejected it flatly as too much extra work. After all, time is money! So Eric, against his own best judgment, set to work painting over the twenty-five paintings that composed *The Missing Princess*. Irving sold a published version of the censored story through his catalog under the title *The New Adventures of Sweet Gwendoline*.

Although John normally licensed his work to Irving, *The Missing Princess* was sold with no strings attached. John, it seems, had a complicated relationship with the work, despite the obvious care taken in its creation. It originated from John's need for money and the demand from his fans for more explicit Gwendoline content. But selling material of this nature through the mail was an incredibly risky and stressful proposition, with the potential for major consequences. From Rob Hillier in Sydney to Charles Guyette in New York, John knew the kind of jail sentences that were handed down around the world for selling sexually oriented work. By selling *The Missing Princess* outright, he washed his hands of the whole affair and left any consequences for its sale at Irving's doorstep.

It also marked the end of John's association with Irving. John had made an honest effort at contract work, but his personal disagreements with Irving and the censorship of his work ultimately became too burdensome to bear. It was time to focus on his own goals once more.

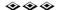

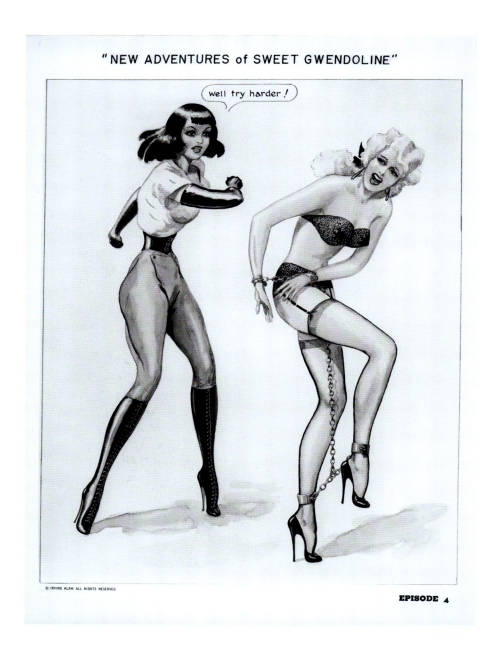

▲ Gwendoline's panties and bra were a later addition by Eric Stanton.

CHAPTER 9
"Obscene and Immoral": Alfred Kinsey

John didn't know it yet, but his fan base was growing in interesting ways.

In 1949, Dr. Alfred Kinsey wrote a letter to Irving Klaw. "I have been negligent about getting copies of your 'Sweet Gwendoline' series by John Willie," Dr. Kinsey wrote. "Will you please send me everything that is available, and that has been published in this series. Please bill me personally."[233]

Dr. Kinsey was midcentury America's preeminent sex researcher and a household name, thanks in large part to the publication of his groundbreaking 1948 book *Sexual Behavior in the Human Male*. The companion tome, *Sexual Behavior in the Human Female*, was published in 1953; together, the two books became known as the Kinsey Reports.

The Kinsey Reports featured data gathered from thousands of interviews with ordinary Americans who offered candid details about their sexual histories. The resulting statistics revealed an American sexual landscape far different from what had previously been assumed. Among other discoveries, Dr. Kinsey and his colleagues learned that 85 percent of men and 50 percent of women had engaged in premarital sex,[234] 50 percent of men and 40 percent of women had engaged in extramarital sex,[235] and 37 percent of men and 13 percent of women had experienced homosexual contact.[236] Dr. Kinsey's research suggested that these activities were relatively common—certainly more common than many readers expected. It also demonstrated a diversity of sexual experience that shocked the nation. The books were instant bestsellers, and Dr. Kinsey became an overnight international celebrity.

The Kinsey Reports weren't just popular; they were controversial publications that attracted praise and criticism in nearly equal measure. Public debates ensued over the validity of Dr. Kinsey's research and methodology and the truthfulness of his interviewees. When *Sexual Behavior in the Human Female* hit bookstores in 1953, the book was front-page news from coast to coast.[237] Before the book was even published, Congressman

Louis B. Heller of New York argued that it should be preemptively banned from the mails on the grounds that it was "contributing... to the depravity of a whole generation, to the loss of faith in human dignity and human decency, to the spread of juvenile delinquency, and to the misunderstanding and confusion about sex."[238] The public disagreed; three weeks prior to publication, the publishers had already received advance orders for 165,000 copies.[239] It was no small feat for an academic text that tipped the scales at over eight hundred pages. Americans were hungry for frank and authoritative information about sex, and Dr. Kinsey was the man to provide it.

Born in Hoboken, New Jersey, in 1894, Alfred Kinsey wasn't always a sex researcher. He started his career as a biologist, tirelessly collecting, measuring, studying, and writing about his primary interest, gall wasps.[240] It was in part through his study of the mating practices of insects and animals that he began to develop an interest in the variety of human sexual experience. He taught zoology and botany at Harvard University and eventually joined the faculty of Indiana University in Bloomington, Indiana, where he spent the remainder of his career.

Dr. Kinsey focused his research on gall wasps for more than twenty years, and his original research met with accolades from the scientific community. But his interest in sexuality continued to grow until it was impossible to ignore. He began speaking out more confidently among his colleagues, and in 1935 he gave a presentation for his fellow faculty members about frank sexual education and the dangers of sexual ignorance.[241] He wasn't alone in his interests. In the 1930s, the students at Indiana University were also campaigning for a course in sexual education, often euphemistically referred to as a "marriage course." Marriage courses were becoming popular additions to college curricula across the country; by 1938, Indiana University's student newspaper, the *Daily Student*, reported more than 250 such classes in universities throughout the United States.[242]

Indiana University would be next. In 1938, Dr. Kinsey began offering a noncredit class called "Marriage and Family" for Indiana University students. The class, which was initially restricted to graduate students and students who were married or in their senior year at school, was intended to offer sex education to the student body. It quickly became one of the most popular classes on campus, enrolling two hundred students during its first semester and 230 students the following semester.[243] Dr. Kinsey interviewed students in the course to create some of his first sexual histories.[244]

"The undergraduate students are wondering why [the marriage course] isn't open to them," the *Daily Student* reported in fall 1938, the first semester the class was offered. "They'd like to know the ropes, too."[245]

"Knowing the ropes" was a difficult proposition in the late 1930s, when information about sexuality was woefully inadequate and misinformation was rampant. Sexually transmitted diseases were on the rise, with statistics suggesting that one in ten people would contract syphilis in their lifetime. Contraction rates for gonorrhea were even worse, with nearly 700,000 new cases reported annually.[246] Organizations such as the American Social Hygiene Association (ASHA) called for commonsense sex education for children, a new and controversial idea in the early twentieth century.

"The time-honored policy has been one of silence and mystery concerning all things sexual," stated the ASHA-published book *Sex-Education*. "Such has been the almost universal attitude of parents until within the present century, when many have awakened to the fact that the policy of silence has been a gigantic failure, because it has not preserved purity and innocence and because it has allowed grave evils, both hygienic and moral, to develop under the cloak of secrecy."[247]

While organized sex education for schoolchildren would not become mainstream for several more decades, college-level courses were an early attempt to lift this "cloak of secrecy" surrounding sexuality.

Despite strong student support and a clear need for accurate, unbiased information about sexual health, Dr. Kinsey's marriage course came under attack from some faculty members, community leaders, and parents. Opponents of the course objected to the explicit content and the professor's attempts to normalize matters such as homosexuality, which at the time was classified as a sexual aberration (in Dr. Kinsey's opinion, "nearly all of the so-called sexual perversions fall within the range of biologic normality").[248] He was forced to resign from his position as head of the Marriage and Family course in the summer of 1940. Though it was a blow to campus life, Dr. Kinsey's work at Indiana University was just beginning.

In 1947, one year after John started *Bizarre*, Dr. Kinsey founded the Institute for Sex Research (now the Kinsey Institute for Research in Sex, Gender, and Reproduction) at Indiana University. In addition to conducting the sexual history interviews that led to the publication of the Kinsey Reports, the institute collected a wide variety of cultural material related to sexuality, including artwork, photographs, magazines, books, and films. The institute and the university at large assumed great risk with their collecting. Much of the material was illegal to possess privately, leading to a later court case that would nearly destroy the institute.

Dr. Kinsey was already familiar with Irving Klaw, thanks to Irving's very popular *Cartoon and Model Parade* mail-order catalog, and the researcher frequently purchased bondage material from Irving for the institute. Indeed, by 1960 the institute had a

standing order with Irving for all of his publications as they were released.[249] When Dr. Kinsey saw John's work, he knew it was something special. The Kinsey Institute would eventually collect every issue of *Bizarre* and each installment of *Sweet Gwendoline* for permanent preservation in its repository. Dr. Paul Gebhard, a founding employee of the institute and coauthor of *Sexual Behavior in the Human Female*, succeeded Dr. Kinsey as the institute's director in 1956. He continued the work Dr. Kinsey had begun on sadomasochistic material, communicating with John through the mail and arranging an interview with him in 1961. The institute also purchased material from John directly, and it became home to much of his artwork at the end of his life.

"To study fetishism and sado-masochism without your data and knowledge is like studying music omitting Beethoven," Dr. Gebhard wrote to John in 1960, adding that the originality of John's work is what compelled the institute to contact him. "To be blunt," he wrote, "if you took away John Willie and Irving Klaw, you would have virtually nothing left in the United States but imitators."[250]

Dr. Gebhard's words were not mere flattery; Dr. Kinsey had also recognized that John's work was a cut above other standard bondage fare. Although the direct communication between Dr. Kinsey and John is limited, Dr. Kinsey frequently wrote to others in the industry inquiring about John's whereabouts or whether he was still producing artwork. John's obvious interest in and commitment to alternative sexual practices made him an important point of contact for Kinsey Institute researchers, who often sought information about how and why fetishism develops.

As to the origins of fetishism, John insisted that he'd "never bothered about the 'why,'"[251] but he made an honest effort to help Dr. Gebhard and his colleagues. The Kinsey Institute respected and championed John's work, and John in turn contributed his own work and knowledge to the institute. As a man concerned with individual rights and freedom of expression, he earnestly

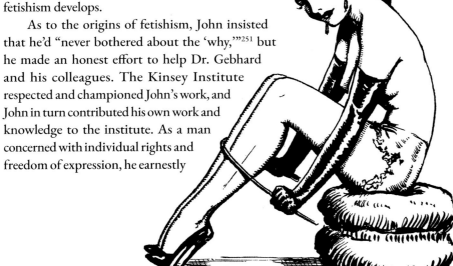

hoped he would be able to assist Dr. Gebhard in his work—but he also knew the hard road that he and many of his colleagues had traveled and the increasingly negative attitudes toward sexuality present in American culture.

"As I said in *Bizarre*—not until people can discuss their likes & dislikes openly & without interference from the laws & the church will we get anywhere," John wrote to Dr. Gebhard. "If you can start a breakthrough of this wall of mass ignorance I'll help all I can—but I don't think much of your chances."[252]

He was preaching to the initiated. The Kinsey Institute had attracted controversy for years and often found itself facing the same "wall of mass ignorance" that so frustrated John. As previously noted, the Kinsey Reports themselves were matters of wide public debate. Some critics cynically suggested that the first book had been a shameless cash grab at the expense of sexual morality—a claim that Dr. Kinsey's wife, Clara McMillen Kinsey, categorically denied. "Every nickel made by *Sexual Behavior in the Human Male* goes to the Institute for Sex Research to be reinvested in further work," she explained in 1948. "[Dr. Kinsey] and his associates do not accept an extra cent, not even for their lectures. They live on their university salaries. If people think we're rich I wish they could take a look at [my husband's] wardrobe. He's only got one decent suit to his name."[253]

The most notable example of controversy at the Kinsey Institute occurred in 1950, when the federal government began seizing multiple shipments of "'obscene and immoral' photographs, books, and statuettes"[254] intended for the institute's archives. Dr. Kinsey had ordered the materials from Europe and Asia to facilitate the study of sexuality on an international scale, but the United States Customs Bureau refused to release the packages, citing an existing federal law against the import of erotic and pornographic materials. Just as creators and distributors of erotic material faced legal consequences for their work, so Dr. Kinsey and his colleagues became targets as a result of their scientific research.

The seizure at customs resulted in a lengthy and expensive court battle for the institute, as well as a wave of negative publicity. On November 17, 1950, an Associated Press story described the battle between customs officials and Dr. Kinsey. "I wouldn't want to describe it over the phone," one customs official stated when pressed for details about the seized material. "It was dirty stuff. I felt there was no need to send this through the mail. There was nothing scientific about it."[255]

The same day the story went to press, Dr. Kinsey attempted to quell the negative remarks with a press release of his own. "The Institute feels that the issue is much broader than that of the importation of a specific object at a given time and place," he wrote. "It considers that the issue is one which concerns all scholars who need

access to so-called obscene materials for scientific investigations which in the long run may contribute to human welfare."[256]

Indiana University also stepped forward to defend the institute, making clear that academic freedom was a priority. University president Herman B. Wells and the university's board of trustees filed an amicus brief on behalf of the institute.

It would take seven years, but the courts ultimately ruled in favor of the institute in 1957, determining that "an object is not legally obscene if the person importing it had a genuine scientific purpose."[257] In handing down his decision, Judge Edmund L. Palmieri also cited the recently settled United States Supreme Court case *Roth v. United States* (1957), which had redefined obscenity as that which appeals to the prurient interest of the average person. The judge determined that since the institute's materials were carefully restrained and made available only to scholars (not "the average person"), importation was not illegal.

For the institute, it was a bittersweet moment. The important legal victory permitted researchers to continue their work unhindered by government oversight, but it came with a terrible price. Dr. Kinsey had died of a heart ailment and pneumonia in August 1956, over a year before the final verdict, broken and exhausted by the legal battle he had been fighting for more than half a decade.[258]

If John Coutts or his fellow artists hoped that Judge Palmieri's decision might loosen the bonds of obscenity legislation, they were mistaken. *Catholic Times*, published in Columbus, Ohio, reminded readers that the decision had only limited precedential strength. The newspaper quoted a stern warning from customs commissioner Ralph Kelly: "Imports of pornographic and obscene materials intended for the general public continue to be illegal and will be seized and destroyed by the Customs Bureau if attempted."[259]

The death of Alfred Kinsey was a blow to the Institute for Sex Research, but under Dr. Gebhard's directorship it continued to flourish. John would work with Dr. Gebhard until the very end of his life, using his final days to advance the institute's research into fetishism and sadomasochism.

CHAPTER 10
Bizarre Returns

After ending his relationships with Robert Harrison and Irving Klaw in the early 1950s, John prepared to embark on his own independent projects. He kept his work a secret. Dr. Kinsey maintained an interest in John and occasionally questioned Irving about his work, much to Irving's annoyance. Perhaps in an effort to put an end to this line of questioning, Irving offered speculative information in a 1950 letter:

> [Episode #22 of] 'Sweet Gwendoline' is the last episode made by John Willie, who, has retired temporarily from art work, presumably, by request of the post-office, although, he doesn't admit it and I'm not sure on this point. He has not drawn anything for Harrison or myself, for quite some time and I presume, he will not do any more drawings for publication, except, occasionally, for private use only.[260]

Irving's prophecy would prove wildly inaccurate. In 1951, using funds from wage labor and sales of *The Missing Princess*, John resumed publication of *Bizarre* magazine with issue 6. *Sweet Gwendoline* appeared again within its pages, reverting to the *Sir D'Arcy D'Arcy* name and introducing a new adventure, *Sir D'Arcy and the Wasp Women*, which would continue in serialized form for two additional issues. On the editor's page, the ever-beleaguered John explained that the delay between issues was the result of dishonest distributors who had not paid him as promised—an already common refrain that would remain an unfortunate hallmark of his career.

"We've taken an awful beating but we're not licked yet," he promised.[261]

With issue 6, the length of the magazine expanded from fifty pages to sixty-eight. By issue 12, John had abandoned the pretense of multiple writers and declared frankly, "*Bizarre* is published by John Willie."[262] In the following issue, and every one he published thereafter, he listed the copyright holder as "John Coutts." Given the subject

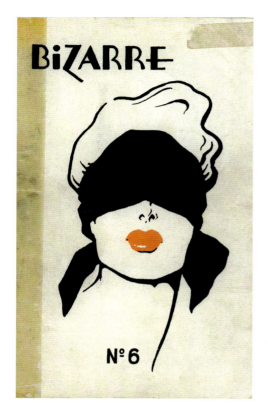

◀ The cover of *Bizarre* issue 6, 1951

matter of the magazine, it was a daring move to use his real name. He may have done so to simplify any claims to copyright; as he discovered almost immediately, piracy was rampant in the adult industry, and his work would be stolen and reprinted without attribution for years.

John published *Bizarre* intermittently from 1951 until July 1956, releasing one to five issues per year. The publication grew in popularity, especially after John mounted a small publicity campaign after issue 8.[263] As a testament to the magazine's success, John was even able to hire a secretary, Nicky, to assist with the administrative side of his work (and occasionally model for photographs).[264] Letters from both men and women poured in. Readers described fetishes, shared photographs, and submitted unusual clippings from *Bizarre* precursors such as *London Life* and *Tit-Bits*.

For many readers, finding *Bizarre* was an experience akin to John's own discovery of *London Life* in Sydney in the mid-1930s. "For a long time I thought I was perhaps rather isolated in my interest in ropes and chains, etc., but your magazine has given me great encouragement," wrote "Don," adding, "It is a great relief to know that I am not alone in my bizarre interests."[265]

"Don" wasn't the only reader who found relief on the pages of *Bizarre*. "Most of us go through life wondering what makes us have the fantasies that bother us, and when expressed, make our associates wonder," wrote "L.M." "If they are lucky a group of like[-]minded people may get together but the vast majority must wait until something like your publication comes along to show them that they are not alone in the world."[266]

For most readers of *Bizarre,* the correspondence section was the most important element of the publication—even more important than photographs and drawings of

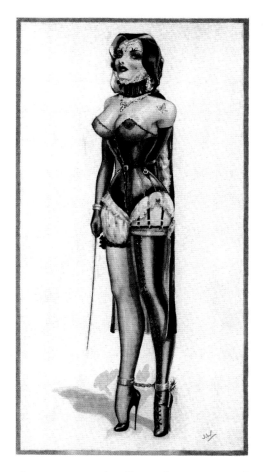

◂ "Miss Bizarre," a drawing that attempts to capture all fetishes popular with readers. John's first published work in *London Life* featured a similar theme.

fetish items. Fetishistic images, though pleasurable to look at, could be found in many places by the mid-1950s. Corseted waists were again in vogue thanks to Christian Dior's "New Look," a haute couture collection that debuted in 1947 and featured nipped-in waists and exaggerated hips and busts. The New Look, with its emphasis on dramatic curves, stood in stark contrast to the more tailored, square-shouldered styles of the 1940s. The New Look would dominate the decade of the 1950s, much to the delight of *Bizarre*'s tiny-waist devotees.

Other fetishized items such as ultra high heels also became easier to find, but the sense of community found on *Bizarre*'s correspondence pages was still rare and special. Readers demanded that more space be allocated to correspondence, and John tried to abide. He discontinued *Sweet Gwendoline* and at least one serialized fiction story to make room for more letters, and a community continued to grow among fans of the magazine.

"Even though I am in my thirties, this is the first time I have been able to avail myself of the sincere, uninhibited thoughts of others regarding leather and bondage," wrote "J. Foster." "So, due to *Bizarre*, I know my hidden desires are not quite as isolated as I had feared."[267]

John tried to support his readers as they gradually came out of their shells and made their feelings known publicly—often for the first time. Some admitted that they had difficulty expressing their sexual feelings even in the privacy of their own homes. In the early years of the magazine, John went so far as to personally respond to some readers who struggled to understand and give voice to their desires.

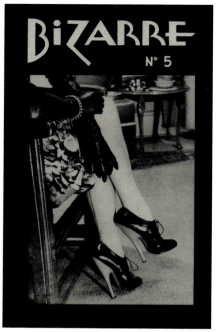
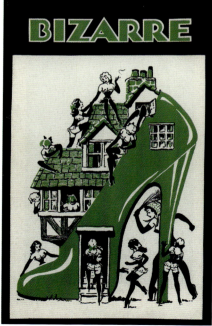
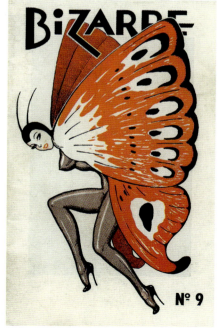

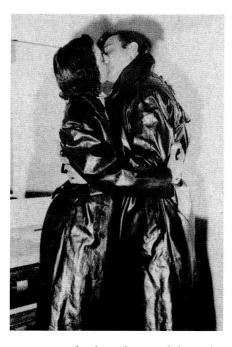

◀◀ Opposite, clockwise from top left: The covers of Bizarre issues 13, 5, 9, and 12

◀ Many Bizarre readers shared their fetishes with loving partners. In this reader-submitted photo, a couple embraces in matching rubber raincoats.

"That was the point that I was trying to make to these fetishists," John stated of his years publishing *Bizarre*. "If they would only come out—they don't want to tell their wives. Goddamnit! I'd write to them, tell them: a man who has secrets from his wife is a damned fool. Tell your wife these things, but get these things out of your system and then they cease to bother you."[268]

John got his own shoe fetishism "out of his system" by wearing women's shoes frequently, noting that his strong sexual response to the shoes decreased through regular wear. With the support of his secretary, he even began wearing high-heeled shoes around *Bizarre*'s office, bringing the spirit of the magazine directly into its day-to-day operations.

"I used to walk all around that bloody office, around my studio, always wearing high-heeled shoes because they're comfortable. And also they're more decorative—the bloody male shoes are pretty heavy damned things," he said, adding later, "I thought, what's the point of preaching this bloody doctrine if I'm not going to wear them?"[269]

The content of *Bizarre* could appear unconventional on the surface, but it was also heteronormative and supportive of married life. The 1950s were a period of unprecedented comfort and growth in the United States, and the postwar baby boom led to the development of suburbs across the country. *Bizarre* celebrated this midcentury domesticity, releasing a special "Home Sweet Home" issue (10) and frequently publishing content about bondage materials for a well-stocked home or novel ways to punish a willing spouse. In issue 3, John drew a selection of sexy costumes to wear around the house, adding that the staff of *Bizarre* had "become champions of the Brighter Home Life Movement. There is no need to have a big party. It isn't even necessary to ask one or two intimate friends—just have one by yourselves."[270]

The magazine also featured photographs and letters from married couples who had discovered a mutual love for "bizarre" topics. "Edna K." wrote of dressing her

HOME SWEET HOME

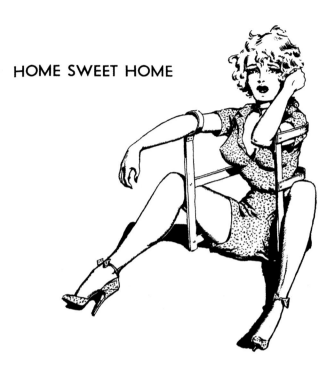

husband in women's clothing, adding, "We lead a harmonious, happy married life and never quarrel. My advice to you girls is—if he likes skirts and aprons, don't feel that there is anything wrong—let him wear them and make him happy!"[271]

Fans of the magazine frequently submitted photographs for publication, often featuring themselves or their domestic partners dressed in fetishwear or posing with copies of *Bizarre* in their own homes. One reader sent amateur photographs of his wife bound and gagged in the woods, along with a letter of explanation.

"Last summer, while on vacation in Maine, my wife and I took a camping trip far into the woods," he wrote. "Of course I took my camera along.... If any of your readers have never experienced a camping trip like ours just remember to take your bondage equipment along next time."[272]

The focus on the domestic was so strong that another reader, "Gauron," commented on it. Noting that most *Bizarre* correspondents were married or had sympathetic family members, he asked, "What are we unmarried people without such obligingly cooperative relatives to do? It makes it tremendously difficult without someone to confide in or share our pleasures with. Suggestions, anyone? . . . What can we do singly? As I see it now the answer is nothing . . . which is rather frustrating to say the least."[273] (To further underscore the point, nobody responded.)

◄ Fantasy costumes for men designed by John ►

Colonel Bloomer **Captain Cincher**

Readers also used *Bizarre*'s correspondence section to hash out gender issues. Men frequently wrote in to describe their interest in wearing traditionally female attire. As a man who enjoyed wearing women's stockings, shoes, and undergarments, John would no doubt be interested to read letters from other men who enjoyed the same.

"I have preferred and worn female underwear as long as I can remember—all the time—though I don't think it's anybody's business but my own," wrote "B.J." "I just happened to like it. When I was a kid, I had a sympathizer—my aunt who raised me, and I told her quite candidly that I would like to wear girls' clothes. She agreed, and I spent the happiest six years of my life living as a girl until I got too masculine to get away with it any longer. In those days, I wore silk bloomers all the time, and never got over wanting to wear them. So, I still do. So there."

"And your friends don't mind and the rest don't matter," John responded in an editorial note.[274]

The most compelling part of *Bizarre*'s letters is their variety. Readers argued with each other (usually good-naturedly) over every aesthetic and philosophical difference. Garter belts or rolled stockings? Dominant women or submissive? Boots or shoes? Besides the perennial favorite corsets and high heels, letters also described less conventional interests. A number of readers described their fascination with older, dominant women. Others expressed a love for bloomers, rubber rainwear, tattoos, or facial piercings. Still others offered (often accurate) predictions for a future where "bizarre" interests were no longer so bizarre.

"The years to come may see the adoption of purple, blue, green or other colors for hair dyes, with effects of strange but real beauty," reader "Raymond" wrote hopefully.[275]

A woman who signed herself "Secretary, Modern Misses Club" described a contest her club held to find the "Super Girl of Tomorrow." Top honors went to "Miss Texas 1975," a woman who attempted to dress as a young woman might dress twenty-five to thirty years in the future. The black leather miniskirt with matching crop top outfit described in her letter might seem bizarre indeed in the 1940s or '50s, but it is not far off the mark for popular styles in 1975.

"Just remember that old proverb," John wrote in issue number 14. "What *Bizarre* begets today—fashion features tomorrow."[276]

Though some of the topics seem quaint to the modern reader, *Bizarre* and other publications of its ilk were incredibly risky propositions in mid-twentieth-century America. It was dangerous to create material that appeared to flout laws against cross-dressing or obscenity.

"Apparently, our Courts do not take into consideration, the origin of fashion, when a male is caught 'masquerading' in feminine clothing, usually treating him as a mental incompetent, or 'Moron,'" wrote one indignant reader. "And yet the official Court Costume, is designed along so[-]called 'feminine' lines with long flowing robes, wigs, and silk stockings and breeches."[277]

The idea of feminine court attire was humorous, but the threat of prosecution was very real. "Masquerade laws" enacted throughout the country in the mid-nineteenth century (ostensibly to prevent people from disguising their appearances) were, by the early twentieth century, routinely used to punish men and women wearing clothing of the opposite sex in public. In 1937, twenty-six-year-old William M. Richeson was arrested in New York City and sentenced to ninety days in prison for "masquerading as a woman," which he readily admitted he had done since the age of sixteen. Richeson's female attire was so convincing that he had even married a man and worked as a chorus girl in a burlesque show.

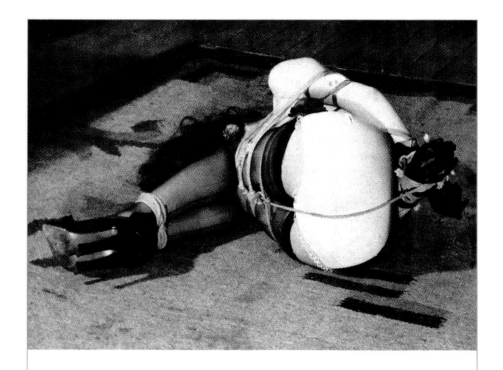

OF COURSE YOU CAN BE LIKE MISS HOUDINI

and get out of this in 10 minutes flat!
(once you've fallen over on your side)

but it might be easier to take care you
don't get into such a mess in the first place.

So — we repeat —

LEARN JIU JITSU
and the art of self-defense

▲ *Bizarre's* "learn jiu-jitsu" advertisements served as an excuse to display women in bondage.

"His attorney appealed for leniency, but Magistrate Sabbatino said he doubted that it would be wise to set Richeson free 'to fool more police officers,'" the *Brooklyn Daily Eagle* reported.[278]

To avoid trouble, many male readers of *Bizarre* stated that they confined the wearing of traditionally female clothing to their own homes, further cementing the domestic nature of the publication.

Men and women lived on equal footing on the pages of *Bizarre*, with letters both from dominant and submissive types featured in roughly equal proportion. At least one reader of the magazine even broached the topic of mutual consent, something rarely discussed in print media of the time. Of *Bizarre*'s famous "Learn jiu-jitsu, the art of self-defense" advertisements, reader "Kibitzer" noted, "Of course there is a considerable difference between a willing and an unwilling partner. 'Don't let it happen

to you' implies an unwilling captive, while the usual *Bizarre* slant concerns the 'joys' of being a willing captive. Ain't we got fun?"[279] The fact that the bondage was fully consensual ensured that *Bizarre*'s overall tone remained positive.

John's distinctive artwork danced through the pages of the magazine. Besides the photographs and multipage spreads of beautiful women rendered in watercolor or gouache, readers could delight in his clever spot illustrations: a bevy of tiny lingerie-clad beauties who live in a high-heeled boot (a storybook fantasy for adults); a caveman dragging a nude woman by the hair; a happy human sea-pony pulling her master through the surf; a nude woman in repose, smiling as she reads a letter; a gang of dominatrices attacking a poor, overworked magazine editor with whips. Years before *Playboy*'s famous Femlins, John Willie's little nude nymphs caused their own trouble in the margins of *Bizarre*.

It's difficult to read *Bizarre* and not see an artist and creator in top form, completely sincere in his undertaking. It is precisely this sincerity—the same kind that permeates all of John's best work—that makes the magazine so special.

Bizarre was not John's favorite project (that honor goes to *Sweet Gwendoline*), but it was certainly his most impactful work. The magazine developed a life of its own as it traveled around the world, gathering new fans everywhere it landed. It was a favorite of a young Fakir Musafar, one of the founders of the later "modern primitives" movement (which focuses on ritual body modification); Fakir sometimes contributed to later issues of *Bizarre* under the name "Ibitoe." In a 1989 interview, Fakir explored John's significance within the context of the modern primitives subculture.

"[John] went through the whole, the entirety, of culture and rearranged everything," Fakir stated. "He had this absolute passion for the modification of the body, tied in with bondage.... In *Bizarre* physical restrictions and disabilities were idealized by John Willie and the readers of *Bizarre* who put the ideas into practice."[280]

Another famous fan of the magazine was actress Maila Nurmi, best known for creating the glamourous and ghoulish character of Vampira. Clad in a long black dress with a plunging neckline and corseted waist, Maila introduced B-grade horror movies on a television program called *The Vampira Show*. The show aired locally in Los Angeles from 1954 to 1955, but Vampira's uniquely macabre style and dark humor ultimately made her a global cult icon. In her final interview in 2017, Maila described the origins of Vampira, which she created around 1953 and initially based on the Charles Addams comic strip character Morticia of *Addams Family* fame.

"Then I saw a magazine called *Bizarre*," Maila recalled. "I saw the magazine cover, and I thought, 'Oh boy, that's a seller!' And then I melded it. I melded it with that

◀ Vampira in Los Angeles, 1950s

dress. I added the black mesh hose, and the high, high heels and the deep V-neck. I slit the dress and added lots of glam, creepy makeup—having been in a tomb for so long, with the glamorous hair that had gone astray. Plus, I added all the phallic things like a long cigarette holder and long, long fingernails and the big padded bosoms and the cinched waist."[281]

Vampira's style was a perfect match for the *Bizarre* aesthetic. Maila would also flaunt "bizarre" styles in her personal life, even shaving her head in 1955.

▲ Bizarre predicts the future of fashion.

Bizarre also inspired countless magazines to follow, including the famous *Exotique*, which was published by Leonard Burtman and focused primarily on the dominant female. *Exotique* debuted in 1951, billing itself as a magazine of "Fiction and Future Fashions"—a close companion to *Bizarre*'s tagline, "A Fashion Fantasia."

As Dr. Paul Gebhard of the Kinsey Institute noted, John's work had "a profound influence on most of the magazines that followed *Bizarre*."[282] Despite this fact, few of the magazines that came after *Bizarre* captured the spirit of the original. John created a community with his magazine, and his artwork gave the publication a polished aesthetic. The women in the magazine, whether photographed, drawn, or painted, are uniformly beautiful and always displayed with careful attention to detail. Although John certainly devoted space to his own favorite topics—including boots, shoes, and pony girls—he endeavored to include all legal reader interests, not only those that he personally found appealing. This commitment to variety offers modern readers a peek into the wide range of sexual fetishes present behind closed doors in mid-twentieth-century America. Finally—and arguably most importantly—John maintained full creative

control over *Bizarre* during his period as owner and editor. While Leonard Burtman relied on a stable of talented artists to bring his vision to life on the pages of *Exotique*, John was an artist himself. He used his creative skills to ensure that every page of his magazine fit his "bizarre" aesthetic.

"None of the imitators ever grasped the reality behind John Willie's publishing, which was so clearly the expression of the primal urge," Fakir Musafar argued. "They became copycats of John Willie and copycats of each other, with no depth."[283] (Fakir would himself go on to produce *Body Play* magazine in the 1990s, a publication heavily influenced by the ethos of *Bizarre*.)

Bizarre was doing well, but dark clouds were forming on the horizon. Before long, local and national campaigns for "decent literature" would put John's magazine and many other publications in the political crosshairs.

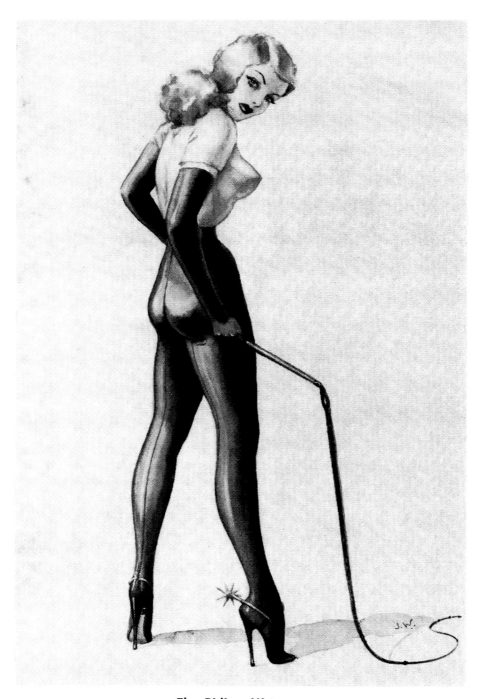

The Riding Mistress

Chapter 11
Juvenile Delinquency

The return of *Bizarre* in the 1950s coincided with a period of unprecedented social concern about bondage and fetish material in the United States. Although pornography had been a source of public concern for decades, bondage and fetish items had typically avoided detection and prosecution. As previously noted, bondage, high heels, and themes of dominance and submission appeared in specialized magazines such as *London Life* and *Bizarre* as well as mainstream pinup magazines. Similar themes also cropped up in Hollywood films. A submissive man might thrill to the sight of Clara Bow whipping a man in *Call Her Savage* (1932), but to the average viewer, it was simply a sign of her character's unbridled temper. Mickey Rooney singing "Treat Me Rough" to a group of Amazonian showgirls in 1943's *Girl Crazy* meant humor to most movie fans but fantasy to a smaller segment of the population.

Things began to change in the 1950s, as the average American became more attuned to the sexually fetishistic subtext of these themes. In May 1955, a Senate subcommittee led by Senator Estes Kefauver of Tennessee met to publicly discuss the impact of obscene and pornographic materials on juveniles, with a special emphasis on the less understood bondage and sadomasochism market. Major New York City mail-order operators were called before the Senate to testify, including Irving Klaw, distributor and pornographic bookstore owner Eddie Mishkin, and publisher Samuel Roth. All three of these men would later feature as defendants in United States Supreme Court obscenity cases. Irving Klaw and Eddie Mishkin would lose their fights; Samuel Roth's case, *Roth v. United States* (1957), made history by establishing a new definition of obscenity.

Prior to the *Roth* case, the Supreme Court defined obscenity broadly and in accordance with a nearly hundred-year-old British precedent, *Regina v. Hicklin* (1868).

◀ An illustration for fans of dominant women

The "Hicklin test" declared that material was obscene if it tended "to deprave and corrupt those whose minds are open to such immoral influences." Under the Hicklin test, even a short erotic passage in a book could render the entire volume "obscene" if it aroused sexual thoughts in the most susceptible members of the population (often defined as young people—or, in the words of one 1930s crime writer, "kids and morons and degenerates").[284] After *Roth*, a piece could be judged obscene only if "the average person, applying contemporary community standards, would find that the work, taken as a whole, appeals to the prurient interest."[285] It was a startling turn of events. Obscenity would now be judged by the opinions of "the average person" rather than by its effects on the imagined young and susceptible members of society. The *Roth* decision also required that the work *taken as a whole* needed to be obscene, rather than a single passage or illustration. *Roth* opened the door for many other obscenity cases; collectively, they changed the face of American culture by ushering in the sexual revolution of the 1960s and '70s.

But *Roth v. United States* was still two years in the future when the Senate Subcommittee to Investigate Juvenile Delinquency convened in 1955, and artists, publishers, distributors, and consumers of adult material were still judged under the draconian Hicklin test. The Senate subcommittee faced the adult industry head on, determined to learn more about it and prevent the spread of adult material among children.

The subcommittee chair, Democratic senator Estes Kefauver, was used to making waves. After a successful career as a lawyer, Kefauver was elected to the House of Representatives in 1939 and served five terms. Kefauver was particularly concerned with corporate monopolization of wealth in the United States, and he became known as a tireless advocate for antitrust legislation and consumer rights, even when his opinions put him at odds with his political colleagues. He continued this battle after being elected to the Senate in 1948.

In 1950, Kefauver was selected to chair a Senate committee on organized crime. The committee held public hearings in fourteen cities, which became known as the "Kefauver hearings" and were aired live on television nationwide in early 1951.[286] Mobsters such as Mickey Cohen and Frank Costello were called to testify, and the hearings are credited with introducing many Americans to words such as "Mafia" for the very first time. They also made Kefauver a household name. An estimated twenty to thirty million Americans tuned into the broadcasts,[287] which were also screened at some movie theaters for those who didn't yet own a television set.

The mass popularity of the Kefauver hearings on organized crime emboldened both Kefauver and the US Senate to pursue further social exploration and change. The 1955 hearings on juvenile delinquency hoped to uncover the effects of violent and sexually charged materials on children, whether those themes appeared in films,

magazines, television programs, or comic books. Of particular concern were those materials that appeared to conflate sexuality and violence, such as bondage photographs, drawings, and stories.

As with the organized crime hearings, much education was necessary to bring the American public—and the politicians leading the subcommittee—up to speed with the current state of adult materials.

"What is a bondage photo?" asked Republican senator William Langer of North Dakota early in the proceedings, admitting, "I never heard that term used before."[288]

Kefauver was surprised to hear Dr. George W. Henry, professor of clinical psychology at Cornell University, describe the practice of bondage as "fairly common."

"Among those who are familiar with this variety of sexual deviation, it is a matter of common knowledge to them," Dr. Henry clarified. "It is not common knowledge to the general public."[289]

A parade of doctors, police officers, attorneys, teachers, and parents were brought before the subcommittee to testify about the dangers of "sex deviation," including bondage and sadomasochism.

"Does [an increase in sex crimes] result in part at least from the reading and looking at magazines and pictures of this kind by children?" Kefauver asked Dr. Henry.

"I would think that was an important factor in the increase," Dr. Henry testified.[290]

One father testified about the mysterious death of his seventeen-year-old son, who was found bound and hanging from a pair of trees behind his house. After his son's death, the father learned of Irving Klaw's *Cartoon and Model Parade*, featuring photographs that resembled his son's position in death.

"I . . . feel there is definitely an evil to this, and I am bound and determined to do what I can to suppress it," the father said. "It isn't good. It is an unhealthy situation. It is not wholesome. There is nothing cultural about it. It is just no damned good. That's all I can say about it."[291]

The grieving father's passionate testimony was the most personal and moving of the entire hearing. It was impossible not to feel the depth of his grief and understand his anger and frustration with the unfamiliar bondage material. Satisfied that they had established a case against pornography and sadomasochistic materials, the senators began to call a new set of witnesses: the men and women who sold bondage photographs, books, magazines, and artwork.

The first distributor called to the stand was Irving Klaw, who pleaded the Fifth Amendment and refused to answer most of the questions presented to him by the committee. The senators were not impressed.

"I must warn you that this committee will cite you for contempt of the Senate if you decline to answer," Kefauver told Irving.[292]

Irving steadfastly refused. Several others who followed took the same tack, leaving the committee with limited usable testimony.

Model Bettie Page had also been subpoenaed but was never called to testify, leaving her both relieved and shaken. "It was the only time I ever saw Bettie upset," recalled

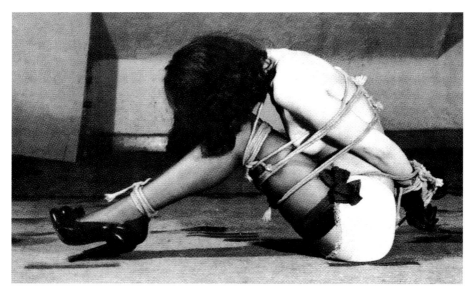

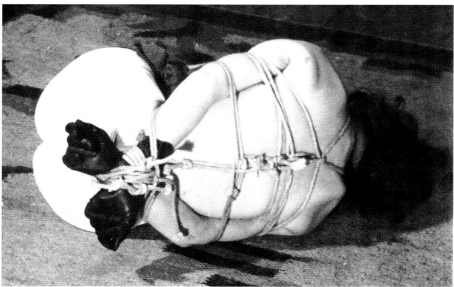

artist Eric Stanton, a fan and friend of Bettie's. "She was horrified at the prospect of having to testify against her friends Irving and Paula."[293] Bettie would retire from modeling within two years.

John escaped being subpoenaed, probably because *Bizarre* and *Sweet Gwendoline* were still small enough operations to fly under the subcommittee's radar in 1955. But there is no question that he, like many Americans, watched the proceedings from the sidelines, helplessly standing by as others in his industry were crushed by the authorities.

The Senate subcommittee was aided in its efforts by United States postmaster general Arthur Ellsworth Summerfield, a strong anti-obscenity advocate who had launched a "Clean Up the Mails" campaign just two months prior to the May hearings. The campaign was intended to address the "growing volume of unwanted lewd and obscene matter . . . sent through the mails into American homes." Examples of problematic material included "risqué snapshots, pornographic magazines and books, and lascivious slides, 'party' films, and records."

"Many criminal, educational, and religious authorities see a definite connection between this disgraceful upsurge in obscenity and the startling growth of juvenile delinquency in the nation," Summerfield said, adding, "Citizens who wish to help the Post Office Department in its 'Clean-Up-the-Mails' campaign can do so by delivering, to their local postmaster, any material received through the mail which they consider obscene."[294]

The campaign met with support from the religious press, which encouraged readers to report obscene materials to their local postmaster. "Postal authorities all over the nation have received complaints about obscenity in the mails from leading clergymen, school groups, newspaper editors and alarmed parents," reported *The Liguorian*, a Catholic magazine.[295]

John himself had joked about Postmaster Summerfield in *Bizarre*. In 1953, the year Summerfield assumed his role as postmaster general, John wrote, "The postal laws and regulations frown on pictures of the nude breast . . . and the Postmaster General sends the FBI, the U.S. Cavalry and the Mounties (to say nothing of Dick Tracy) after you with guns if you show just one nipple in print and send it through the mails."[296] The joke would eventually sound more like a premonition.

The Catholic-led National Organization for Decent Literature (NODL) also fought against obscene publications, encouraging community boycotts of stores and news dealers that stocked reading material perceived as indecent. NODL had been conducting similar boycotts since the late 1930s and by the 1950s was one of the most powerful censorship organizations in the United States.

◀ Two examples of John's ropework and photography from *Bizarre* issue 11

"Unlike liquor, lewd literature cannot be used in moderation or in small doses," NODL stated. "It is an evil in itself, and is calculated to destroy private and public morality without which there can be no Christian civilization."[297]

In advocating for boycotts, NODL encouraged followers to make "mild threats"[298] to vendors who refused to purge their businesses of indecent material. The boycotts were often successful, limiting the distribution of adult-oriented materials more quickly than legal measures through the courts.

These tactics were criticized by some, including the American Library Association, who argued in 1953: "The present laws dealing with obscenity should be vigorously enforced. Beyond that, there is no place in our society for extralegal efforts to coerce the taste of others, to confine adults to reading matter deemed suitable for adolescents, or to inhibit the efforts of writers to achieve artistic expression."[299]

But the American Library Association was in the minority, and the heat was on. Between Summerfield's mail campaign, public magazine boycotts, and the Senate hearings, it seemed the whole country was talking about juvenile delinquency and its supposed link to "smut," including bondage and fetish material. For John and his close circle, there was much more to come.

Although John had not been formally subpoenaed, he still faced judgment in the court of popular opinion. In May 1956, a magazine titled *Behind the Scene* published an article that called out *Bizarre* by name, quoting extensively from its correspondence section and describing the publication as "a *special kind* of gutter literature . . . the pornography of perversion!"[300]

The article opened by imagining a beleaguered district attorney somewhere in Illinois, reading issues of *Bizarre* at his desk until he is too disgusted to continue. Angry local citizens telephone his office, demanding to know what the local authorities will do to suppress fetish literature, which the DA admits is not illegal.

"Finally, when he could stand it no longer, the young D.A. swept the magazines to the floor with a violent gesture," the article read. "'Corsets . . . gloves . . . high-heeled shoes!' he muttered in frustration. 'All this filth, and it's outside the law's reach!'"[301]

The imaginary DA illustrates the anxiety that many midcentury Americans felt regarding juvenile delinquency and a rapidly changing society. The magazine admitted that it was Kefauver's subcommittee hearings that introduced bondage and fetish material to the mainstream. "Thanks to the Kefauver committee and to a host of other federal, state, and local groups, the hard spotlight of public attention has recently been focused on the $30,000,000 smut industry, which has infested our schools and homes," *Behind the Scene* reported.

JUVENILE DELINQUENCY

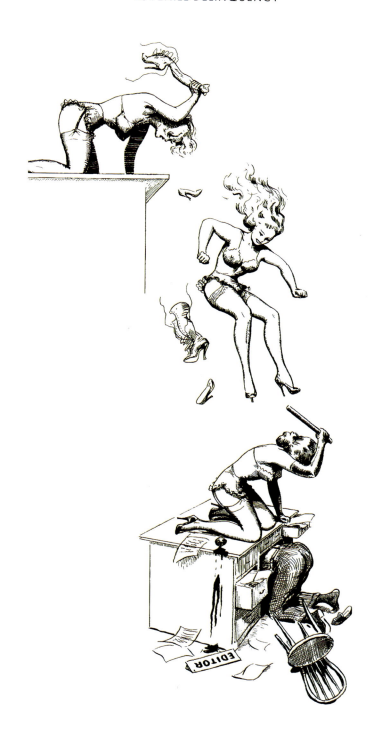

The six-page exposé went on to describe *Bizarre*'s content in lurid detail, explaining the fetishistic nature of high-heeled shoes and corsets ("To obtain such objects . . . the fetishist will often steal, or even kill") and mocking the readers who enjoyed activities such as cross-dressing and wearing rubber.

The magazine also found fault with *Sweet Gwendoline*, writing, "Lest the run-of-the-mill, homosexual type of pervert should feel neglected on paging through *Bizarre*, one of the comic-strip panels shows Gwendoline and Agent U-69 walking hand-in-hand, their gloved fingers lovingly entwined."[302] In a moment of true hysteria, the magazine even suggested that the title *Sir D'Arcy D'Arcy* might have a secret, perverse meaning to fetishists—for whom "even the oddest words have a special meaning."

"The pornography of perversion *is* filth; it *is* obscene; it *is* inherently illicit and illegal," the article concluded. "It is time, long since time, that it be brought within the realm of prosecution and erased from our society."

For John, *Bizarre*'s bad publicity could not have come at a worse time. As the article noted, the Kefauver committee's research into juvenile delinquency had brought bondage and fetish materials into the public spotlight for the first time. By 1956, public concern about juvenile delinquency was reaching a fevered pitch, and magazines and comic books on newsstands across America were targeted as a cause of the problem. Now a national magazine pointed its finger at *Bizarre*, loudly proclaiming that its content should be "erased from . . . society."

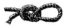

John's former employer Robert Harrison, of pinup magazine fame, also faced problems with the law. Robert had been hard at work on new projects since John left the fold. By the early 1950s, more daring men's magazines such as *Playboy* rendered the mild pinup magazines of the 1940s virtually obsolete. Robert developed a new, more lucrative idea inspired by the 1951 organized crime hearings that had made Estes Kefauver's name. Like millions of other Americans, Robert watched with rapt attention as gangsters, sex workers, and racketeers provided juicy details about their lives and crimes on television. The fact that so many people could be enthralled by a Senate subcommittee hearing gave Robert an idea. What if there was a magazine as sordid and exciting as the subcommittee testimony?[303]

He called his new magazine *Confidential* and packed it with sexy, scandalous, and sometimes downright cruel stories about Hollywood elites. Why did Marilyn Monroe and Joe DiMaggio divorce? Did Frank Sinatra really eat Wheaties cereal as an aphrodisiac? Which Hollywood heartthrobs were secretly gay? True to its tagline, *Confidential*

"[Told] the Facts and Name[d] the Names." By 1955, *Confidential* ranked among the bestselling magazines in America—much to the annoyance of Hollywood studios and actors and the morality groups focused on "clean reading." One opponent curiously wrote that the magazine's publishers should be "horsewhip[ped]" for their scandalous content, adding, "A cat-o'-nine-tails speaks a powerful language."[304]

Like other controversial publications of the era, *Confidential* came under fire in the courtroom and on the American political stage. In 1955, Postmaster General Summerfield set his sights on the magazine, actively working to prevent several issues from being mailed. Some states introduced bills that would limit the sale of "scandal magazines" such as *Confidential*, typically linking the publications to existing anti-obscenity legislation. And in 1957, *Confidential* was charged with "conspiring to publish criminally libelous and obscene matter" in Los Angeles.[305]

The lawsuit against *Confidential* became one of the most sensational ever brought against a magazine in the United States, and it added fuel to the long-burning controversy of obscene literature. The public read accounts of the proceedings in newspapers and watched coverage of the trial on television. Full articles were read aloud in the courtroom, becoming matters of public record that were subsequently reprinted in magazines and newspapers across the country.[306] The jury deliberated for two weeks before declaring that they were unable to reach a verdict, and the case ended in a mistrial.

What seemed like a passive victory for *Confidential* was anything but. Robert Harrison had already spent a hefty $500,000 in legal fees defending the magazine, and when the state of California expressed its intention to retry the case, Robert agreed to a deal.[307] The agreement stipulated that *Confidential* would no longer publish personal stories about Hollywood celebrities. Charges of conspiracy to commit criminal libel were dropped, but the obscenity charges remained. At the end of the year, Robert was charged an additional $5,000 when *Confidential* was found guilty of conspiracy to publish obscenity.[308]

The trial at an end, Robert tried halfheartedly to publish a less tawdry version of *Confidential*. Sales tanked when the Hollywood gossip was removed, and by the summer of 1958, Robert had left the publishing business. As scholar Samantha Barbas has noted, "The elimination of *Confidential* from the nation's newsstands was accomplished not through official bans, postal restrictions, anti-scandal legislation, or criminal sanctions, but rather through the exhaustion and financial depletion of publisher Robert Harrison."[309]

Robert's publishing empire had once ranked among the most successful in America. The fact that it could be destroyed so easily with allegations of obscenity was not lost on John. The publishing industry was no longer safe.

❖ ❖ ❖

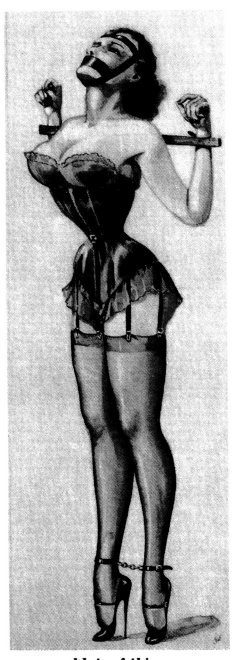

and lots of this — **and this —**

CHAPTER 12
The End of Bizarre

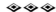

With the publication of the unflattering article in *Behind the Scene* magazine, John found himself at an impasse. He felt sure that postal authorities would be coming for him next, as they had for Irving Klaw and others in the industry. John had worked carefully over the years to attract new readership while maintaining a fairly clandestine publication. Now the coded language and fetish correspondence had been publicly dissected, ridiculed, and exposed in a national magazine, potentially piquing the interest of authorities. Worse still, the article called for legal sanctions to be placed on bondage and fetish material. (Although *Behind the Scene* was not as well known as other gossip magazines such as *Confidential*, the strength of its readership should not be underestimated. In Miami, Florida, it ranked third in sales among a crowded field of scandal magazines in 1955, behind *Confidential* and *Private Lives*.)[310]

The subcommittee hearings led by Senator Kefauver were another point of concern. John published only one issue of *Bizarre* in 1955, the year of the obscenity hearings. When the magazine resumed publication in 1956 with issue 17, it began with an unusually political note titled simply "WE SPEAK." The short editorial discussed sexuality frankly, with none of the humor John typically injected into his writing for *Bizarre*.

"As for sex, ignorance is abysmal, because for centuries those who could not satisfy themselves, except by denying pleasure to others, have taught generation after generation that 'sex is taboo,'" John wrote. "Thou shalt not think about it or discuss it. In fact it's a dreadful thing, but it's all right so long as you don't enjoy it. If you have any other ideas on the subject, you are a pervert." He continued:

◂ An illustration for fans of submissive women

The basis of a decent society is a happy home. Marriages break up almost invariably because of sex. What you do, or do not do, is your own business, all that matters is that the enjoyment be mutual—and the time to discuss these things is before you get hitched up. There is a partner to suit everyone somewhere, but the search will be difficult until we can discuss our likes and dislikes, openly, in good taste, without threat from our own brand of standardized Police State.[311]

The message, obviously aimed at those who might call *Bizarre* obscene, attempted to explain the crux of the magazine's belief system in commonsense terms. *Bizarre*, like John himself, had always stood for the freedom of the individual: freedom of dress, freedom of choice, and freedom to engage in sexual activity with the willing partners of his or her choice. To put it another way, as John did in the magazine's debut issue, *Bizarre* "typifies that freedom for which we fought [in World War II] . . . the freedom to say what we like, wear what we like, and amuse ourselves as we like in our own sweet way."[312] It was an idealized mission statement, but one John tried to live up to with each issue of the magazine. Freedom was also the goal he strived for in his personal life, only occasionally finding it. And it was freedom he sought again as he approached the end of his work with *Bizarre*.

In the end, it wasn't just the *Behind the Scene* magazine article or the Kefauver subcommittee that caused issues for John. The high level of work and creativity required to keep *Bizarre* going was unsustainable. He had hired a team to work for him, but the majority of the artwork, writing, and editorial work still fell to John himself. Releasing correspondence-only issues from time to time helped lighten the workload. As the years went by, John also created fewer pieces of original art for the magazine. *Bizarre* never achieved the monthly release schedule that John had ambitiously imagined, but it did come out several times per year, and each issue was a massive creative and financial undertaking.

"Sometime last year John Willie got fed up with forever dipping into his own pocket to keep *Bizarre* afloat," John had written in 1953. "Why make money drawing cartoons and then lose it all on a small pocket[-]sized magazine?"[313] Although his financial situation had improved in the ensuing three years, he would never become rich from *Bizarre*.

An additional problem was the near-constant piracy of the magazine by other publishers. This practice undercut John's own earnings and became a source of great discouragement. Beginning with issue 13, John included a stern copyright statement on the first page of each issue, indicating that the cover and contents could not be reproduced without written permission. By this time it was much too late; pirates had already stolen extensive material from *Bizarre* and would continue to do so for the duration of the magazine's run. Dr. Gebhard of the Kinsey Institute reported a rumor that copies of John's drawings were sold under the counter in London

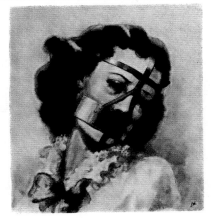

Pirated versions of John's artwork appear on the cover and throughout the interior of this 1960s fetishwear catalog.

bookshops for up to one pound per image ("This is in keeping with your genius for making money for everyone but yourself," he told John).[314] John's work would also appear without attribution in numerous domestic and foreign bondage and fetish magazines, and the fly-by-night quality of many of the publications made it difficult to pinpoint the perpetrators.

"Dammit! Read this . . ." John wrote in issue 14. "The name *Bizarre* and the photos and sketches appearing in this magazine have been reproduced by various people without our permission. Our attorneys have the matter in hand. Publication of our material by any other person is not authorized, and we strongly advise readers to write to us direct before answering any advertisements giving an address other than ours."[315] Indeed, advertisements did appear in magazines and newspapers offering *Bizarre* for sale from bogus addresses, causing headaches for John and readers alike.[316]

"All sorts of strange wild fowl are using the name *Bizarre* in various ways," John reminded readers a few issues later. "They have absolutely no connection with us whatever—so if you do business with them and get clipped—don't blame us."[317]

Ultimately, a combination of bad publicity, bad luck, poor management, a punishing work schedule, and a chronic lack of money led John to abandon *Bizarre* entirely. In the tense climate of 1956, the magazine had also become too great of a liability, with the potential for very serious legal consequences. The final issue to be published under John's direction was number 20, released in the summer of 1956. Although he didn't yet admit that he was leaving, his final editorial expressed his sense of exhaustion. "We have had so many problems that we're absolutely worn out—and we're afraid the magazine shows it," he wrote. "We have always tried to turn out nothing but the best, even if many readers are satisfied with any old thing, and so rather than be mediocre we think a rest is called for to revive our shattered tissues."[318]

He also alluded to Estes Kefauver's juvenile delinquency hearings and the unflattering *Behind the Scene* article, telling readers, "As you know this is an election year in the U.S.A.—and the do-gooders are really whooping it up trying to blame everyone (and publishers in particular) instead of themselves for all the juvenile delinquency that's around. You can believe it or not but there really are people who are firmly convinced that every reader of *Bizarre* is a homicidal maniac."[319]

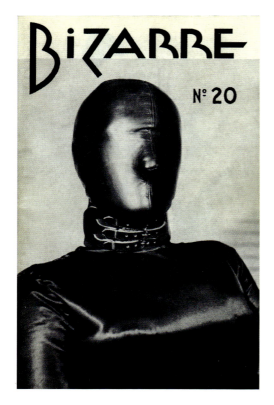

John was tired. *Bizarre* number 20 was another all-correspondence issue, after which he quietly left the publication in the hands of his staff. Though he made an effort to appear unconcerned about moving on from *Bizarre*, in truth John was deeply affected by what undoubtedly felt like a great failure.

"I severed all connection with *Bizarre* as of 1 July, 1956," he wrote in a bitter letter to his mailing list in late 1956 or early 1957. Foregoing his usual modesty, he continued:

If you are puzzled at my throwing away the magazine which I, alone, as John Willie and The Editor (all rolled into one) had created, and had kept going for so long, in spite of all manner of obstacles—let me put it this way:—What had started off as a happy carefree ramble through the tangled wild woods had become nothing but an aimless wandering in a somewhat smelly swamp. I could have continued in business, but I could not have turned out another issue. This prospect was too dreary to contemplate—so I quit. I believe the people who took over intend to put out new issues, but I really don't know; it's nothing to do with me anyway.[320]

▲ The cover of *Bizarre* number 20, the last issue with John as editor
▶▶ *Opposite:* John's successors at *Bizarre* did not share his attention to detail or his skill at ropework.

To say that he "really [didn't] know" whether the new owners of *Bizarre* would release additional issues was a lie. He sold the entirety of Bizarre Publishing Company to his longtime secretary/model, Nicky, and Robert Braine, a man John described as the secretary's "boy friend," with the understanding that they would continue to publish new issues.[321] John had previously praised Nicky and her boyfriend, describing them as a "darn good crew working for me,"[322] but he apparently felt unhappy with the results of the sale. In addition to the unusually terse and self-aggrandizing letter to his mailing list, he railed against the new owners in private correspondence.

"So the people who took over *Bizarre* have gone in for a new series of photos—This is interesting, and I'd like to see what they've turned out because neither of them (my former secretary & her boy friend) know anything about anything,"[323] he wrote to one correspondent. The acquaintance sent samples of the series for John to inspect. As expected, John did not have a high opinion of the photos.

"My God!" he responded. "Of all the abortions of a job this is it. . . . If they had been put out under any other name but *Bizarre* I wouldn't be so burnt up." John went on to insult the appearance of his former secretary (the model in the photos) before concluding, "Christ it makes me mad."[324]

John was so frustrated with the path *Bizarre* had taken that he filed a formal copyright for *Sweet Gwendoline* in 1958, ostensibly to protect his favorite project from falling into other hands.[325]

It is true that the new owners of *Bizarre* did not have a personal interest in fetish material, and the quality of the magazine markedly declined after

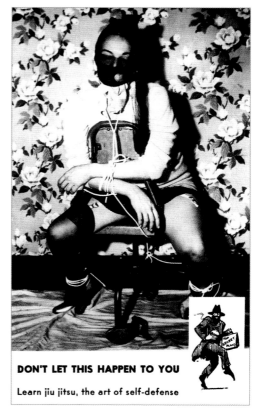

John's departure in mid-1956. The new publishers tried to make a smooth transition; they kept the format, the editor's letters, and even the Omar Khayyam quotes that John printed at the top of the first page of every issue. But the lack of passion was obvious from issue 21, the first without John at the helm. The cover artwork is lazy,

the interior articles lack John's humor, and an attempt to re-create the famous "Learn jiu-jitsu, the art of self-defense" advertisements produces a weak bondage image with a mess of loosely tied rope.

The editors attempted to improve the magazine in the issues that followed, but they were clearly uncertain how to proceed, relying heavily on reproductions of Hollywood film stills and promotional photographs of burlesque queens. Even hiring the versatile and talented artist Mahlon Blaine as a replacement for John Willie was not enough. Mahlon had a long career as an artist of impressive breadth; beginning in the 1920s, his illustrations graced a variety of published materials, including classic novels such as *Arabian Nights*, children's books, magic trick manuals, and erotic publications.[326] In the mid-1950s he served as associate editor of *Good Times: A Revue of the World of Pleasure*, another risqué magazine established by provocateur and free speech advocate Samuel Roth of *Roth v. United States* fame.[327] But Mahlon's baroque-inspired 1950s work did not translate to black-and-white print as readily as John's art, and response from readers was tepid.

"We had our share of complaints on the last issue," the editors admitted in issue number 24, adding that the primary problem was "far, far too many pictures, not enough correspondence."[328]

Not all feedback on the later issues of the magazine was negative. One reader wrote that each new issue of *Bizarre* was "like meeting an old friend after a long separation."[329] But most sensed a change for the worse in their favorite magazine.

"Having been a fan of yours for some years, I am slightly disappointed in the recent issues," "Blackmaster" confirmed.[330] His letter was addressed to John Willie, indicating that at least some readers were not aware of the change in ownership at *Bizarre*. Letters to John Willie continued through the final issue of the magazine. The new owners, aware that they were in unfamiliar waters, did not attempt to correct the misconception that John still owned the magazine.

The last issue of *Bizarre*, number 26, appeared in 1959. It featured a cover by Mahlon Blaine, but the interior pages were dominated by John's artwork (recycled from material originally issued years before). This last-ditch effort to save the publication was not successful, and no further issues were published.

For John's part, the final nail in *Bizarre*'s coffin was a relief. No longer would he need to worry about new issues destroying the legacy of the magazine he had created. Behind him were the headaches of newsstand distribution, the humiliation of constant financial failings, and the dishonesty of his more business-savvy colleagues.

▶ The cover of *Bizarre*'s final issue, number 26

Leaving *Bizarre* also meant the possibility of returning to work he personally found fulfilling. No longer dictated by the whims of his fan base, he now hoped he would be able to draw and paint freely. While working on the magazine, he often set aside his own interests in favor of customer demands—like he had earlier in his career when he created *Sweet Gwendoline* episodes for Robert Harrison. "The logical thing to do . . . was to turn out what was wanted—regardless of whether I personally thought it attractive or not," he later wrote to Dr. Gebhard at the Kinsey Institute of his days as a magazine editor. "When I dropped *Bizarre* I said to hell with thinking of pleasing these people."[331]

❖ ❖ ❖

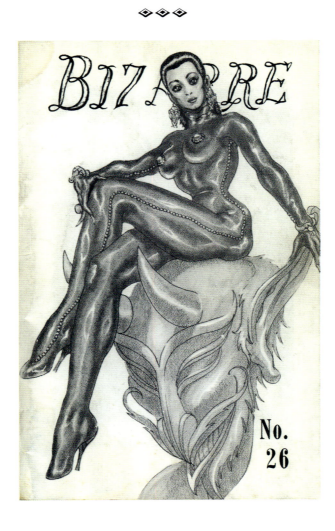

CHAPTER 13
Los Angeles

By the time *Bizarre* folded, John was long gone. In 1957, shortly after sending the letter to his mailing list announcing his official departure from *Bizarre*, he packed up shop and moved to Los Angeles. Why California? It may have been the weather, the thriving arts scene and plentiful models, or simply a desire to get as far as geographically possible from New York City, friends turned enemies, and all the mistakes he felt he had made. Los Angeles was to be a fresh start.

The City of Angels had begun its ascent with the development of the film industry in the 1920s. By the time John arrived in the 1950s, Los Angeles was home to some of the fastest-growing housing developments in America. *Life* magazine reported in July 1953 that "an average of 400 people has been moving into the Los Angeles area every day for 13 years."[332] Walt Disney's Disneyland opened in nearby Anaheim in 1955, and in 1958, John's favorite baseball team, the Dodgers, moved to Los Angeles from Brooklyn. More importantly for John, the city was also home to a booming adult industry.

Several small magazines for sexual minorities, similar in scope to *Bizarre*, were based out of Los Angeles in the 1940s and '50s. The first lesbian magazine in the United States, *Vice Versa* (subtitled *America's Gayest Magazine*), was established in Los Angeles in 1947, one year after *Bizarre*'s founding. Like *Bizarre*, *Vice Versa* utilized coded language to reach its intended audience of gay women. (In a line that could have come directly from *Bizarre*, the debut issue of *Vice Versa* describes the magazine as "dedicated, in all seriousness, to those of us who will never quite be able to adapt ourselves to the iron-bound rules of Convention.")[333] Although the magazine lasted only one year, it set the stage for two more Los Angeles–based publications critical to the gay community: *One*, America's first nationally distributed pro-gay magazine (1952–1969), and *The Ladder*, a lesbian interest magazine (1956–1972). While the issues faced by bondage fans pale in comparison to the social and political battles fought by the gay and lesbian

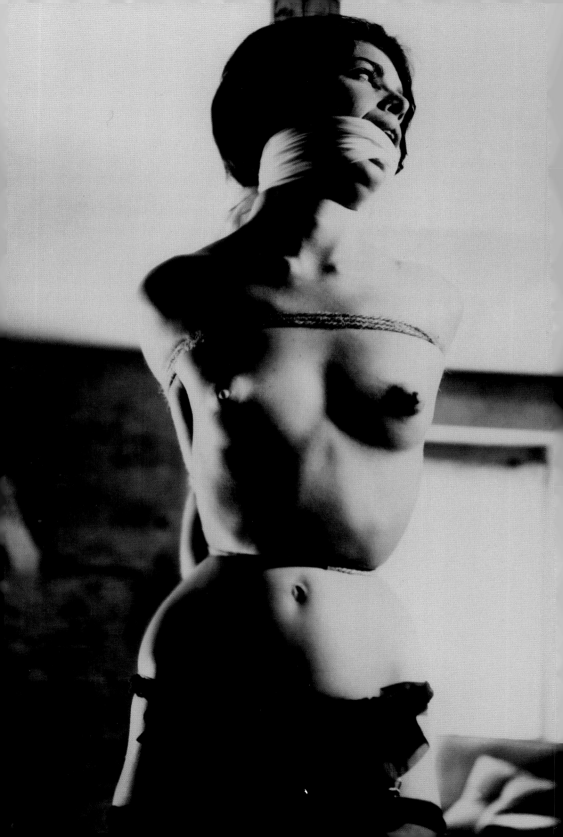

communities, all were viewed as "deviant" in the 1950s, and their publications faced similar legal backlash. When *One* magazine was deemed obscene by federal postal authorities in 1954, the publishers fought back. The Supreme Court ruled in favor of *One* in 1958, determining that the publication was not obscene.

The presence of other publishers campaigning for sexual freedom in Los Angeles meant that John's new environment should have been an improvement, but he had trouble gaining creative traction on the West Coast. His anger and bitterness didn't help matters. However justified he may have been in holding grudges against Irving Klaw, Robert Harrison, or the new owners of *Bizarre*, the resentment was interfering with his life. Even placing thousands of miles of physical separation between himself and his sources of anger did not dull the emotional impact. Sometimes it seemed John would never overcome his feelings of being cheated, lied to, and treated as expendable during his years in New York.

"I have had so many disappointments in connection with *Bizarre* & I have become associated through it with all the scum of the earth of such a revolting type—from mobsters to filthy, ignorant jerks (Klaw for one) that I am only too glad to forget it," he wrote of his experience in New York.[334]

It was time for a change. In his correspondence with friends, he mulled over some paths forward: working on his true passion of comics, or perhaps even reestablishing his shoe design business. Why not? The war was more than a decade past, leather could be had again, and if *Bizarre* had taught him anything, it was that demand for ultra high heels never waned. But these dreams remained just out of his grasp, due mainly—as usual—to a lack of money. He was now fifty-five years old, and the hard physical labor of life on a ship was no longer realistic. The other way he knew to make money, selling photographs, seemed as dismal as a return to the magazine trade— but in the end, it was the only way. Like many who had lived through the Great Depression, John had seen the horrors of poverty and would do anything at all to avoid returning.

John Coutts again set to work as John Willie, offering photographs to the carefully guarded mailing list that he had now spent close to twenty years building. This time, he set the ground rules early. As always, he considered his photography to be little more than a necessary corollary to the real work of drawing. He had grand plans for his beloved character Sweet Gwendoline and hoped to release a new collection of comics featuring her.

◀ A dramatic image from John's years in Los Angeles

"I have no intention of getting into the picture selling business, catering to every whim in regards to costume, etc., so please don't ask for it," he wrote to his mailing list. "I'm not trying to please anybody, it's just work which I must do for this cartoon."

In fact, "the picture selling business" would become John's primary source of income during his Los Angeles years, even though *Sweet Gwendoline* took precedence in his mind. He began producing a large number of narrative photo sets, which one flyer advertises as ranging in price from $5.00 to $26.00 for twelve to seventy-four images. These sets told simple bondage stories, often centered on the same type of thin plotlines that have populated erotic photography since its earliest days—wrestling women, for instance.

These sorts of picture stories had their origins in some of John's earliest photographs. Even in Australia he had arranged photo shoots of one woman gradually tying up another. In New York, too, he made fun and sexy photo sets for his fans. The most famous of these New York–era sets, titled "Typist in Trouble," featured John's blonde secretary bound and placed in a wooden crate to mail to Sir D'Arcy. These story-based photo sets were consistent moneymakers and often provided the most payment for a limited amount of work. Although John privately expressed his dislike for the "sex photo selling" business, in public correspondence he attempted to frame the work in positive terms.

"Unless a model is a good actress, and has 'that type' of face it's difficult for her to look sad and miserable when working for me," he wrote in a brochure to his mailing list in late July 1957. "My studio is a pretty cheerful place, and quite unlike the atmosphere that surrounds Gwendoline when the Countess gets hold of her."[335]

In an attempt to return to his true passion of drawing, he began advertising Gwendoline comics for mail-order sale in various men's magazines. The response to his mail-order advertisements was encouraging, but John quickly found himself facing a painful reality: he would never be able to make a living from his comic alone.

"The 'Sweet Gwendoline' cartoon was to me the answer to everything—but again I had so many heartbreaks over 'distribution' on Newstands [sic] that it drove me crazy," John wrote of his work. "I saw a faint chance of success when I found the response to my ads for Mail order but to overcome the problems of finance I realized that I was drifting into the 'sex photo' selling business. The cartoon is such clean sexy fun—to sell photos to give some frustrated guy a kick is not."[336]

Again, John's protectiveness of *Sweet Gwendoline* came to the fore. To him, the comic strip was simply "clean sexy fun" for adults (a descriptor that fits that majority of his work). The "sex photo" selling business was lucrative but depressing, especially as John began to abandon his own fetishistic interest in the later years of his life. John admitted that sex was the last thing on his mind when he began to feel down, "be it a

cold in the nose or just a sore thumb,"[337] and he was certainly feeling down during his early years in Los Angeles.

It was a major change for a man who had always been frank about the fact that he was not merely a peddler of fetish material but a practitioner himself. As editor of *Bizarre*, John had established himself as an authority on rope bondage and the design and creation of ultra high heels. His personal correspondence describes sexual experiences with Holly and other women; in interviews, he stated that he later attended sex parties with a fetishistic bent.[338] By 1960, this had changed. In a letter to Dr. Gebhard, he describes himself as having been "a 'fetishist' myself once"[339] but declined to share many details about his personal sexual history. "If you want a blow[-]by[-]blow description of my methods of fornication . . . I can tell you right now you're out of luck," he wrote, shutting down the possibility of sharing a sexual history of the type documented in the famous Kinsey Reports.[340]

When quizzed about matters such as bondage, he responded in a detached tone that made it clear his interest had dimmed. It was a far cry from the enthusiasm present in *Bizarre*'s editorials or earlier letters to friends and associates.

Had he mellowed with age? Perhaps. More likely, John had begun to grow weary of the industry that he had toiled in for two decades, which demanded a focus on sexuality to the exclusion of all else. By the time he arrived in Los Angeles, he was more private, more selective, and—despite living in one of the largest cities in the world—more secluded than ever before. No longer a young man with dreams of starting a magazine or developing a community, he was now firmly in middle age. He had established himself as an artist of undeniable skill. A return to photography, which John had always viewed as a means to an end rather than an art form in itself, felt like a step in the wrong direction.

John's personal feelings on the subject of photography were not shared by his fans, who often imagined that he led an ideal life. Tying up willing, scantily clad "Gwendolines" and photographing them from every angle sounded like a fantasy come to life for many men, and John's customers often wrote to him in hopes of meeting his models. Some assumed that John had sex with the women he photographed. In fact, he was typically quite private when speaking of his sex life and expressed a genuine fondness for women. He frequently wrote of his models in respectful terms. When Dr. Gebhard asked if any models exhibited an "emotional reaction"[341] to being bound and photographed, John did not romanticize the work. "Some get a kick out of it, some do it just as they would any modeling job [and] that's all there is to it," he responded.[342]

Many fans also wondered where John found his models, who tended to be slender, dark haired, long legged, and very pretty. The answer was pedestrian: he usually contracted the women through professional modeling agencies or met them through his various contacts in the adult business.[343] Although he had started out by photographing

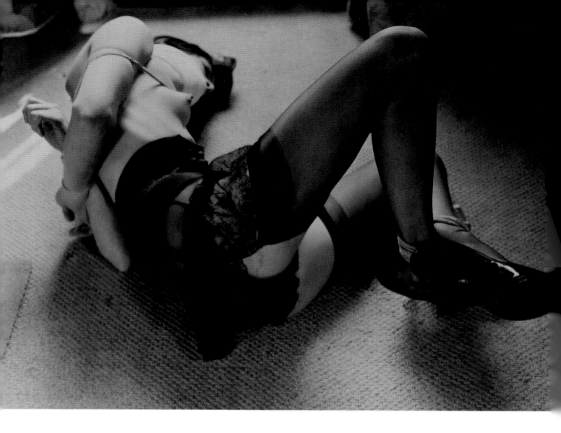

amateur models in Australia, by the time he reached Los Angeles he photographed professionals exclusively. This added to the sophisticated appearance of his work.

In 1951, he offered advice on the subject of working with models to a young man just starting out in the bondage photography field. "Why does [a woman] model for you?" he wrote in a letter, before answering his own question:

> Usually for one of two reasons, in some cases for both. One, for the fee you pay her, or because she likes the feeling of helplessness. That is, if she feels it is safe. On that subject, be professional, don't make advances. For if she should wish to make your relationships a bit more than model-photographer, she will let you know, to be sure. . . . And, I'm sure you know this already, maintain sincerity. Remember that the model you work with has friends, and if the experience is pleasant for her, or you pay her enough, the word gets around that you are a chap to be trusted.[344]

Especially in Los Angeles, John worked consistently with many of the same models. The fact that the women agreed to work with John on a regular basis suggests that after nearly a decade, he continued to follow the same advice he gave to this young man in the early 1950s: be safe, be professional, pay her well, and don't make advances.

◀ John regularly photographed models at his home in Los Angeles.

Just as *Bizarre* had begun to feel like catering to the sexual demands of an ungrateful readership, so photography became a millstone around John's neck. Of course there was still some pleasure to be taken from tying up beautiful women and photographing them. But John wanted to draw in peace, and each day spent away from the drawing board felt like more wasted time. He had fewer friends in Los Angeles than he had had in Australia or New York, and he rarely fraternized with those in the fetish community or others in the adult industry.

When Dr. Gebhard visited Los Angeles in the early 1960s, he found that despite talking to many artists, photographers, and those in the magazine trade, he could locate few of John's friends or associates. "While virtually all of them knew of you, it was clear that few, if any, knew you," he wrote to John. "I generally kept my face closed and sooner or later someone would say, 'There's a man, up in North Hollywood I think, you ought to see, but he's hard to get to.'"[345]

For the first time, John seriously considered exiting the industry entirely. But what else could he do? All his lifelong pursuits, from working on ships to keeping up with trends in the adult industry and avoiding the law, required a youthful energy that was beginning to wane. Working as a deckhand had helped keep *Bizarre* afloat in its leanest years; without manual labor to sustain him, only photography remained. He was beginning to feel trapped in a fetish industry he himself had helped create. The things his customer base wanted were not the same things John wanted to make.

Taking photographs became rather like the manual labor of his younger years: not a dream profession, but one that would pay the bills and sustain his true passion of drawing. John worked on *Sweet Gwendoline* when he could, but he also contracted models from local modeling agencies to create the sorts of bondage photos his customers demanded. To John's credit, he continued to create high-quality images with carefully executed bondage ties. John's sense of integrity demanded that everything bearing his name met the same high standard. He was bothered by the turn that *Bizarre* had taken under its new owners, and may have felt pressured to redeem the public name of John Willie.

John had grown tired of photography, but his fans' interest in the images he created never diminished. In the 1990s, one amateur bondage photographer and former *Bizarre* reader recalled, "[John] once wrote me and asked why I wanted to purchase some of his photos when I could take my own. The answer, of course, was that his photos were so much better than mine, more alive. The bondage was better, the gags were better, and his models were lovely. In fact, in my eyes, he was the best and has never been equaled to this day."[346]

CHAPTER 14
The Glamour Girl Killer

Life in Los Angeles was not quite panning out as John had envisioned. If he had imagined that the end of *Bizarre* would give him time to work on *Sweet Gwendoline*, he was sorely mistaken; money troubles had put Gwendoline on the back burner yet again. Without *Bizarre* magazine to help sustain him financially, he was forced to return to the world of photography. It was fast work for fast money, but it didn't feel like art. At times John wondered if the stars would ever align to bring him money, time, and inspiration in equal measure.

He finally began to feel his creativity returning with the discovery of a petite nineteen-year-old model named Judy. She was blonde like Sweet Gwendoline, easygoing, fun to work with, and amendable to any wild idea he might have for photographs. She lived less than 2 miles away from his West Hollywood apartment, making it easy to arrange photo shoots. And they seemed to have a good rapport—or so he thought. In midsummer of 1957, she abruptly abandoned him.

Nobody was sure where Judy had gone. There were rumors that she had run off with a photographer boyfriend, but nothing had been substantiated. The media shared photos of the pretty young missing model, leading more cynical friends to suggest that the whole thing was a publicity stunt.

For John, it was back to square one. He wasn't happy. Just what the hell had happened to Judy? Was she involved in some crazy bid for publicity? She wanted to make it big in the modeling business, he knew, and it sometimes seemed that women in Hollywood would stop at nothing to get in the papers. But she also had a small child to support and an angry ex-husband who didn't like her modeling. Could he somehow be involved?

John continued to photograph other models, but he also continued to wonder. "There's still no word of what happened to her," he wrote in a personal letter in May 1958, nine months after Judy's disappearance.[347]

The truth was much worse than he could have imagined.

John wasn't the only photographer to land in Los Angeles in 1957. Early that same year, an awkward twenty-nine-year-old man named Harvey Glatman arrived in Hollywood from Denver, Colorado, and found an apartment just 4 miles down the road from John.[348] Like John, Glatman had spent some time in New York City and was fascinated with rope bondage. He wasn't a professional photographer, but it was a serious hobby—one he spent nearly all his time thinking about. The jug-eared, bespectacled Glatman arrived in Los Angeles with a Rolleicord camera and began haunting the local modeling studios, where attractive women posed by the hour for camera clubs and aspiring professional photographers.

It was in one such studio that Glatman claimed to have met the blonde pinup model Lynn Lykles.[349] Lynn was a veteran model from Florida who had also posed for photos in Irving Klaw's New York studio.[350] Although there is no evidence that she and John ever met, their shared circles added another link between John and Glatman. In July 1957, Glatman arrived unannounced at the West Hollywood apartment that Lynn shared with her two roommates, Betty Carver and Judy Ann Dull (who modeled under her maiden name, Judy Van Horn).

He arrived with his camera, hoping to arrange a private photo shoot with Lynn, but was disappointed to discover that she wasn't home. Betty was the only one of the three roommates at home that evening, and she had a friend over for a visit. She wasn't impressed by Glatman, who introduced himself as "Johnny Glynn," but she let him come in when he mentioned that he wanted to photograph Lynn for a magazine. While Betty was out of the room retrieving Lynn's modeling portfolio, Glatman's eyes landed on a photograph of Judy.

When Betty returned, Glatman insisted that he needed to photograph Judy. When would she be home? Betty offered to take Glatman's phone number, but he refused, stating that he would call her instead. Betty provided the phone number for the apartment and promised to tell Judy about the modeling opportunity.

Two days later, Glatman called Judy and explained the assignment he had to offer. He needed a model for a detective magazine—nothing unusual—and on the basis of the photo he had seen of her, she would be a perfect fit. Betty had warned Judy that "Johnny Glynn" seemed like an odd character, and Judy was initially resistant to meeting him. Then he made the perfect offer: he would photograph her in her own apartment, which would add to the realism of the photos and also allow her plenty of time to get ready for the other modeling assignments she had that day.[351] Judy agreed.

When Glatman arrived at Judy's Sweetzer Avenue apartment on August 1, he explained that plans had changed. They would need to shoot at his studio. Judy,

already prepared for photos, did not argue. She packed her bag with street clothes, as he suggested, and brought along additional outfits for her other jobs later that day. They left together, and Glatman left his phone number with Betty in case anyone needed to reach Judy.

Hours later, the phone was ringing in the apartment the three models shared. Where was Judy? She hadn't shown up for her other assignments, and Betty had her hands full apologizing to annoyed photographers. She promised to call to see what was keeping her roommate. But when she called the number Glatman had supplied, she knew something was very wrong. The number led to a mechanic's shop, and nobody there had ever heard of Johnny Glynn.[352]

Day turned to night. Betty, Lynn, and Judy's ex-husband, Robert, reported Judy missing to the police. As John had heard through the rumor mill, some suspected that Judy wasn't missing at all. Maybe she had run off with that photographer. Maybe she just wanted attention.

For most people, suspicions that Judy was faking her disappearance went away a few days later when she failed to show up at a custody hearing for her young daughter. Her friends couldn't believe that she would skip that.

Judy's ex-husband, twenty-two-year-old Robert Dull, wasn't so sure. To him, it seemed like just another stunt from his irresponsible ex-wife. "I don't know where my wife is and I don't care,"[353] he told reporters immediately after being awarded full custody of his daughter on August 9.

It would be over four months before Judy's body was found in the desert outside Los Angeles, and more than a year before she was identified as the victim.[354] She had been raped and murdered. On the night of her murder, Glatman tied her up under the pretext of taking bondage photographs for a crime magazine. He took photos of her before raping her repeatedly, driving her to the desert, and strangling her to death with a rope. Glatman would strike twice more, killing twenty-four-year-old mother Shirley Bridgeford (who was not a model and met Glatman through a lonely hearts club) and twenty-four-year-old model and dancer Ruth Mercado. In each case he followed the same routine: bind, photograph, rape, murder. He was finally apprehended in the fall of 1958 while attempting to subdue a fourth victim, Lorraine Vigil, who fought back and bravely turned Glatman's own gun on him.

The media gave him nicknames: Glamour Girl Killer, Pinup Killer. Some reports implied that the women were asking for trouble by modeling in the first place, yet another example of the "wall of mass ignorance" that John saw surrounding sexuality in the mid-twentieth century. Lorraine Vigil, the woman who ended Glatman's killing spree, was rewarded for her bravery with an eviction notice on her apartment door after the story hit the press.

"I don't like this publicity," Lorraine's landlady told the *Los Angeles Times* just days after her tenant was attacked. "I warned Lorraine about the hazards of being a model, but she would not listen to me."[355]

Diane Fox, owner of the modeling agency that employed Lorraine, scoffed at her employee's ordeal and maintained that she herself had also been targeted by the murderer. "I could see through that creep like a sieve," Diane bragged, referring to Glatman, whom she had met and introduced to Lorraine.[356]

When a reporter noted that Lorraine had "overpower[ed] the confessed killer in a fierce hand-to-hand battle," Diane was not impressed.

"He intended to kill me," she explained. "You know I'm smaller and thinner, and he probably would have won."[357]

Even some news outlets that lauded Lorraine's courage downplayed her role in taking down Glatman. Several newspaper accounts noted that the first police officer on the scene also happened to be "a former professional football player."[358]

"As alert law enforcement officers are supposed to, he could smell trouble," the *St. Louis Post-Dispatch* reported—a not-quite-accurate account, since the officer had happened upon the scene entirely by chance. With the arrival of the authorities, the paper explained, "Fate bowed out and routine police work took over."[359]

The police released some of Glatman's bondage photos to the press. The most revealing images were destroyed, but others—including Judy bound and gagged in a skirt and cardigan sweater— would not have looked out of place in *Bizarre* magazine, if they had been consensual rather than forced. When the police searched Glatman's apartment, they discovered that the walls were papered with bondage images cut out of magazines.[360]

Judy's horrific murder affected the normally stoic John as nothing had affected him before. By all accounts, he was deeply saddened, disturbed, and wracked with guilt over his perceived role in her death. Judy had only recently turned nineteen years old when she was murdered. She hadn't been in the business for long. Had her experiences modeling for John made her feel safe and secure working as a bondage model? Had he introduced her to bondage photography? Had she misjudged the phony photographer on the basis of her positive experiences with John?

Some friends said that John was afraid he had somehow been involved in the murder. Endless unanswered questions plagued him. Had he met Glatman? Perhaps suggested the photo studio where Glatman met Judy's roommate, Lynn? John received fan mail from a lot of men who wanted to talk to him about his work, and he sometimes

swapped stories with other artists and photographers over a pint at the bar. Maybe he had been drinking? Maybe he had met Glatman but didn't realize how weird he was. Maybe he just seemed like any other gawky, unsophisticated man who didn't have any social grace to speak of, whose entire life revolved around fantasy. John had met those men many times. Other men tracked him down with the specific intention of meeting his models. Maybe . . .

But it was all maddening speculation on his part. Despite running in similar circles in Los Angeles, there is no evidence to suggest that John ever met Glatman, let alone led him to Judy's door. The only person responsible for Judy's death was Harvey Glatman himself.

The guilt, of course, ran deeper. John had grown tired of *Bizarre*, tired of photography, tired of struggling through life and having very little to show for it. John knew better than to put stock in the newspaper articles that blamed the victims for their own deaths, arguing that women shouldn't model. But it was impossible not to wonder how things might have been different if Judy had never become involved in the industry in the first place. It was an industry John had, in many ways, come to detest. His life's work had been a collection of images that someone like Glatman loved and emulated. Yes, John's artwork brought comfort, happiness, and gratification to many people—men and women alike. They had told him as much in their letters. But it also attracted someone sick like Glatman. And now Judy and two other women were dead.

Harvey Glatman was executed in 1959 for the murders of Shirley Bridgeford and Ruth Mercado. Lorraine Vigil, sobbing openly at her horrifying experience, was the star witness at his trial and ensured his conviction. Glatman was never tried for Judy's murder, which occurred in a different jurisdiction from the slayings of Shirley and Ruth. The details came out at trial anyway, and for weeks the papers were full of Judy's smiling face.

CHAPTER 15
New Directions

Judy's murder weighed heavily on John's mind. The news coverage of the Glatman slayings served as a constant reminder that John's own lifelong sexual proclivities—and those of his fan base—were shared with a madman. It also, of course, brought constant reminders of Judy. She had been one of the first models John worked with in Los Angeles, and he called her "one of the best models I've had in years." It was distressing to watch the terrifying details of her murder emerge.

"This drawing idea was like flogging a dead horse anyway—but with her I guess I could have humped over the hill," he wrote of Judy shortly after her disappearance. "She was lovely as all get out, and a vain little bugger, but not unduly so."[361]

Adding to the stress and sadness were the undeniable similarities between himself and Glatman, which could not have been lost on John. Although they came from very different worlds, in the eyes of law enforcement they were similarly situated. Both men photographed nude or scantily clad women, often tied up with rope. Both traveled in underground circles. And both engaged in criminal or "borderline" criminal activity. The authorities would have liked to see both put away: Glatman to the gas chamber for rape and murder, and John to federal prison for obscenity. But despite the superficial similarities, John knew the core of his own sexuality was quite different from Glatman's.

"I don't like extreme cruelty—your real flagellant is a most vicious person," John had written to a correspondent in 1950, underscoring the difference between consensual sadomasochism and the violence of a criminal like Glatman.[362] John's "cruelty" was always of a consensual variety, ensuring that both he and his submissive partners were experiencing pleasure in the activity.

The murders also left John questioning his profession. Again he considered walking away from the adult industry, but he couldn't afford to leave. His entire life had been dedicated to his work. Instead he withdrew, maintaining a low profile and trying to

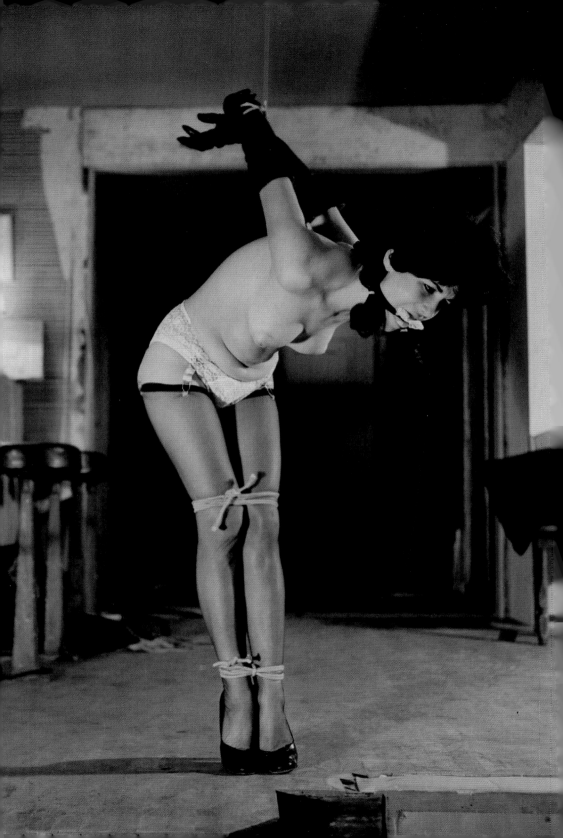

forget the terrible events surrounding him. He spent much of 1958 quietly working on his favorite creative outlet, the character of Sweet Gwendoline. He also reluctantly continued his photography, arranging photoshoots with select models regularly in his West Hollywood apartment.

John's return to the "sex photo selling business" was complicated by Judy's death and the discovery of Harvey Glatman's secret stash of bondage magazine photos. If he had previously felt that producing images "to give some frustrated guy a kick" was distasteful, it was now nearly impossible. John felt a new contempt for his audience that had not been present before.

"The regular customers become absolute cranks," he wrote bluntly to Dr. Gebhard. "I have met one or two—which is why I flatly refused to meet anymore."[363]

It was a departure from his attitude earlier in his career. As editor of *Bizarre*, he had been known to personally respond to letters from fans, spending countless hours offering support, suggestions, or encouragement. A reader who contributed photographs to *Bizarre* during John's tenure as editor reported being "surprised to receive a long and friendly letter from J.W."[364] in return. After exchanging correspondence, the pair met on several occasions.

Another amateur photographer and *Bizarre* reader recalled decades later his regular correspondence with John in the early 1950s, which included free artistic critiques: "He was forever trying to help me out in my bondage photography. I remember one letter where he said that my gags looked a little phony and asked me to try his method."[365]

It is impossible to imagine a more business-savvy fetish purveyor such as Irving Klaw offering suggestions to strangers—free of charge—about how to gag a submissive, but while publishing *Bizarre*, John valued the community aspect of the work. In the early years of the magazine, he even offered his original artwork for free to readers who had inspired the pieces. "In future if your letter appears in print and J.W. takes it into his head to illustrate it, you may obtain his original by simply writing in for it—for nothing," he wrote in issue 3.[366]

But in the late 1950s, as he neared the end of his career, his weariness became ever more apparent. His well-intentioned but naive efforts to help people had led nowhere. He was disillusioned with the industry and with the demands of his fan base. Although he had often worked on commission in the early years as a way of making extra money, he now routinely answered "no" to any fan who wrote requesting specific photographs

◀ Model Pat Conley strikes a challenging pose.

or drawings. "Pandering to [a customer's] weakness for the sake of a buck (which I'm still doing because I need it) I find rather more nauseating than somewhat," he explained to Dr. Gebhard.[367]

Despite his frustration, John still felt some obligation to the community he had built with *Bizarre*. In one 1958 letter to a fan, John advised that he didn't "ordinarily bother to answer letters" and again refused a commission for special work. However, he did take the time to reassure the fan of his sexual "normalcy."

"As to your being 'different,' I can assure you that there are millions the same as you all over the world," John wrote. "It always takes 2 to make a party & there are plenty of fair damsels whose tastes coincide with yours in every way."[368]

It had been three decades since John had discovered *London Life* in MacNaught's shoe store, yet he had not forgotten the fearful feeling of being "different" from everybody else—nor the relief at learning that he was not the only shoe fetishist on Earth. That John still made an effort to support a fellow sexual outsider, even after refusing money and a commission, is a testament to his integrity and his dedication to sexual freedom in a distinctly sex-negative world.

John also maintained a few relationships with customers he had originally met in New York. One, a wealthy collector known as "A Manhattanite," visited John and even photographed a favorite model in bondage while John assisted.[369] Another fan recalled visiting him in Los Angeles in the late 1950s, after Judy's death.

"At the time I visited him he looked drawn and tired, and not in the best of health," the fan wrote. "He told me he had been drinking too much, and was annoyed with himself for having recently been cited for mixing his drinking and driving. He seemed disillusioned and bitter. . . . I was disappointed not to see any of his [drawings or paintings], and he said that he hadn't done any for a long time."[370]

Judy's murder also brought difficult memories of accusations that had seemed ludicrous before. *Behind the Scene* magazine had reported in 1956 that some fetishists would kill to acquire the objects of their obsession. That same year, John himself had mocked the article's suggestion that "every reader of *Bizarre* is a homicidal maniac." Now it seemed there was at least one such maniac in the magazine's midst—Harvey Glatman—and perhaps there were more.

Meanwhile, the pressure on "smut peddlers" that began with the Kefauver hearings on juvenile delinquency had not abated. In 1960, Postmaster General Summerfield published a book about the history of the post office and used the opportunity to send grave warnings to those who might attempt to send obscene matter through the mails.

"The obscenity racketeers will yield only as they are literally driven out of business," Postmaster Summerfield wrote. "Nothing will touch them short of constant action by the Post Office Department, constant pressure by the public for adequate legislation and prosecution, and the most rigorous punishment the courts can apply."[371]

The postmaster general's book was just one arm of a multipronged approach to the continued fight against obscenity in the mails. In the late 1950s, Summerfield employed a group of women to travel the country speaking against obscene materials, armed with examples of "smut" seized from the mail.[372] Another initiative was a private pornography museum—"kept under lock and key near [Summerfield's] office in the Post Office Department"[373]—which displayed obscene materials for visiting reporters and members of Congress. From 1953 to 1961, the Post Office Department even employed a special cancellation stamp that stated boldly, "REPORT OBSCENE MAIL TO YOUR POSTMASTER."[374] (The cancellation stamps were ultimately eliminated "after some complaints about their appearance on Christmas cards and other personal mail.")[375]

In 1959, Postmaster Summerfield established a citizens' advisory board to explore the issue of obscenity in the mails. The board included a committee chairman of the National Organization for Decent Literature (NODL), the group that had organized public boycotts against businesses that sold risqué literature.

Summerfield argued that the advisory board would be "in no sense of the word ... a censorship body." Rather—in a definition that sounds suspiciously like a censorship body—the board would help the postmaster general determine "whether or not a specific piece of literature submitted for mailing is obscene and should be denied access to the United States mails."[376] One thing was certain: the adult mail-order business was a difficult proposition under Postmaster Summerfield's watch. He tirelessly worked to ensure that the attention of the nation remained fixed on the issue of obscene publications, with the ultimate goal of eradicating such material from public view.

Although he had grown weary of the adult industry, John's photography style matured in Los Angeles. By late 1958, he had whittled his list of models to just a few trusted names. One of the most important additions to his roster was a professional model named Pat Conley. Pat's expressive face, fearless attitude, and ability to handle difficult bondage scenarios with grace and ease made her one of the most important models of John's Los Angeles period. His photographs of Pat were often unusual: wrapping her in plastic, contorting her body into backbends, and tying her nude outdoors. Among his rare nude photographs are a series he took of Pat at the famous

Spider Pool, a Hollywood Hills landmark formerly owned by eccentric silent film actor Jack McDermott. The swimming pool, called the Spider Pool because of a distinctive wall tiled to resemble a spider in a web, served as a popular pinup photography site for a wide array of mid-twentieth-century photographers and models.

Pat was a regular fixture in men's magazines of the 1950s, finding steady work as a model in standard pinup photography as well as in John's bondage material. She was also an occasional actress, starring in the Edgar G. Ulmer film *The Naked Venus* in 1959 and appearing in numerous short striptease loops. Born Patricia Pauline Conley in tiny Wetumka, Oklahoma, on November 29, 1937, she left her hometown for Los Angeles in the mid-1950s. It seemed like the place to be for a young woman like Pat, who could sing, dance, and model. She also had a flair for the arts, especially sculpture and bronzes.

Pat quickly gained popularity as a model. She was natural and versatile and appeared equally comfortable in studio portraits or outdoors. The famous pinup photographer Peter Gowland featured Pat in several of his books, and more than one men's magazine published feature photo stories about her.[377] John would continue to photograph Pat for the remainder of his career, and the professional relationship resulted in some of the most enduring images of his Los Angeles years.

Pat was one bright light in the otherwise difficult year of 1958. Another high point occurred in November, when John released *Sweet Gwendoline and the Race for the Gold Cup*, a beautiful comic book that represents some of his best work. *The Race for the Gold Cup* was a substantially reworked version of the original *Sir D'Arcy D'Arcy* comic strip; John had rewritten the panels, expanded the character development, and improved the artwork, adding additional details to strengthen the continuity of the story.

In a letter to his mailing list, John advertised the comic strip in typically purehearted terms:

> In this cartoon I take a villain, as low as they come . . . give him a sensuo[u]s companion, and throw in a handful of pretty girls who are always just about coming out of their clothes—add a heroine who invariably is tied up, or chained up, to await her doom—stir the whole thing briskly—pour on corn by the bucketful—and present it to you, the reader.[378]

Although it was a creative triumph, *The Race for the Gold Cup* would also be his last completed work featuring Gwendoline. He continued to draw but was once again compelled to focus on photography for pay.

▲ A successful model before she met John, Pat Conley appeared on many magazine covers.

CHAPTER 16
Kitan Club: Bondage in Japan

In 1958, the same year he released *Sweet Gwendoline and the Race for the Gold Cup*, John began corresponding with an American military man named "Doc" who was stationed in Japan. Although John had left *Bizarre* nearly two years prior and moved on to new projects, the fondness that fans felt for the magazine had not diminished. As previously noted, the final issue of the magazine still has letters from readers addressed to "John Willie," as if they might will him back into being as the editor of their favorite fetish publication. And for those fans just discovering the magazine, it was still a fresh revelation more than a decade after its debut.

Like *London Life* before it, *Bizarre* was not limited to its country of origin. At least one letter in the magazine came from a writer who claimed to be a British man stationed in India. Many readers shared exotic tales of lands they had visited during the war. While the details of the stories may have been exaggerated, it is likely that many readers really had seen places such as Germany, France, or the South Pacific.

By the 1950s, the aesthetics of *Bizarre* found an audience even among those with only a rudimentary understanding of the English language, and the images were pirated in Germany and parts of Asia. The most important new audience was Japan, and the ensuing interplay between John and his fellow fetishists in Japan would change both Japanese and Western bondage forever.

It might seem like *Bizarre* was the only magazine of its kind available in the 1940s, and in some sense this is correct. Part of the reason *Bizarre* developed such a large and devoted fan base so quickly was because it fulfilled a need for readers that had gone largely ungratified since the discontinuation of *London Life*'s correspondence column.

But outside the United States, similar work was afoot. Thousands of miles away in Japan, a group of artists were hard at work on their own fetish magazine: *Kitan Club*.

The first issue of *Kitan Club* (Strange Tales Club) appeared in 1947—one year after *Bizarre*'s debut—under the editorship of Minoru Yoshida. Yoshida initially envisioned *Kitan Club* as a standard *kasutori* (pulp) magazine, featuring provocative drawings of nude women and other sensationalistic fare popular in postwar Japan (*kasutori* is a word that refers to the lowest grade of the Japanese rice wine *sake*, used popularly to denote "lowbrow" or cheaply produced magazines). Artist Toshiyuki Suma joined the staff in 1948; his influence guided the magazine in the direction of sadomasochistic content, which would ultimately become its signature. It was Suma's extraordinary artwork—created under a variety of names, including Kou Minomura and Reiko Kita—that provided polish to early issues of *Kitan Club* and helped establish its unique aesthetic.

Although *Kitan Club* contained drawings of bound women as early as 1948, bondage and sadomasochism (SM) did not become the exclusive focus of the magazine until 1952. The postwar American occupation of Japan ended that year, and with it ended the intense media restrictions of the era. Recognizing the increasing popularity of sadomasochistic material, the magazine turned away from general interest content in favor of the niche fetish market. *Kitan Club* published *kinbaku* (Japanese erotic bondage) photographs for the first time in 1952; these images added to the magazine's appeal and became a central element of each issue.[379]

Like *Bizarre*, *Kitan Club* published letters from both women and men and openly encouraged female sexuality. In September 1953, the magazine published a "roundtable discussion" with *kinbaku* models, moderated by established model Tanako Kawabata. Kawabata was a sought-after artists' model who could withstand difficult rope ties and was also known for her ability to tie herself in traditional bindings. At the roundtable, the women discussed their work as models, how it felt to be bound, and issues of safety at photo shoots.

Although some of the women—including Kawabata—expressed a genuine pleasure in bondage, most viewed the work strictly as a job. Asked about a particular *kinbaku* photograph that appeared in *Kitan Club*, one model candidly responded, "The photo was taken when I was thinking that I would want to finish the photo shoot early and go to the cinema."[380]

In 1953, Toshiyuki Suma left *Kitan Club* to establish his own magazine, *Uramado* (Rear Window). *Uramado* billed itself as "Japan's Most Remarkable SM Magazine" and eventually became a direct rival to *Kitan Club*.

In a special edition issue released in December 1953, *Kitan Club* published the work of John Willie for the first time.[381] The appearance of John's work also represents the first time a Western artist appeared in *Kitan Club*. Interestingly, the piece they chose was not taken from the pages of *Bizarre* magazine. The image, a painting of a curvaceous blonde woman bound at the wrists and ankles in a barn, was a supplement to the two-part story "From Girl to Pony," which appeared in issues 11 and 12 of *Bizarre* in 1952. John sold these supplemental illustrations separately because, as he explained in issue 11, "space does not permit their inclusion in these pages."[382] (In fact, the supplemental illustrations often featured bare breasts or other elements that made them too risqué for public distribution in a mid-twentieth-century American magazine.) The supplemental illustrations were "printed in a suitable size to fit in the magazine,"[383] allowing readers to add the pages directly into the story they were intended to illustrate.

In experimenting with the inclusion of Western artists, *Kitan Club*'s editors had unwittingly stumbled upon a gold mine. Though unethical, pirating the work provided new and exciting content for free. Unbeknownst to John until much later, his work would appear in every issue of *Kitan Club* for nearly a year and half (and in many issues thereafter). Though they did not ask permission or compensate John for the work, *Kitan Club* often stated that the images were "imported" or "Western" and eventually began noting in print that the work was from *Bizarre*.[384] Later Japanese fetish magazines, including Toshiyuki Suma's very popular *Uramado*, also included pirated artwork from *Bizarre*.[385]

John's drawings, paintings, and photographs were extremely popular with readers and inspired a change in the style of *Kitan Club*'s domestic artists. Prior to 1953, most of the magazine's bondage photographs featured nude models or models clad in traditional kimono. After the introduction of John's work, there was a sharp increase in images of women in Western garments. *Kitan Club* also introduced images of dominant Japanese women and submissive men, a decision likely inspired by the popularity of John's artwork, which sometimes featured dominant women. Prior to this point, female subjects in *Kitan Club* always adopted a submissive role in photographs and drawings. The popularity of John's work also inspired *Kitan Club* and *Uramado* to pirate work from other American bondage artists, including Eric Stanton's contemporary Gene Bilbrew, as well as photographs from Irving Klaw's studio.[386] (It was Irving who later introduced Dr. Alfred Kinsey to *Kitan Club*.)[387]

Kitan Club's piracy did not end with artwork. On at least one occasion, the editors also published correspondence from *Bizarre*, translated into Japanese and accompanied by John's illustrations.[388] Articles exploring "overseas sadism" in general were another popular addition to the magazine and frequently featured spot illustrations created by John or inspired by his work.

In 1955, things began to change for *Kitan Club*. The April issue was the first issue in nearly a year and a half to feature no artwork or photography from *Bizarre*. The May issue of *Kitan Club* was banned by Japanese authorities, and the magazine ceased publication for several months. (In 1959, Irving Klaw described the magazine as "widely distributed and sold all over Japan for quite some time until they were banned by pressure groups because they were going too far in their illustrations.")[389] When it resumed regular publication in 1956, the magazine featured fewer illustrations, and its full-color covers were replaced by black-and-white images. John's artwork continued to appear in *Kitan Club*, with decreasing frequency, through at least December 1957. *Kitan Club* continued publication until March 1975, but the magazine's golden age had ended.

Though Western bondage artwork was new to most Japanese readers in the 1950s, bondage itself was not. Rope bondage has a long history in Japan, including its use in earlier eras as a means of restraining and binding prisoners. During the Edo period (1603–1868), rope suspension was an officially accepted means of torture to extract confessions from suspected criminals.[390] In the Meiji period (1868–1912), some artists began exploring *kinbaku* more openly in their work.

One such artist was Seiu Ito, a man who might be described as John Willie's Japanese counterpart. Ito was a multitalented innovator in a manner similar to John, and he went on to become a major contributor to *Kitan Club*. Ito was born in 1882, and his interest in bondage began in childhood.[391] He was photographing women in bondage by the early 1920s and, like John, typically used his photographs as references for drawing and painting. Also like John, one of Ito's early models was his wife, Kise Sahara. Both men were vocally opposed to bondage photographs that featured weak ties from which a model could easily escape.

In the early twentieth century, Ito became fixated on an 1885 woodblock print by the artist Yoshitoshi titled *Lonely House on Adachi Moor*. The dramatic print features a heavily pregnant woman tied in bondage and suspended, inverted, over the fire of a cruel *onibaba* (demon hag). Ito desperately wanted to re-create the image in reality, and in 1921 he photographed his pregnant wife, Kise, in a nearly identical re-creation. It was an extremely dangerous proposition to bind and suspend a pregnant woman, and the broad dissemination of this image made Ito infamous as a *kinbaku* artist.[392] He also photographed his wife in a notorious series called *Snow Torture*, in which she was bound nude in the snow. Ito's work, like John's, would ultimately inspire generations of bondage artists in his home country.

KITAN CLUB: BONDAGE IN JAPAN

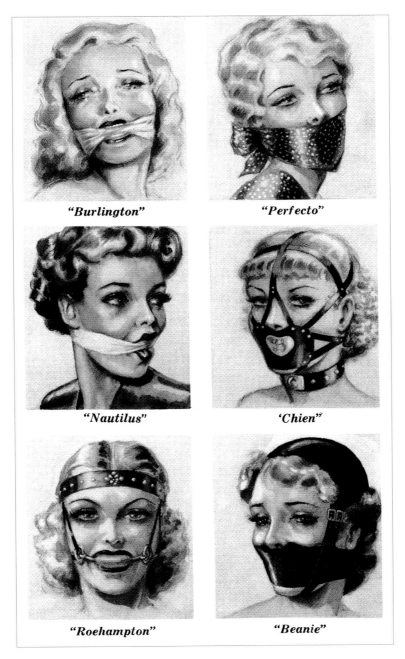

▲ One of many images from *Bizarre* that later appeared in *Kitan Club*

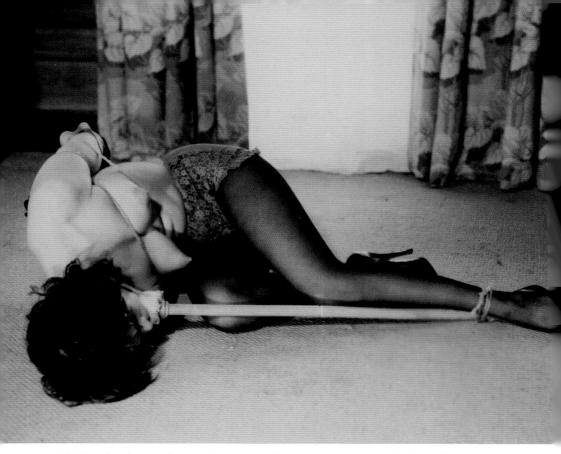

▲ John's Los Angeles–era photography incorporated Japanese elements such as this long pole.

How did John's digest-sized, self-published magazine make its way around the world in the 1950s? John's mailing list included a worldwide clientele, and it is possible that some issues of *Bizarre* landed in the hands of *Kitan Club* staff through Doc, John's correspondent in Japan. Doc was a fan both of Japanese fetish magazines and *Bizarre*. When he saw a drawing from *Bizarre* in *Kitan Club*, he graciously sent the issue to John in the United States.

Beginning in the late 1950s, the Kinsey Institute also traded issues of *Bizarre* with a Japanese doctor and sex researcher who would in turn supply the institute with Japanese fetish materials, including issues of *Kitan Club*. Kinsey staff would at times mail up to six issues of *Bizarre* at a time and developed a fruitful exchange policy with their overseas counterparts.[393]

"I have read through all three *Bizarres* and they interested me very much," the Japanese doctor wrote to Dr. Wardell Pomeroy, longtime colleague of Dr. Kinsey, in June 1959. "I am glad to hear you will kindly send me six more . . . I hope this exchange of magazines will last for many and many years."[394]

John was not flattered to learn that his work was being pirated in a foreign magazine (as Sir D'Arcy might say, "Foiled again!"). He was particularly perturbed by the fact that *Kitan Club*'s country of origin was Japan, a place that he—like many postwar Westerners—still considered enemy territory. It is clear, however, that he examined the work in *Kitan Club* carefully. Slowly, traditional Japanese styles of bondage began to appear in his own work.

Bondage aficionados often praise John's ropework for its beauty and perfectionism. It is also interesting to note how his style of tying evolved over the years. John's earliest photographs from Australia typically feature simple bonds at the wrists, ankles, and midsection. John's ropework became more complex after arriving in New York in the 1940s, perhaps as a result of the influence of new friends such as Little John (the bondage fan who taught the ropes to Irving and Paula Klaw) and Charles Guyette. It is during the New York years that John's creativity in the bondage field truly becomes apparent. But after 1958, when John presumably first saw the work of Japanese artists such as Seiu Ito, he began to incorporate new elements into his ropework that had previously been unknown in the West.

As *kinbaku* practitioner and researcher Master "K" has noted, we see in John's Los Angeles photos details such as rope suspension and the incorporation of long wooden poles.[395] While these ideas were very unusual among Western bondage enthusiasts in the late 1950s, they had been common in Japan for centuries. John admitted in a letter to Doc that he planned to "try out these Jap punishment ties" in his own photography.[396] One image from John's Los Angeles years features his model Pat Conley bound with a wooden pole in her mouth; the November 1957 issue of *Kitan Club* features drawings of this exact form of popular Japanese bondage, along with easy-to-follow illustrated instructions for the dedicated bondage enthusiast. In some cases, it appears that John carefully examined photographs from magazines such as *Kitan Club* and *Uramado* and then attempted to re-create the ties on his own models. Master "K" points out the most blatant example of this: John's use of the *ebi* or shrimp tie, which is one of the most famous ties in Japanese bondage but was almost entirely unknown in 1950s America.[397] The *ebi* tie is a unique binding technique in which the torso and neck are tied to the ankles in a cross-legged position, and John made use of this in his Los Angeles–era artwork.

In 1961, John admitted the influence of Japanese bondage on his own style.

"The Japanese . . . are now gallant allies of the USA," he wrote sarcastically when asked about the broad piracy of his work in Japan. "Those bastards will steal anything that isn't nailed down. But at the same time I've learnt a lot from them too."[398]

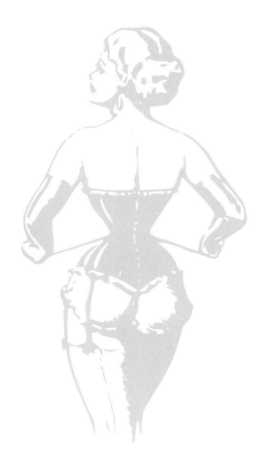

Chapter 17

"Bury Me by Some Sweet Garden-Side"

John's Los Angeles years weren't always easy, but they were anything but stagnant. His style matured, and he had a loyal fan base thanks to his reputation as a talented and fastidious artist who mailed out only the highest caliber of bondage art. Although his goal was to work primarily on his comics, the need for money brought him back to photography again and again.

Finally, after some work, John believed he had found a way to continue his latest Sweet Gwendoline project, *The Wasp Women*. He was, as usual, frank with the members of his mailing list.

"When Newstand [*sic*] Distribution at 50 [cents] fell through, I had to go into Mail Order to get out from under," he wrote in a letter distributed en masse to his readership, continuing:

> Now it is impossible to draw AND run a Business, and, without going into details, I can assure you that to find someone whom I could rely on to help me has been a problem. At last I have solved it. *Operation Wasp Women* is out of moth balls, but will take at least 2 months to put into commission.[399]

John's excitement didn't last long, and he soon sent another letter with bad news. After advertising new bondage photographs of Pat, he offered a sheepish postscript:

> In a previous form-letter I said that at last I thought I had found someone to run this office, and thus give me a free hand to draw and complete the next episode [of] *The Wasp Women*. (Famous last words)—I goofed. He ran it alright—just about into the ground. He was dishonest, pulled a lot of scurvy tricks, and is now 10,000 miles away out of my reach—dammit. (And he had excellent

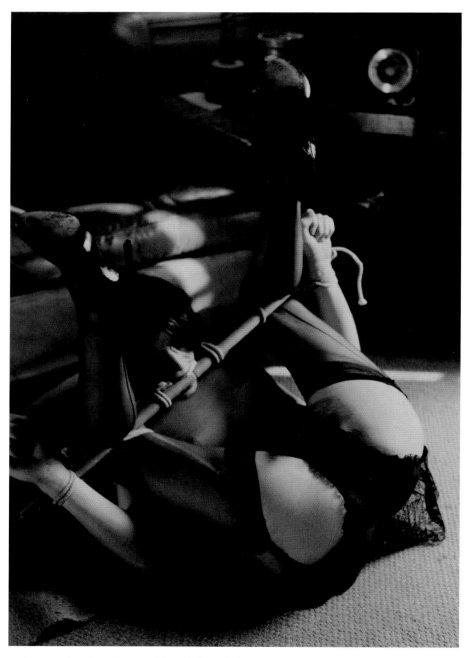
▲ A creative bondage photograph from the late 1950s

references too.) If you were one of those inconvenienced by his activities, I hope you will accept my apologies and realise that we can all make a mistake. It shall not be repeated.[400]

It was yet another major disappointment. Though John did continue to work on *The Wasp Women*, a series featuring the devilish Sir D'Arcy alongside corseted women with exaggerated wasp waists, the intriguing story was never completed.

In the late 1950s, John dove into the booming Los Angeles real estate market and purchased a home in North Hollywood. Although this would seem to imply a great increase in his financial status, John noted in a personal letter that homes in Los Angeles could be had for almost no money down, making home ownership a very attractive alternative to renting. He also set to work remodeling the house, which he hoped to eventually sell at a profit. With the exception of some specialized work, John was committed to doing all the renovations himself, tapping into his long history as a manual laborer.[401]

Remodeling was slow work, but in the meantime his new home was a near-perfect fit. He was walking distance from the post office, where he kept a mailbox and sent packages to his customers; he could also walk to a number of bars and liquor stores. The only real downside was the new distance placed between himself and the main action (and many models) of West Hollywood, but established models such as Pat were willing to travel a reasonable distance to work with him. He took many photographs in his new home, increasingly incorporating some of the Japanese bondage techniques he had learned from looking at the foreign bondage magazines. He earned enough money from his work to hire a new secretary, a woman he referred to in letters as his "girl Friday."[402]

It seemed that John had at last achieved some measure of stability. His customers and models were loyal, his work appreciated, and he even had a permanent place to live and a few extra dollars to spend at the bar. If he couldn't be described as "happy," he was certainly better off than he had been in many years.

In 1960, John began corresponding with Dr. Paul Gebhard, then director of the Kinsey Institute. Dr. Gebhard initially wrote to John to learn more about fetishism and sadomasochism, two topics the institute had been researching more deeply. At first, John was skeptical of the institute's academic approach.

"You are, like many others, interested in 'why?'" he wrote. "I never bothered about the 'why'—I simply accepted the situation as it stood."[403] Nonetheless, he made a concerted effort to answer Dr. Gebhard's questions about the appeal of fetish materials and the nature of fetishists, often writing for several pages at a time.

Dr. Gebhard also sent John money in exchange for his work, including photographs and issues of *Bizarre* that were missing from the Kinsey Institute's collection.[404]

With John's help, the institute collected a full run of *Bizarre*. The institute's interest in collecting every issue of *Bizarre* was a testament to the magazine's importance; although Dr. Gebhard and his colleagues collected many magazines, the proliferation of sex-based publications in the 1950s and '60s required them to become more selective. They frequently refused offers of periodicals that did not substantially contribute to the institute's research goals. The originality, popularity, and influential nature of *Bizarre* made it an important addition to the collection.

"If your research is based on the lines of *Bizarre* then publish a small book along those lines . . . in that book ask for correspondence—as I did—just stand back so you don't get snowed under by the letters," John suggested, perhaps only partly in jest. "Advertise the 2nd Edition in the first & you'll have all the data for your research that you could want—and also a small bloody fortune in which I expect to be generously included."[405]

In late 1960, Dr. Gebhard offered John work as a consultant for three days at the Kinsey Institute in Bloomington, at a rate of $25 per day plus free room, board, and transportation. Dr. Gebhard hoped that John would be able to assist with "a major study of sex in photography," sharing insight into John's own work and identifying works by other photographers.[406] Although it would have been a very special opportunity, it was not to be. In early 1961, John began experiencing health problems. By the spring, his symptoms—including diminished mobility, eyesight trouble, and lack of feeling in his limbs—were impossible to ignore. Recognizing John's poor health and advancing age, and eager to learn more about his work specifically and sadomasochism generally, the Kinsey Institute arranged for a recorded interview with John.[407] The interview took place in Arizona, where he believed he was recovering from his illness under the care of a doctor. Then came a worse diagnosis: John had a brain tumor.

Lacking health insurance, John recognized that his hopes of survival in the United States were limited. He used his savings to fly to London to seek treatment a British hospital. In England, doctors conducted emergency brain surgery to remove a cyst, which released some of the pressure on his brain. After returning to Los Angeles, however, he recognized that the removal of the cyst was not enough. Doctors at University of California, Los Angeles (UCLA), diagnosed him with cancer. It was almost certainly a death sentence, and John knew it.

"I only got the gory details a few days ago," he wrote. "I just said, 'Fuck it! What a bastard!'—open[ed] a can of beer & then lay back to contemplate."[408]

The prognosis was not good. John regretted not knowing of his diagnosis sooner, when he could have stayed in London for treatment.

"There at least I'd be looked after," he noted soberly. "Here—without money you can die in the gutter for all they care."[409]

John knew that if he hoped to recover, he would not be able to continue his mail-order business and battle cancer at the same time. As he set plans in motion to close his business, postal inspectors at last caught wind of his operations and approached him to shut down or risk fines and imprisonment. It was a turn of events that John had been anticipating for at least four years, ever since Estes Kefauver's Senate hearings on juvenile delinquency brought fetish content to the forefront of public consciousness. Although fetish material was still technically legal, John had personally seen the struggles of associates who faced sanctions for mailing "borderline obscene" material. Irving Klaw had been raked over the coals at the Senate hearings, was eventually barred from conducting business in the state of New York, and spent the end of his life fighting court battles in defense of his work. For John—who faced both serious health issues and a growing disdain for the fetish industry as a whole—a protracted legal battle was not realistic.

"I could perhaps have fought it but I was too tired," he wrote.[410]

Instead he was frank with the authorities, explaining his illness and his preexisting plans to close the business. The inspectors were unusually sympathetic, giving him four weeks to tie up loose ends and close for good.

"I pointed out that by closing I was NOT admitting my stuff was obscene," John wrote of his arrangement with the postal authorities. "They were simply pushing me ahead a few weeks."[411]

On June 12, 1961—nearly five years to the day since his departure from *Bizarre*—John broke the news of his illness to his mailing list. In his outward persona of John Willie, he remained steadfastly unemotional.

"There will be no more 'Gwendoline,' and the whole business will be closed as of June 25th," he wrote. "And now this is the end. It has been nice to have known you and I wish you the very best in your games of fun and nonsense."

He closed with a favorite stanza by Omar Khayyam:

Ah, with the Grape my fading Life provide,
And wash my Body whence the Life has died,
And in a Windingsheet of Vine-leaf wrapt,
So bury me by some sweet Garden-side.[412]

Showing integrity to the end, he promised to (and did) destroy his mailing list, a document he had carefully protected throughout his life. He also destroyed many of his photographs and all his negatives. The postal authorities had expressed their intention to seize John's cache of images; rather than lose control of his work, he chose to eliminate it.

Far from mourning the loss of his artwork, John felt some relief. His photography business had begun to feel problematic long before, and the feelings of guilt had intensified after his model Judy's murder in 1957.

"When the Postal Dep[artment] came in and cut short my business about a month before I was intending to quit I was absolutely delighted, & I cut up those negatives with glee," John wrote from the hospital in August. "At last I'd cut the Gaudion Knot & the relief mentally was immense. My 'Girl Friday' who watched the process like a twittering hen said 'John! How do you feel[?]' (she was horrified) & I answered, 'Never so happy in my life.'"[413]

John sought additional treatment for a short time at UCLA but was unable to live independently. He experienced double vision and partial blindness, and he was unable to lift his arms due to the toll the illness had taken on the section of his brain dedicated to fine motor skills. To his great sadness, this also meant that he was unable to draw—the one skill that had carried him through his entire life, both creatively and financially. It was a devastating blow to a man already struggling to hope for recovery. Where could he go next?

Harkening back to his lifelong love of fantasy stories, John wrote, "The Prince in the fairy tale confronted with 12 locked doors, all identical, & all leading to chaos except one has nothing on me for a choice."[414]

Dr. Gebhard of the Kinsey Institute visited John in the hospital in August 1961, even sneaking in a bottle of whiskey—which John, determined to overcome his illness, uncharacteristically refused.

"I love Scotch or if not available—Bourbon—but Alcohol, except in the form of a very very small amount is no good for my plague," he explained. As an alternative, he turned to Olympia beer, drinking "about 9 cans" in the weeks after his departure from the hospital.[415]

Dr. Gebhard later provided an update on John's health to Irving Klaw. "He is partially paralysed so that walking, writing, and drawing are difficult and his vision is a bit impaired," he wrote. "Nevertheless there is no self-pity or complaining in the man, and I admire his fortitude."[416]

John sold his home at a loss and returned to England to be cared for by his older sister, who lived on the small island of Guernsey. For a man accustomed to big cities, world travel, and physical activity, Guernsey's slow pace was excruciating. John repeatedly expressed gratitude for his sister's care, but he felt frustrated by his physical limitations, which were slow to improve. He worked daily on physical rehabilitation, eventually walking 1 to 2 miles per day. Ever the tinkerer, he created a pulley system in his sister's garage to exercise his arms, eventually gaining the strength to dress and undress himself without assistance.[417] He began to feel optimistic about overcoming the cancer and even made plans to return to Los Angeles and reopen his business. Although he had exited the industry in disgust, financial need forced his hand even in the depths of his illness.

"My social security payments have stopped so I have to make a move," John explained in a letter. "I have no intention of bumming off my sister. She can't afford it anyway."[418]

Despite all the troubles he had encountered, he may even have found himself missing the work that had sustained him for so many years. The negative attitude he had adopted about his work in Los Angeles gave way to a sense of nostalgia as he neared the end of his life. He had ideas for new, improved materials and expressed an interest in finding an artist who could imitate his style and create *Sweet Gwendoline* comics under his direction.

"It's a pity that I flipped my lid & threw away my mailing list, negatives & house but that's one of those things,"[419] he wrote. He began asking Dr. Gebhard about the photographs at the Kinsey Institute, and if they could be copied to help reestablish his business in the United States. Dr. Gebhard agreed to create copy images of some of the work to help jump-start the effort.

Ultimately, it was not to be: although John Coutts knew he had more to contribute, he never returned to America. He died in his sleep on August 5, 1962, at the age of fifty-nine.[420]

As John approached death, he had adopted a pragmatic attitude. "I'm a good old agnostic so I don't worry about it & to be candid I am a bit tired of life," he wrote of his illness. "All my old friends in England & elsewhere are dead & gone & the only thing that annoys me—& I am annoyed—is that after the life I've led and the risks I've taken I have to go out this way. It's so bloody silly."[421]

Epilogue

John Alexander Scott Coutts traveled the world in his lifetime, living on four continents before dying quietly in a small village off the coast of England. His contributions to the world of fetish art are immeasurable. Today we see the influence of John Willie's artwork everywhere, from fashion runways to the walls of art galleries—and of course in the aesthetics of almost every classic fetish subculture around the globe. His ideas have by now fed the sexual ideas and fantasies of generations of people. Men and women have tattooed his work on their bodies, a turn of events that he no doubt would have found delightful. With his iconic illustrations and the groundbreaking content of *Bizarre* magazine, he is perhaps the one person most responsible for introducing fetish style to the mainstream.

Of course, John's work did not exist in a vacuum. The majority of his contemporaries, like John himself, faced difficulties later in life. After fighting endless legal battles of his own, Irving Klaw departed New York City for New Jersey, where he attempted to continue his mail-order business under the name Nutrix. He died in 1966 at the age of fifty-five. Edythe Farrell, pioneering businesswoman and editor of Robert Harrison's pinup magazines, died by suicide in her swimming pool at the age of forty-seven in 1961. Both Robert himself and "G-String King" Charles Guyette lived into the 1970s. Bettie Page outlived them all, overcoming personal difficulty and mental illness and dying in 2008 at the age of eighty-five.

John Willie's work hangs in no major museums; mainstream art critics have ignored him. This is not unusual for an artist who once described his own work as "all commercial."[422] But the effect that *Bizarre* and *Sweet Gwendoline* had on the fetish community spread far and wide, ultimately invading the mainstream. By the 1960s, countless other bondage magazines appeared for sale, each attempting to recapture the popularity of

EPILOGUE

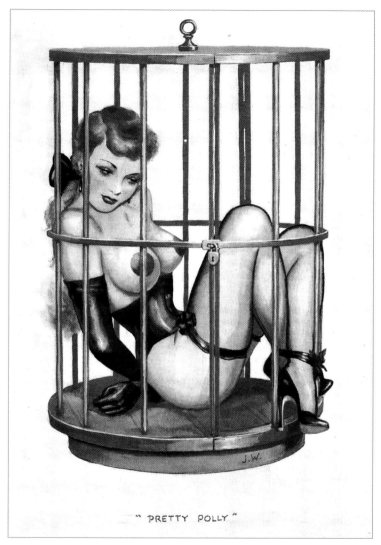

▲ "Pretty Polly," from *Bizarre* issue 20

Bizarre. Many of the magazines used the word "bizarre" as a euphemism for bondage and fetish material—a turn of phrase John helped popularize with the introduction of his publication in 1946. In the 1970s, John's work found a new audience among the punk scenes of England and the United States. The popular band Adam and the Ants used his artwork on early promotional materials such as T-shirts and pinback

buttons. Iconic punk fashion designer Vivienne Westwood and others began adopting *Bizarre*-style bondagewear as fashion; the punk sensibility eventually spread to the wider rock music sphere, and soon bands and fans around the world were embracing the bondage aesthetic.

"I don't think any of us were really sure exactly what bondage was," rock musician David Lee Roth recalled of the 1970s style trend. "We just knew that the leather belts looked cool."[423]

In time, high-end designers such as Jean Paul Gaultier and Thierry Mugler also adopted bondage style as an influence. The pages of *Bizarre* have come to life many times over in the decades since its publication: unnatural hair colors, tattoos, piercings, miniskirts, plastic shoes, and lingerie as outerwear are just a few of the fashion predictions John and his readers suggested that later came true.

In 1984, *Sweet Gwendoline* provided inspiration for the French film *The Perils of Gwendoline in the Land of the Yik-Yak*, directed by erotic filmmaker Just Jaeckin (best known for his 1974 film *Emmanuelle*) and starring American actress Tawny Kitaen as Gwendoline. Although the film does not follow a traditional *Sweet Gwendoline* storyline as established by John, it attempts to capture the signature mix of eroticism, humor, silliness, and heart present in the original comic. It also features bondage, nudity, and seminude women pulling chariots—three details always sure to meet with the John Willie stamp of approval!

Those who discovered John's artwork after his death were no less enchanted than readers who first saw his drawings in the 1940s. Books and pamphlets dedicated to John's work have been published since at least the 1970s. When the publishing house Taschen rereleased every issue of *Bizarre* in two bound volumes in the mid-1990s, it helped introduce John Willie to an entirely new generation of fans. This coincided with a renewed cultural interest in John's contemporaries Irving Klaw and Bettie Page (Bettie was believed to be "missing" throughout the 1980s and early 1990s, leading to intense public speculation and a general interest in her role in the 1950s fetish and pinup modeling world). Today, John Willie's artwork is frequently shared on social media, and his sophisticated style remains popular and impactful eight decades after it first appeared in print.

Even more critical than the influence of John's art is the influence of his ideas about sex, love, and personal expression. His ideas matched the ethos of the sexual revolution, which was just beginning at the time of his death. John argued for freedom of expression in matters such as dress, gender identity, and sexuality—all matters that were subject to criminalization in the mid-twentieth century and remain hotly debated today. For readers of *Bizarre*, the magazine was much more than entertainment. It represented a community of like-minded individuals, an environment where uncommon sexual

interests could be freely shared among other adults. As they shared in their letters, fans were inspired by John's work to live more openly and authentically.

John had no way of knowing that his work would remain appreciated, imitated, and beloved the world over so many years after his death. Nor could he know that his influence would extend so far. As for his own opinion of his impact, John was characteristically modest. "As to any influence I had on Klaw or any of the magazines that followed *Bizarre*—that's all balls," he wrote to Dr. Gebhard. "Every smart operator realised that here was something for which people would pay good money—and yet which apparently could be sold openly—so they just copied me—and then did as I did or went even better—and gave the customer what he wanted."[424]

But can we truly reduce the man's work to "giving the customer what he wanted"? John's artwork, though largely commercial in nature, was at its core about the tension of fantasy and reality. From his childhood fantasies of knights in shining armor and princesses tied to trees sprang a lifetime of other dreams, sexual fantasies that he brought to life in pen and ink. He imagined a different world, one that was kinder to sexual difference, and he worked to build this environment for himself and his fans. But throughout his life, John's fantasies were tempered by the rock of reality: brutal labor, oppressive poverty, legal issues, and dreams that fell to pieces around him. It is a testament to his character that he continued to work and to dream, creating the images that fuel the dreams of others and building a bridge to a different future—beyond his lifetime—that is a little closer to his ideal.

❖ ❖ ❖

Notes

1. "Strangler of 3 Leads Police to 2 Girls' Graves," *Evening Star* (Orlando, FL), October 21, 1958.
2. "Capture of Killer Told by Model," *San Francisco Examiner*, November 1, 1958.
3. Ibid.
4. "Strangler of 3 Leads Police to 2 Girls' Graves."
5. Ibid.
6. Ibid.
7. "Hid Bodies in Desert," *Shreveport Times* (Shreveport, LA), October 31, 1958.
8. *Casper Tribune-Herald* (Casper, WY), October 31, 1958.
9. "Mild-Mannered Repairman Admits Killing 3 Models," *Reporter-News* (Abilene, TX), October 31, 1958.
10. J. B. Rund, *The Adventures of Sweet Gwendoline by John Willie* (New York: Belier, 1999), 299.
11. John Coutts letter to Paul Gebhard, October 10 [1960], Dr. Paul H. Gebhard Era Correspondence, correspondence concerning recordings, cartoons, and photography on the subject of erotica, Kinsey Institute for Research in Sex, Gender, and Reproduction, Indiana University, Bloomington.
12. Ibid.
13. *Stanley v. Georgia*, 394 U.S. 557 (1969)
14. John Coutts, interview by Dr. F. A. Shannon, 1961–1962, audio, Library and Special Collections, Kinsey Institute for Research in Sex, Gender, and Reproduction, Indiana University, Bloomington.
15. 1911 England Census [database online] (Provo, UT: Ancestry.com Operations, 2011).
16. Ibid.
17. Rund, *The Adventures of Sweet Gwendoline by John Willie*, vi.
18. Coutts, interview.
19. Ibid.
20. Ibid.
21. Ibid.
22. Ibid.
23. *Patons List of Schools and Tutors: An Aid to Parents in the Selection of Schools* (London: J and J Paton, 1911), xix.
24. Ibid., 68.
25. Coutts, interview.
26. Ibid.
27. Ibid.
28. John Coutts letter to Paul Gebhard, October 10 [1960], Dr. Paul H. Gebhard Era Correspondence, Kinsey Institute for Research in Sex, Gender, and Reproduction, Indiana University, Bloomington.
29. "Fine Bowling by W. Honeyman," *Dundee Courier*, July 16, 1920.
30. Ibid.
31. "History of Glenalmond," Glenalmond College, accessed January 2, 2019, http://www.glenalmondcollege.co.uk/about-us/history-of-glenalmond.
32. Royal Military College Form 18A, "Particulars regarding John Alexander Scott Coutts," Sandhurst Collection.
33. Martin Gilbert, *Churchill: A Life* (New York: Holt, 1991), 32, 37.
34. Royal Military College Cadet Register, 1923, The Sandhurst Collection.
35. Ibid.
36. Report for the Term Ending December, 1922 on Gentleman Cadet Coutts, J. A. S., Sandhurst Collection.
37. Royal Military College, Fourth Term, July 1923, Gentleman Cadet Coutts, J. A. S., Sandhurst Collection.
38. Royal Military College Cadet Register.
39. "Regular Forces: Infantry," *London Gazette*, August 31, 1923.
40. "Historic Croydon Airport," Historic Croydon Airport London, accessed January 21, 2019, http://www.croydonairport.org.uk/The-Airport.
41. "Art and Artists," *Observer* (London), April 19, 1925.
42. John Coutts letter to Paul Gebhard, August 24 [1961], Dr. Paul H. Gebhard Era Correspondence, correspondence concerning recordings, cartoons, and photography on the subject of erotica, Kinsey Institute for Research in Sex, Gender, and Reproduction, Indiana University, Bloomington.
43. Coutts, interview.
44. "Marriages Registered in July, August and September, 1925," *England & Wales, Civil Registration Marriage Index, 1916–2005* [database online] (Provo, UT: Ancestry.com Operations, 2010).
45. Karl Baedeker, *London and Its Environs: Handbook for Travellers* (London: T. Fisher Unwin, 1923), 380.
46. Baedeker, *London and its Environs*.
47. E. Charles Vivian, *The British Army from Within* (New York: George H. Doran, 1914), 146–47.
48. Jon Pardoe, *Captain Malcolm Kennedy & Japan, 1917–1945*, doctoral thesis, University of Sheffield, 1990, 69.
49. *UK and Ireland, Outward Passenger Lists, 1890–1960* [database online]. Lehi, UT: Ancestry.com Operations, 2012.
50. Ibid.
51. Coutts, interview.
52. *New South Wales Police Gazette and Weekly Record of Crime* (Sydney, Australia: 1860–1930), December 7, 1927 [issue no. 49], 704.
53. *New South Wales Police Gazette and Weekly Report of Crime* (Sydney, Australia: 1860–1930), July 11, 1928 [issue no. 28], 454.
54. Coutts, interview.
55. Ibid.
56. "Crocodile Hunting on the Kennedy River," *Cairns Post*, October 26, 1948.
57. "Crocodile Dines on Fence Wire," *Courier Mail* (Brisbane, Australia), August 7, 1948.
58. "Croc. Hunting Is Thrilling," *Daily Bulletin* (Townsville, Queensland), October 23, 1948.
59. "Coutts v Coutts," *Sydney Morning Herald*, September 28, 1929.

NOTES

60. "In Divorce," *Sydney Morning Herald*, July 23, 1930.
61. *Australia, Marriage Index, 1788–1950* [database online], Lehi, UT: Ancestry.com Operations, 2010.
62. "Shooting Crocs," *Australian Women's Weekly*, February 1, 1947, 19.
63. *Queensland, Australia, Commonwealth Electoral Rolls, 1906–1969* [database online], Lehi, UT: Ancestry.com Operations, 2022.
64. Frank G. Clarke, *History of Australia* (Westport, CT: Greenwood, 2002), 120.
65. Annie Stevens, "Skint! Making Do in the Great Depression," Museums of History New South Wales, accessed May 17, 2023, https://mhnsw.au/stories/general/skint-making-do-great-depression/.
66. "Defining Moments: Great Depression," National Museum Australia, updated September 27, 2022, https://www.nma.gov.au/defining-moments/resources/great-depression.
67. B. J. Costar, "The Great Depression: Was Queensland Different?," *Labour History*, May 1974, 33.
68. Costar, "The Great Depression: Was Queensland Different?," 37.
69. "Van Eyk Reported Dead!," *Truth* (Sydney, Australia), January 7, 1940.
70. "Hardly Fair," *Brisbane Courier*, August 8, 1930.
71. "They Clapped Too Loud," *Evening News* (Rockhampton, Queensland), August 11, 1930.
72. "Van Eyk's Hocus Pocus," *Truth* (Sydney, Australia), February 23, 1936.
73. "Van Eyk's Hocus Pocus."
74. J. A. S. Coutts, "A Relief Worker's Suggestion," *Telegraph* (Brisbane, Australia), January 25, 1933.
75. Coutts, "A Relief Worker's Suggestion."
76. Clarke, *History of Australia*, 123.
77. "King's Cross: Australia's 'Little Paris,'" *Pix*, April 13, 1940, 22–25.
78. Coutts, interview.
79. Ibid.
80. Ibid.
81. Ibid.
82. Ibid.
83. Lisa Z. Sigel, "Fashioning Fetishism from the Pages of *London Life*," *Journal of British Studies* 51, no. 3 (July 2012): 671.
84. Coutts, interview.
85. Ibid.
86. Ibid.
87. Rund, *The Adventures of Sweet Gwendoline by John Willie*, 21.
88. Robert V. Bienvenu II, *The Development of Sadomasochism as a Cultural Style in the Twentieth-Century United States*, PhD diss., University of Indiana, 1998, 90.
89. Quoted in Bienvenu, *The Development of Sadomasochism as a Cultural Style in the Twentieth-Century United States*, 90.
90. Bienvenu, *The Development of Sadomasochism as a Cultural Style in the Twentieth-Century United States*, 91.
91. Ibid., 92–93.
92. Coutts, interview.
93. Ibid.
94. Ibid.
95. Ibid.
96. "Registered Firms," *Dun's Gazette for New South Wales* 59, no. 8 (February 21, 1938): 206, accessed May 27, 2023. https://nla.gov.au/nla.obj-769493052/view?partId=nla.obj-769501909#page/n5/mode/1up/.
97. Coutts, interview.
98. Quoted in Bienvenu, *The Development of Sadomasochism as a Cultural Style in the Twentieth-Century United States*, 93.
99. Coutts, interview.
100. Ibid.
101. Ibid.
102. Ibid.
103. Achilles, "High Heels," *Bizarre* 2 (1946): 7.
104. High Heel Artiste, "Furred Heels," *Bizarre* (1956): 55.
105. "Footwear Fantasia," *Bizarre* (1954): 14.
106. Coutts, interview.
107. Ibid.
108. Ibid.
109. Quoted in Bienvenu, *The Development of Sadomasochism as a Cultural Style in the Twentieth-Century United States*, 76.
110. "Government Decision to Ban Pornographic Magazines Has Increased Sales," *Smith's Weekly* (Sydney, Australia), July 16, 1938.
111. "Registered Firms," *Dun's Gazette for New South Wales* 62, no. 11 (September 11, 1939): 200, accessed May 27, 2023. https://nla.gov.au/nla.obj-769853177/view?sectionId=nla.obj-781882863.
112. "Text of Official Statement on Shoe Rationing," *New York Times*, February 8, 1943.
113. Ibid.
114. Coutts, interview.
115. "Holly Anna Faram Coutts," Find a Grave, originally posted January 4, 2017, https://www.findagrave.com/memorial/174874292/holly-anna-coutts.
116. "Woolloomooloo," *Dictionary of Sydney*, State Library of New South Wales, accessed September 13, 2019, https://dictionaryofsydney.org/entry/woolloomooloo.
117. "Pioneer of the Nude Models," *People*, April 12, 1950, 33.
118. "London College of Music," *Sydney Morning Herald*, December 28, 1929.
119. "Artist's Model . . .," *Wireless Weekly*, July 8, 1938, 39.
120. Ibid.
121. "The Social Round," *Telegraph* (Brisbane, Australia), May 22, 1934.
122. "Pioneer of the Nude Models," 31.
123. "The News behind the Nudes," *Smith's Weekly* (Sydney, Australia), August 20, 1938.
124. "Second Australian Imperial Force Personnel Dossiers, 1939–1947," series B883, National Archives of Australia, Canberra, Australian Capital Territory, Australia.

125. "Pioneer of the Nude Models," 32.
126. "Sydney Sculptress Works 18 Hours a Day," *Pix*, August 13, 1930, 41.
127. "New Art for New Theatre," *Labor Daily* (Sydney, Australia), June 23, 1938.
128. Loma Lautour, *Scrapbook* [manuscript], 1935–1953, QAGOMA Research Library.
129. "Artists' Models' Union," *Daily Telegraph* (Sydney, Australia), November 20, 1936.
130. "Models Seek Award," *Daily Telegraph* (Sydney, Australia), February 24, 1938.
131. "Cold Job Posing in the Nude," *Labor Daily* (Sydney, Australia), July 8, 1937.
132. Ibid.
133. Alwyn Lee, "Coals to Newcastle," *Daily News* (Sydney, Australia), February 8, 1939.
134. Coutts, interview.
135. "Artist's Model . . .," *Wireless Weekly*, July 8, 1938, 39.
136. "Enlistment Standards," Australian War Memorial, last updated January 3, 2020, https://www.awm.gov.au/articles/encyclopedia/enlistment.
137. "Second Australian Imperial Force Personnel Dossiers, 1939–1947," series B883, National Archives of Australia, Canberra, Australian Capital Territory, Australia.
138. *Australia, Marriage Index, 1788–1950* [database online] (Lehi, UT: Ancestry.com Operations, 2010).
139. Coutts, interview.
140. Ibid.
141. Ibid.
142. *New York, U.S., Arriving Passenger and Crew Lists (including Castle Garden and Ellis Island), 1820–1957* [database online] (Lehi, UT: Ancestry.com Operations, 2010).
143. Ibid.
144. *Massachusetts, U.S., Arriving Passenger and Crew Lists, 1820–1963* [database online] (Lehi, UT: Ancestry.com Operations, 2006).
145. "Pioneer of the Nude Models," 33.
146. Ibid.
147. *Daily Telegraph* (Sydney, Australia), February 12, 1947.
148. "Pioneer of the Nude Models," 32.
149. "FARAM, Grace Helena," *Sydney Morning Herald*, August 24, 1960.
150. *Memories: Kings Cross 1936–1946* (Potts Point, Australia: Kings Cross Community Aid and Information Service, 1981), 50.
151. *Australia Cemetery Index, 1808–2007* [database online] (Provo, UT: Ancestry.com Operations, 2010).
152. "Holly Anna Faram Coutts," Find a Grave, originally posted January 4, 2017, https://www.findagrave.com/memorial/174874292/holly-anna-coutts.
153. Sigel, "Fashioning Fetishism from the Pages of *London Life*," 665.
154. "*Redheap* Prohibited," *Chronicle* (Maryborough, Queensland), May 23, 1930.
155. "Man Gaoled for Filthy Photos," *Evening Advocate* (Innisfail, Queensland), November 20, 1945.
156. "Editor!," *Bizarre* 4 (1946): 5.
157. *Bizarre* 3 (1946, reprinted 1953): 2.
158. Quoted in Bienvenu, *The Development of Sadomasochism as a Cultural Style in the Twentieth-Century United States*, 97.
159. "Editor!," *Bizarre* 2 (1946, reprinted 1953): 3.
160. Coutts, interview.
161. "Back Numbers," *Bizarre* 4 (1946): 3.
162. Needle, "Well Tattooed," *Bizarre* 2 (1946, reprinted 1953): 38.
163. XYZ, "A Question of Heels," *Bizarre* 2 (1946, reprinted 1953): 39.
164. Quoted in Bienvenu, *The Development of Sadomasochism as a Cultural Style in the Twentieth-Century United States*, 96.
165. Editor, *Bizarre* 6 (1951): 41.
166. *Bizarre* 3 (1946, reprinted 1953): 35.
167. John Coutts letter to mailing list [February 1956], Vertical Files, Sado Masochistic Erotica Producers (United States) (20th century)—Coutts, John Willie, Kinsey Institute for Research in Sex, Gender, and Reproduction, Indiana University, Bloomington.
168. *Bizarre* (1956): 6–7.
169. "Our Next Issue Vol. 3," *Bizarre* 2 (1946, reprinted 1953): 37.
170. *Englishwoman's Domestic Magazine* 15 (1872–77): 55, accessed January 15, 2022, https://archive.org/details/sim_englishwomans-domestic-magazine_1872-1877_15/page/54/.
171. *Englishwoman's Domestic Magazine* 18 (1872–77): 223, accessed January 15, 2023, https://archive.org/details/sim_englishwomans-domestic-magazine_1872-1877_18/page/222/.
172. Ibid. 165.
173. "Sir D'Arcy D'Arcy—Episode 1," *Bizarre* 3 (1946, reprinted 1953): 33.
174. John Coutts letter to Paul Gebhard, September 1961, Dr. Paul H. Gebhard Era Correspondence, Kinsey Institute for Research in Sex, Gender, and Reproduction, Indiana University, Bloomington.
175. S.W., *Bizarre* 5 (1952): 12.
176. C.H. McC., "Dammit Countess, Here's a Cad," *Bizarre* 6 (1951): 57.
177. Gauron, "A Challenge to Carolyn," *Bizarre* 8 (1952): 17.
178. John Coutts letter to Paul Gebhard, June 12 [1961], Dr. Paul H. Gebhard Era Correspondence, Kinsey Institute for Research in Sex, Gender, and Reproduction, Indiana University, Bloomington.
179. "Editor!," *Bizarre* 3 (1946, reprinted 1953): 4.
180. Ibid.
181. Carl McGuire, "Letter from P.O. Box 162, Montreal," *A John Willie Portfolio*, September 1987, 6.
182. Carl McGuire, "Remembering 'A Manhattanite,'" *Bondage Life* 81 (October 2000): 38.
183. *Within a Story*, Kinsey Institute for Research in Sex, Gender, and Reproduction, Indiana University, Bloomington.
184. John Coutts letter to Paul Gebhard, October 10 [1960], Dr. Paul H. Gebhard Era Correspondence, Kinsey Institute for Research in Sex, Gender, and Reproduction, Indiana University, Bloomington.

185. Les Biederman, "The Scoreboard," *Pittsburgh Press*, March 6, 1951.
186. Ibid.
187. Harold C. Burr, "Cricket Bowler Comes Up with New Dodger Gadget," *Brooklyn Daily Eagle*, June 25, 1950.
188. Richard Pérez Seves, *Charles Guyette: Godfather of American Fetish Art*, Vintage Fetish (Lexington, KY: CreateSpace, 2017), 119.
189. John Coutts letter to Paul Gebhard, December 15 [1960], Dr. Paul H. Gebhard Era Correspondence, Kinsey Institute for Research in Sex, Gender, and Reproduction, Indiana University, Bloomington.
190. Pérez Seves, *Charles Guyette: Godfather of American Fetish Art*, 134.
191. Henry E. Scott, *Shocking True Story: The Rise and Fall of Confidential, "America's Most Scandalous Scandal Magazine"* (New York: Pantheon Books, 2010), 14–15.
192. "Manhood Restored," *National Police Gazette*, January 28, 1893, retrieved July 31, 2022, https://archive.org/details/sim_national-police-gazette_1893-01-28_61_804/page/n13/mode/.
193. Jeanette Smits, "Girl Editor Feels Able to Decide What Men Will Like," *Evening News Magazine* (Buffalo, NY), July 5, 1941.
194. Pérez Seves, *Charles Guyette: Godfather of American Fetish Art*, 131
195. Corinne Hardesty, "Sex and Crime Ageless, Styleless," *Post-Gazette* (Pittsburgh, PA), December 6, 1941.
196. Smits, "Girl Editor Feels Able to Decide What Men Will Like."
197. Adelaide Kerr, "Woman Edits Gazette," *New York Post*, June 26, 1941.
198. Smits, "Girl Editor Feels Able to Decide What Men Will Like."
199. "She Edited the Police Gazette . . . ," *New York Post*, March 8, 1961.
200. Henry E. Scott, *Shocking True Story*, 16.
201. Ibid.
202. Jack Olsen, "Magazine Caters to Lowest Tastes," *Courier* (Waterloo, IA), November 28, 1955.
203. "You Said It Babe," *Flirt*, June 1949, 26.
204. Coutts, interview.
205. Ibid.
206. Ibid.
207. Ryan Paul, "Impressions," *Bondage Life*, July 1977, 48.
208. Coutts, interview.
209. Irving Klaw letter to Alfred Kinsey, March 20, 1950, "Large correspondence between Irving Klaw and Kinsey regarding the exchange of materials and insights into the reception of his work," Dr. Alfred C. Kinsey Era Correspondence, Kinsey Institute for Research in Sex, Gender, and Reproduction, Indiana University, Bloomington.
210. *Hannegan v. Esquire, Inc.*, 327 U.S. 146 (1946).
211. Patricia Robertus, "Obscenity in the Mails: Controls on Second-Class Privileges, 1942–1957," paper presented at the annual meeting of the Law Division, Association for Education in Journalism (Ottawa, ON: August 1975), 6.
212. Robertus, "Obscenity in the Mails," 24.
213. "Mailing Rights Restored to Police Gazette," *Buffalo News* (Buffalo, NY), September 1, 1943.
214. Coutts, interview.
215. Ibid.
216. Courtney Ryley Cooper, *Designs in Scarlet* (Boston: Little, Brown, 1939), 238–39.
217. Art Spiegelman, "Those Dirty Little Comics," in Bob Adelman, *Tijuana Bibles: Art and Wit in America's Forbidden Funnies, 1930s–1950s* (New York: Simon & Schuster, 1997), 5.
218. Gloria Leonard, "Interview with Paula Klaw," *High Society*, October 1980, https://www.americansuburbx.com/2013/05/interview-about-irving-klaw-interview-with-paula-klaw.html.
219. Ibid.
220. Bienvenu, *The Development of Sadomasochism as a Cultural Style in the Twentieth-Century United States*, 107.
221. Gloria Leonard, "Interview with Paula Klaw."
222. Quoted in Bienvenu, *The Development of Sadomasochism as a Cultural Style in the Twentieth-Century United States*, 107–08.
223. *The Irving Klaw Years, 1948–1963* (North Hollywood, CA: Harmony Communications, 1976), 12.
224. *Movie Star News* 29 (1949), 23, "Sadomasochistic Erotica Producers (United States) (20th Century)—Klaw, Irving," Kinsey Institute for Research in Sex, Gender, and Reproduction, Indiana University, Bloomington.
225. *Irving Klaw: The Pin-Up King* [February 1950], 2, "Sadomasochistic Erotica Producers (United States) (20th Century)—Klaw, Irving," Kinsey Institute for Research in Sex, Gender, and Reproduction, Indiana University, Bloomington.
226. *Irving Klaw: The Pin-Up King* [June 1950], 4, "Sadomasochistic Erotica Producers (United States) (20th Century)—Klaw, Irving," Kinsey Institute for Research in Sex, Gender, and Reproduction, Indiana University, Bloomington.
227. *Irving Klaw: The Pin-Up King*, n.d., 2, "Sadomasochistic Erotica Producers (United States) (20th Century)—Klaw, Irving," Kinsey Institute for Research in Sex, Gender, and Reproduction, Indiana University, Bloomington.
228. Quoted in Bienvenu, *The Development of Sadomasochism as a Cultural Style in the Twentieth-Century United States*, 107.
229. R. Q. Harmon, "A Conversation with Eric Stanton," *Bondage Life* 76 (1999): 23.
230. For example, Eric Stanton and Gene Bilbrew, both recent graduates of the School of Visual Arts in New York City when they began working for Klaw.
231. Irving Klaw letter to Alfred Kinsey, March 13, 1950, "Large correspondence between Irving Klaw and Kinsey regarding the exchange of materials and insights into the reception of his work," Dr. Alfred C. Kinsey Era Correspondence, Kinsey Institute for Research in Sex, Gender, and Reproduction, Indiana University, Bloomington.
232. Richard Pérez Seves, *Eric Stanton & the History of the Bizarre Underground* (Atglen, PA: Schiffer, 2018), 31.

233. Alfred Kinsey letter to Irving Klaw, October 3, 1949, Dr. Alfred C. Kinsey Era Correspondence, "Large correspondence between Irving Klaw and Kinsey regarding the exchange of materials and insights into the reception of his work," Kinsey Institute for Research in Sex, Gender, and Reproduction, Indiana University, Bloomington.
234. Ernest Havemann, "The Kinsey Report on Women," *Life*, August 24, 1953, 45.
235. Ibid.
236. Ibid., 48.
237. "Flood of Kinsey Book Reaction Praises, Condemns, Ignores," *Evening Star* (Washington, DC), August 21, 1953.
238. "Postal Ban Urged on Kinsey's Book," *New York Times*, August 30, 1953.
239. "Flood of Kinsey Book Reaction Praises, Condemns, Ignores."
240. Jonathan Gathorne-Hardy, *Sex the Measure of All Things: A Life of Alfred C. Kinsey* (Bloomington: Indiana University Press, 2000), 42.
241. Ibid., 121.
242. Ibid., 124.
243. "Marriage Class Gains 11 Pct. in Semester," *Brooklyn Citizen*, April 6, 1939.
244. Gathorne-Hardy, *Sex the Measure of All Things*, 127.
245. As quoted in "Exchange Extras," *Aurora Bulletin* (Aurora, IN), October 6, 1938.
246. Allan M. Brandt, *No Magic Bullet: A Social History of Venereal Disease in the United States since 1880* (New York: Oxford University Press, 1985), 129.
247. Maurice Bigelow, *Sex-Education* (New York: Macmillan, 1936), 11–12.
248. Quoted in Donna J. Drucker, "'A Noble Experiment': The Marriage Course at Indiana University, 1938–1940," *Indiana Magazine of History*, September 2007, 246.
249. Paul Gebhard letter to John Coutts, January 7, 1961, Dr. Paul H. Gebhard Era Correspondence, Kinsey Institute for Research in Sex, Gender, and Reproduction, Indiana University, Bloomington.
250. Paul Gebhard letter to John Coutts, October 6, 1960, Dr. Paul H. Gebhard Era Correspondence, Kinsey Institute for Research in Sex, Gender, and Reproduction, Indiana University, Bloomington.
251. John Coutts letter to Paul Gebhard, October 10 [1960], Dr. Paul H. Gebhard Era Correspondence, Kinsey Institute for Research in Sex, Gender, and Reproduction, Indiana University, Bloomington.
252. John Coutts letter to Paul Gebhard, November 9 [1960], Dr. Paul H. Gebhard Era Correspondence, Kinsey Institute for Research in Sex, Gender, and Reproduction, Indiana University, Bloomington.
253. "There Is a Mrs. Kinsey: She Supports His Views," *Gazette* (Montreal), July 2, 1948.
254. "Destruction of Kinsey Material Asked," *Daily Times* (Seattle, WA), July 17, 1957.
255. "Kinsey Tangles with Customs: Are Scientific Pictures Lewd?," *Evening Star* (Washington, DC), November 17, 1950.
256. Press release, November 17, 1950, quoted in Kenneth R. Stevens, "United States v. 31 Photographs: Dr. Alfred C. Kinsey and Obscenity Law," *Indiana Magazine of History*, December 1975, 304.
257. "Decision Alters Obscenity Rule," *Evening Star* (Washington, DC), January 3, 1958.
258. Gathorne-Hardy, *Sex the Measure of All Things*, 438.
259. "Obscenity Bars Not Down, Official Says," *Catholic Times* (Columbus, OH), January 10, 1958.
260. Irving Klaw letter to Alfred Kinsey, February 7, 1950, Dr. Alfred C. Kinsey Era Correspondence, Kinsey Institute for Research in Sex, Gender, and Reproduction, Indiana University, Bloomington.
261. "Editor!," *Bizarre* 6 (1951): 5.
262. "Back Numbers," *Bizarre* 12 (1953): 3.
263. "We Are Going to Have a Rest!," *Bizarre* 12 (1953): 5.
264. John Coutts letter to Paul Gebhard, July 18 [1962], Dr. Paul H. Gebhard Era Correspondence, Kinsey Institute for Research in Sex, Gender, and Reproduction, Indiana University, Bloomington.
265. Don, "Looking for Trouble?," *Bizarre* 15–16 (1955): 18.
266. L.M., "And Relaxing," *Bizarre* 20 (1956): 54.
267. J. Foster, "White Circle Club," *Bizarre* 22 (1957): 51.
268. Coutts, interview.
269. Ibid.
270. "Fancy Dress," *Bizarre* 3 (1946, reprinted 1953): 18.
271. Edna K., "A Sensible Solution," *Bizarre* 8 (1952): 23.
272. Mr. and Mrs. D.E., "Wood-Craft," *Bizarre* 17 (1956): 35.
273. Gauron, "More Agin the Dungarees," *Bizarre* 9 (1952): 37.
274. B.J., "Bloomers for Men," *Bizarre* 10 (1952): 45–46.
275. Raymond, "Beauty in a Riot of Colour," *Bizarre* 5 (1946): 20.
276. "Nini Ninette Ninon," *Bizarre* 14 (1954): 37.
277. C.H. McC., "Dammit Countess, Here's a Cad," *Bizarre* 6 (1951): 58.
278. "He Weds Man; Is Arrested by Cop as Flirt," *Brooklyn Daily Eagle*, October 11, 1937.
279. "A Critical Commentary," *Bizarre* 11 (1952): 64–65.
280. V. Vale and Andrea Juno, *Modern Primitives* (San Francisco: V/Search, 1989), 23–24.
281. Stacey Asip-Kneitschel, "Vampira Actress Maila Nurmi: The Last Interview—Part 1," Please Kill Me, originally posted September 7, 2017, https://pleasekillme.com/vampira-actress-maila-nurmi-part-1/.
282. Paul Gebhard letter to John Coutts, October 6, 1960, Dr. Paul H. Gebhard Era Correspondence, Kinsey Institute for Research in Sex, Gender, and Reproduction, Indiana University, Bloomington.
283. Vale and Juno, *Modern Primitives*, 23–24.
284. Courtney Ryley Cooper, *Designs in Scarlet* (Boston: Little, Brown, 1939), 234.
285. *Roth v. United States*, 354 U.S. 476 (1957)
286. Charles L. Fontenay, *Estes Kefauver: A Biography* (Knoxville: University of Tennessee Press, 1980), 180–82.

287. Ibid., 182.
288. *Hearings before the Subcommittee to Investigate Juvenile Delinquency of the Committee on the Judiciary,* United States Senate, Eighty-Fourth Congress, first session, May 24, 26, 31, and June 9 and 18, 1955 (Washington, DC: United States Government Printing Office, 1956), 70.
289. Ibid., 212.
290. Ibid., 214.
291. Ibid., 226–27.
292. Ibid., 231.
293. Ira Steven Levine, "Bettie Page: The Case of the Vanishing Pinup," *Rolling Stone*, November 16, 1989, accessed September 10, 2022, https://www.rollingstone.com/culture/culture-news/bettie-page-the-case-of-the-vanishing-pinup-204454/.
294. "P.O. Starts Drive on Lewd Matter Glutting Mails," *Courier-Post* (Camden, NJ), March 19, 1955.
295. M. J. Huber, "Help Clean up the Mails!," *The Liguorian*, July 1959, 9.
296. "Fancy Dress for Special Evenings and the Peacock Parade," *Bizarre* 12 (1953): 20.
297. National Organization for Decent Literature, *The Drive for Decency in Print* (Huntington, IN: Sunday Visitor Press, 1939), 23.
298. Ibid., 26.
299. "Freedom to Read," *Arizona Librarian*, October 1953, 17.
300. "You Can't Print That Stuff in a Magazine," *Behind the Scene*, May 1956, 27.
301. Ibid., 27.
302. Ibid., 56.
303. Scott, *Shocking True Story*, 17–18.
304. Inez Robb, "Cat-o'-Nine-Tale," *Time*, August 8, 1955, 66; quoted in Samantha Barbas, "The Most Loved, Most Hated Magazine in America: The Rise and Demise of *Confidential* Magazine," *William & Mary Bill of Rights Journal* 121 (2016): 190
305. Gladwin Hill, "Accord Approved for Confidential," *New York Times*, November 13, 1957.
306. Scott, *Shocking True Story*, 174.
307. Ibid., 187.
308. Samantha Barbas, "The Most Loved, Most Hated Magazine in America: The Rise and Demise of *Confidential* Magazine," *William & Mary Bill of Rights Journal* 121 (2016): 59.
309. Barbas, "The Most Loved, Most Hated Magazine in America," 190.
310. "Expose Mags Big Hit with Miami Public," *Miami Daily News*, November 13, 1955.
311. "We Speak," *Bizarre* 17 (1956): 5.
312. *Bizarre* 2 (1946, reprinted 1953): 1.
313. "We Are Going to Have a Rest!," *Bizarre* 12 (1953): 5.
314. Paul Gebhard letter to John Coutts, February 7, 1962, Dr. Paul H. Gebhard Era Correspondence, Kinsey Institute for Research in Sex, Gender, and Reproduction, Indiana University, Bloomington.
315. "Dammit! Read This . . . ," *Bizarre* 14 (1954): 27.
316. For example, see advertisement for *Bizarre* in *Vancouver Sun*, December 9, 1953.
317. "Editorial," *Bizarre* 20 (1956): 4.
318. Ibid.
319. Ibid.
320. Carl McGuire, "A Brochure from the New York Address," *A John Willie Portfolio*, September 1987, 19.
321. John Coutts letter to Paul Gebhard, March 19, 1962, Dr. Paul H. Gebhard Era Correspondence, Kinsey Institute for Research in Sex, Gender, and Reproduction, Indiana University, Bloomington.
322. Carl McGuire, "Letter from 230 Church St., New York," *A John Willie Portfolio*, September 1987, 12.
323. Carl McGuire, "Letter Mailed from 6715 Hollywood Blvd . . . ," *A John Willie Portfolio*, September 1987, 27.
324. Carl McGuire, "Letter from Los Angeles," *A John Willie Portfolio*, September 1987, 29.
325. Copyright Office, Library of Congress, *Catalog of Copyright Entries, Periodicals: January–June 1958* 12, part 2, no. 1 (Washington, DC: Library of Congress, 1959), 367.
326. Roland Trenary, *Mahlon Blaine: One-Eyed Visionary* (Kingston, WA: Grounded Outlet, 2015), 21, 23.
327. *Good Times: A Revue of the World of Pleasure* 1, no. 2 (1953): 3.
328. "Who'd Be an Editor!," *Bizarre* 24 (1958): 5.
329. Pierced-Nose, "En Ami," *Bizarre* 24 (1958): 53.
330. Blackmaster, "Rubber Clad," *Bizarre* 24 (1958): 36.
331. John Coutts letter to Paul Gebhard, October 10 [1960], Dr. Paul H. Gebhard Era Correspondence, Kinsey Institute for Research in Sex, Gender, and Reproduction, Indiana University, Bloomington.
332. "A New Mayor, a New Councilwoman . . . and 400 New Angels Every Day," *Life*, July 13, 1953, 23.
333. "Vice Versa at RKO Studios," ONE Archives at the USC Libraries, accessed May 6, 2023, https://one.usc.edu/story/vice-versa-rko-studios.
334. John Coutts letter to Paul Gebhard, January 6, 1961, Dr. Paul H. Gebhard Era Correspondence, Kinsey Institute for Research in Sex, Gender, and Reproduction, Indiana University, Bloomington.
335. Carl McGuire, "A Brochure from P.O. Box 1483, Hollywood," *A John Willie Portfolio*, September 1987, 31.
336. John Coutts letter to Paul Gebhard, August 24 [1961], Dr. Paul H. Gebhard Era Correspondence, Kinsey Institute for Research in Sex, Gender, and Reproduction, Indiana University, Bloomington.
337. John Coutts letter to Paul Gebhard, April 3 [1962], Dr. Paul H. Gebhard Era Correspondence, Kinsey Institute for Research in Sex, Gender, and Reproduction, Indiana University, Bloomington.
338. Coutts, interview.
339. John Coutts letter to Paul Gebhard, October 10 [1960], Dr. Paul H. Gebhard Era Correspondence, Kinsey Institute for Research in Sex, Gender, and Reproduction, Indiana University, Bloomington.

340. John Coutts letter to Paul Gebhard, April 3 [1962], Dr. Paul H. Gebhard Era Correspondence, Kinsey Institute for Research in Sex, Gender, and Reproduction, Indiana University, Bloomington.
341. Paul Gebhard letter to John Coutts, October 6, 1960, Dr. Paul H. Gebhard Era Correspondence, Kinsey Institute for Research in Sex, Gender, and Reproduction, Indiana University, Bloomington.
342. John Coutts letter to Paul Gebhard, October 10 [1960].
343. Ibid.
344. R.W., "John Willie: A Personal Look," *Bondage Life*, August 1989, 9.
345. John Coutts letter to Paul Gebhard, August 9, 1962, Dr. Paul H. Gebhard Era Correspondence, Kinsey Institute for Research in Sex, Gender, and Reproduction, Indiana University, Bloomington.
346. Nyle Baxter, "Back When It All Began," *Bondage Life*, February 1991, 9.
347. "'The Fun Begins': A Letter from J.W.," *Bondage Photo Treasures*, May 1984, 18.
348. Michael Newton, *Rope: The Twisted Life and Crime of Harvey Glatman* (New York: Pocket Books, 1998), 81.
349. Ibid., 103.
350. An advertisement for Irving Klaw's photos of Lynn appears in *Flirt*, August 1953, 38.
351. Newton, *Rope*, 106.
352. Ellery Queen, "Album of Death," *Palm Beach Post*, May 17, 1959.
353. "Missing Model's Estranged Husband Awarded Daughter," *San Bernardino County Sun* (San Bernardino, CA), August 10, 1957.
354. Newton, *Rope*, 118–19.
355. "Fourth 'Victim' Tells How She Fought for Life," *Los Angeles Times*, October 31, 1958.
356. Lou Jobst, "Modeling-Studio Owner Certain She Was Marked for Death by Sex Fiend," *Independent* (Long Beach, CA), November 1, 1958.
357. Ibid.
358. "Capture of Killer Told by Model," *San Francisco Examiner*, November 1, 1958.
359. Joseph Laitin, "The Man Who Strangled Models," *St. Louis Post-Dispatch*, November 9, 1958.
360. Newton, *Rope*, 173.
361. J. B. Rund, *Possibilities: The Photographs of John Willie* (New York: Belier, 2016), 232.
362. Rund, *The Adventures of Sweet Gwendoline by John Willie*, xvii.
363. John Coutts letter to Paul Gebhard, October 10 [1960].
364. *The First John Willie Bondage Photo Book*, February 1978, 32.
365. Nyle Baxter, "Back When It All Began," *Bondage Life*, February 1991, 9.
366. "Correspondence," *Bizarre* 3 (1946): 35.
367. John Coutts letter to Paul Gebhard, October 10 [1960].
368. *The Bound Beauties of Irving Klaw & John Willie, 1947–1963, Volume Two*, May 1977, 60.
369. "Los Angeles 1961: The Master Is There!," *Bondage Photo Treasures*, October 1986, 6.
370. *The First John Willie Bondage Photo Book*, 32.
371. Arthur Summerfield and Charles Hurd, *U.S. Mail: The Story of the United States Postal Service* (New York: Holt, Rinehart and Winston, 1960), 144
372. Bienvenu, *The Development of Sadomasochism as a Cultural Style in the Twentieth-Century United States*, 131–32.
373. "Postal Chief Junks Pornography Horde," *Capital Journal* (Salem, OR), February 3, 1961.
374. Bienvenu, *The Development of Sadomasochism as a Cultural Style in the Twentieth-Century United States*, 121.
375. "Postal Policies Due for Change," *Chattanooga Daily Times*, March 20, 1961.
376. Summerfield and Hurd, *U.S. Mail*, 147–48.
377. For examples of magazine coverage, see *Adam*, 1960 Annual; *Adam*, September 1963; and *Mermaid* 1, no. 8.
378. Rund, *The Adventures of Sweet Gwendoline by John Willie*, 200.
379. Although some earlier examples exist, *kinbaku* photography began in earnest with *Kitan Club*'s July 1952 issue.
380. "Kawabata Tanako: Rope-Bottom Roundtable-Talk, from Kitan Club 1953," Kinbaku Books, originally posted April 6, 2015, http://kinbakubooks.wordpress.com/2015/04/06/kawabata-tanako-rope-bottom-roundtable-talk-from-kitan-club-1953/.
381. *Kitan Club*, special issue, December 1953, 2.
382. *Bizarre* 11 (1952): 32.
383. Ibid.
384. For example, see *Kitan Club*, November 1954, 8.
385. *Uramado*, August 1962.
386. For examples of Klaw's work, see (among others) *Kitan Club*, June 1954; for Bilbrew, see *Uramado*, April 1962 and June 1962.
387. Paul Gebhard letter to Irving Klaw, February 24, 1959, Dr. Alfred C. Kinsey Era Correspondence, "Large correspondence between Irving Klaw and Kinsey regarding the exchange of materials and insights into the reception of his work," Kinsey Institute for Research in Sex, Gender, and Reproduction, Indiana University, Bloomington.
388. *Kitan Club*, August 1954, 49–51.
389. Irving Klaw letter to Paul Gebhard, February 27, 1959, Dr. Alfred C. Kinsey Era Correspondence, Kinsey Institute for Research in Sex, Gender, and Reproduction, Indiana University, Bloomington.
390. Master "K," *The Beauty of Kinbaku* (New York: King Cat Ink, 2015), 25.
391. Ibid., 65.
392. Ibid., 66.
393. Wardell Pomeroy letter to Akio Hori, June 16, 1959, "Dr. Paul H. Gebhard Era Correspondence, correspondence from an individual in Japan asking for copies of *Bizarre* in exchange for Japanese magazines," Kinsey Institute for Research in Sex, Gender, and Reproduction, Indiana University, Bloomington.

394. Akio Hori letter to Wardell Pomeroy, June 25, 1959, Dr. Paul H. Gebhard Era Correspondence, Kinsey Institute for Research in Sex, Gender, and Reproduction, Indiana University, Bloomington.
395. Master "K," *The Beauty of Kinbaku*, 42.
396. "The Personal Correspondence of John Willie," *The Works of John Willie*, 17.
397. Master "K," *The Beauty of Kinbaku*, 42.
398. John Coutts letter to Paul Gebhard, February 7 [1961], Dr. Paul H. Gebhard Era Correspondence, Kinsey Institute for Research in Sex, Gender, and Reproduction, Indiana University, Bloomington.
399. John Coutts letter to mailing list, undated, vertical files, Sado Masochistic Erotica Producers (United States) (20th century)—Coutts, John Willie, Kinsey Institute for Research in Sex, Gender, and Reproduction, Indiana University, Bloomington.
400. John Coutts letter to mailing list, [January 1961], vertical files, Sado Masochistic Erotica Producers (United States) (20th century)—Coutts, John Willie, Kinsey Institute for Research in Sex, Gender, and Reproduction, Indiana University, Bloomington.
401. John Coutts letter to Paul Gebhard, September 25 [1960], Dr. Paul H. Gebhard Era Correspondence, Kinsey Institute for Research in Sex, Gender, and Reproduction, Indiana University, Bloomington.
402. John Coutts letter to Paul Gebhard, August 24 [1961], Dr. Paul H. Gebhard Era Correspondence, Kinsey Institute for Research in Sex, Gender, and Reproduction, Indiana University, Bloomington.
403. John Coutts letter to Paul Gebhard, October 10 [1960], Dr. Paul H. Gebhard Era Correspondence, Kinsey Institute for Research in Sex, Gender, and Reproduction, Indiana University, Bloomington.
404. Paul Gebhard letter to John Coutts, December 22, 1961, Dr. Paul H. Gebhard Era Correspondence, Kinsey Institute for Research in Sex, Gender, and Reproduction, Indiana University, Bloomington.
405. John Coutts letter to Paul Gebhard, April 3 [1962], Dr. Paul H. Gebhard Era Correspondence, Kinsey Institute for Research in Sex, Gender, and Reproduction, Indiana University, Bloomington.
406. Paul Gebhard letter to John Coutts, November 2, 1960, Dr. Paul H. Gebhard Era Correspondence, Kinsey Institute for Research in Sex, Gender, and Reproduction, Indiana University, Bloomington.
407. Coutts, interview.
408. John Coutts letter to Paul Gebhard, June 18 [1961], Dr. Paul H. Gebhard Era Correspondence, Kinsey Institute for Research in Sex, Gender, and Reproduction, Indiana University, Bloomington.
409. Ibid.
410. Ibid.
411. Ibid.
412. John Coutts letter to mailing list, June 12, 1961, Dr. Paul H. Gebhard Era Correspondence, Kinsey Institute for Research in Sex, Gender, and Reproduction, Indiana University, Bloomington.
413. John Coutts letter to Paul Gebhard, August 24 [1961], Dr. Paul H. Gebhard Era Correspondence, Kinsey Institute for Research in Sex, Gender, and Reproduction, Indiana University, Bloomington.
414. Ibid.
415. John Coutts letter to Paul Gebhard, September 1961, Dr. Paul H. Gebhard Correspondence, Kinsey Institute for Research in Sex, Gender, and Reproduction, Indiana University, Bloomington.
416. Paul Gebhard letter to Irving Klaw, September 8, 1961, Dr. Alfred C. Kinsey Era Correspondence, "Large correspondence between Irving Klaw and Kinsey regarding the exchange of materials and insights into the reception of his work," Kinsey Institute for Research in Sex, Gender, and Reproduction, Indiana University, Bloomington.
417. John Coutts letter to Paul Gebhard, 3 July [1962], Dr. Paul H. Gebhard Era Correspondence, Kinsey Institute for Research in Sex, Gender, and Reproduction, Indiana University, Bloomington.
418. John Coutts letter to Paul Gebhard, July 18 [1962], Dr. Paul H. Gebhard Era Correspondence, Kinsey Institute.
419. John Coutts letter to Paul Gebhard, 3 July [1962], Dr. Paul H. Gebhard Correspondence, Kinsey Institute for Research in Sex, Gender, and Reproduction, Indiana University, Bloomington.
420. Doug Alcorn letter to Paul Gebhard, September 17, 1962, Dr. Paul H. Gebhard Era Correspondence, "Alcorn's correspondence with Gebhard regarding research into exhibitionism," Kinsey Institute for Research in Sex, Gender, and Reproduction, Indiana University, Bloomington.
421. John Coutts letter to Paul Gebhard, June 18 [1961], Dr. Paul H. Gebhard Correspondence, Kinsey Institute for Research in Sex, Gender, and Reproduction, Indiana University, Bloomington.
422. John Coutts letter to Paul Gebhard, November 9 [1960], Dr. Paul H. Gebhard Era Correspondence, Kinsey Institute for Research in Sex, Gender, and Reproduction, Indiana University, Bloomington.
423. David Lee Roth, *Crazy from the Heat* (London: Ebury, 2000), 80.
424. John Coutts letter to Paul Gebhard, October 10 [1960], Dr. Paul H. Gebhard Era Correspondence, Kinsey Institute for Research in Sex, Gender, and Reproduction, Indiana University, Bloomington.

Index

Page numbers in italics refer to images.

Achilles (shoes), 33, 36–37, 39–43, *44*, 45, 50, *52*, 63, 68
A Manhattanite, 142
American Library Association, 112
American Social Hygiene Association (ASHA), 89
Arabian Coffee Shop, 30, 47, 53, 54
Ashton, Julian, 49, 50

Bagley, Richard, 67
Beeton, Isabella, 60
Beeton, Samuel, 60
Behind the Scene (magazine), 112–114, 117, 118, 120, 142
Bilbrew, Gene, 149
Bizarre (magazine), 10, 11, *12*, 13, 47, 56–64, *59*, *65*, 67, 72, 74–75, 77, 79, 81, *82*, 89–90, 91, 93–105, *94*, *96*, *101*, *104*, 111, 112, 114, 117–123, *120*, *121*, *123*, 125, 127, 129, 131, 133, 136, 137, 141–142, 147–150, *151*, 152, 157–158, 162–165, *163*
Blaine, Mahlon, 122
bondage, 9, 10, 13, *14*, 16, 18, 25, 34, 43, *51*, 56, *57*, 60, 63, 64, 68, 71, 74, 75, 77, 79–81, *80*, 84, 89–90, 95, 97, 98, *101*, 102, 103, 107, 109, *110*, 112, 114, *116*, 117, 119, *121*, 122, 125, *126*, 128, 129, 130, *130*, 131, 134–136, *140*, 141, 142, 143–144, 147, 148–150, *152*, 153, 155, *156*, 157, 162–164, *163*
Braine, Robert, 121
Bridgeford, Shirley, 7, 135, 137
Burtman, Leonard, 104

Call Her Savage (film), 107
Carlo, 43
Carver, Betty, 134
Chumley's (bar), 67
Confidential (magazine), 114–115
Conley, Pat, *140*, 143–144, *145*, 153
Cooper, Courtney Ryley, 78
Coutts, Edith, 15
Coutts, Eveline. *See* Fisher, Eveline
Coutts, Holly. *See* Faram, Holly
Coutts, William, 15, 24
cross-dressing, 11, 16–17, 52, 56, 97, 100, 114

Dior, Christian, 94
Dodgers (baseball team), 68, 125
Dull, Judy, 7, 8, 133, 134–135, 136–137, 139, 141, 142, 159
Dull, Robert, 135

Englishwoman's Domestic Magazine, 60–61
Esquire (magazine), 76
Exotique (magazine), 104

Faram, Holly, *2–3*, 33, *40*, 41, *46*, 47–54, *51*, *52*, *54*, 55, 59–60, 63, 84, 129
Farrell, Edythe, 69–72, 74, 76, 79, 162
Fisher, Eveline, 22–23, *24*, 25, *26*, 28
Flirt (magazine), *69*, 72, *73*
Fox, Diane, 136

Gebhard, Paul, 11, 90–91, 92, 104, 118, 123, 129, 131, 141, 142, 157–158, 160, 161, 165
Girl Crazy (film), 107
Giunio, Eveline. *See* Fisher, Eveline
Giunio, Nicholas, 25–26
Glatman, Harvey, 7–10, 13, 134–137, 139, 141, 142
Grable, Betty, 71
Great Depression, 27–28, 41, 50, 79, 127
Guyette, Charles, 68–69, 71, 72, 74, 79, 85, 153, 162
Gwendoline and the Missing Princess, 84–85, *84*, *86*, 93

Harrison, Robert, 69, 71, 72, 74–75, 79, 93, 114, 115, 123, 127, 162
Henry, George, 109
high heels, 9, 16, 18, 19, 21, 25, 30, *31*, 32, 33, *34–35*, 35, 36, *38*, 39–43, *42*, *44*, 45, 52, 56, 60, 61, 62, 68, 71–72, 74, 75, 80, 95, 100, 103, 107, 127, 129
Hillier, Rob, 55, 85

Indiana University, 11, 88, 89, 92
Ito, Seiu, 150, 153

Jaskulsky, Walter, 28

Kawabata, Tanako, 148
Kefauver, Estes, 107, 108–109, 112, 114, 117, 118, 120, 142, 159
Khayyam, Omar, 11, 63, 121, 159

INDEX

Kinsey, Alfred, 83, 87–93, 149
Kinsey, Clara McMillen, 91
Kitan Club (magazine), 147–150, 152–153
Klaw, Irving, 76, 79–81, 83–85, 87, 89–90, 93, 107, 109–111, 117, 127, 134, 141, 149, 150, 153, 159, 160, 162, 164
Klaw, Paula, 79–80, 81, 111, 153

Ladder, The (magazine), 125
Langer, William, 109
Lautour, Loma, 49
Lindsay, Norman, 49, 50, 55
Little John, 79–80, 81, 153
London Life (magazine), 32–36, 39, 40, 43, 45, 50, 55, 56, 57, 58, 60, 61–62, 64, 68, 77, 94, 95, 107, 142, 147
Lonely House on Adachi Moor, 150
Lykles, Lynn, 134, 136

MacNaught's (shoe store), 31–32, 33, 34, 36, 50, 60, 142
Marshall, Thurgood, 13
Mercado, Ruth, 7, 8, 135, 137
Mishkin, Eddie, 107
Musafar, Fakir, 103, 105

National Organization for Decent Literature (NODL), 111–112, 143
National Police Gazette (magazine), 70, 70–72, 76
Norton, Rosaleen, 49–50
Nurmi, Maila, *102*, 103–104

On the Bowery (film), 67
One (magazine), 125, 127

Page, Bettie, 81, *82*, 110–111, 162, 164
Palmieri, Edmund, 92
People (magazine), 53–54
Perils of Gwendoline in the Land of the Yik-Yak, The (film), 164
piracy, 93–94, 118–119, *119*, 149, 153
Police Gazette. See *National Police Gazette*
pony play, 43, 75, 103, 104, 149, *165*

Regina v. Hicklin, 107–108
Roth, David Lee, 164
Roth, Samuel, 107–108, 122
Roth v. United States, 92, 107–108, 122

Sahara, Kise, 150
Select Bibliotheque, 43

Sexual Behavior in the Human Female (book), 87–88, 90
Sexual Behavior in the Human Male (book), 87, 91
She Done Him Wrong (film), 70
Sir D'Arcy D'Arcy. See *Sweet Gwendoline*
Sir D'Arcy and the Wasp Women, 93, 155, 157
Spider Pool, 143–144
Stanley v. Georgia, 13
Stanton, Eric, 85, *86*, 110–111, 149
stockings, 9, 10, 11, 16–17, 18, 25, 30, 32, 35, 47, 48, *54*, 56, 74, 98, 100
Suma, Toshiyuki, 148, 149
Summerfield, Arthur, 111, 115, 142–143
Sweet Gwendoline, 13, 63–64, 72, 74, 75–77, 79, 81, 83–85, *84*, *86*, 87, 90, 93, 95, 103, 111, 114, 121, 123, 127, 128, 131, 133, 141, 144, 147, 155, 157, 159, 161, 162, 164
Sweet Gwendoline and the Race for the Gold Cup, 144, 147
Sweet Rosie O'Grady (film), 71

Tijuana bibles, *78*, 78–79

Uramado (magazine), 148, 149, 153

Vampira. See Nurmi, Maila
Van Eyk, Frederick, 28–29
Van Horn, Judy. See Dull, Judy
Vargas, Alberto, 76
Vice Versa (magazine), 125
Vigil, Lorraine, 7–8, 135–136, 137
Vivian, E. Charles, 23

West, Mae, 70, 78
Wink (magazine), 68, 72, 74, 75, 76
Within a Story (film), 67

Yoshida, Minoru, 148
Yoshitoshi, 150

About the Author

Jane Garrett is an archivist and writer whose personal research focuses on the history of sexuality in America. A collector of John Willie's work for over 20 years, she also has experience as an artists' model and teacher. She has lived in Japan, in England, and throughout the United States and currently resides in Washington State with her husband, Rik.

Photo by Rik Garrett